Rowing and Sculling

GREENWICH LIBRARIES

11/97

Please quote number and last date stamped
if you wish to renew by post or telephone

Rowing and Sculling

The Complete Manual

BILL SAYER

ROBERT HALE · LONDON

ISBN 0 7090 5845 4

Robert Hale Limited
Clerkenwell House
Clerkenwell Green
London EC1R 0HT

1 3 5 7 9 10 8 6 4 2

Photoset in North Wales by
Derek Doyle & Associates, Mold, Clwyd.
Printed in Great Britain by
St Edmundsbury Press, Bury St Edmunds, Suffolk.
Bound by WBC Book Manufacturers Ltd, Bridgend,
Mid-Glamorgan

Contents

Introduction

I came to rowing later than many participants, being introduced to the sport by a friend at university. Lacking in ball skills, I had not enjoyed the traditional team games at school, but I was immediately taken with this wonderful sport. I loved being out on the water and I liked the challenge of mastering the new and deceptively simple skills. Above all I relished the competition and the feeling that I could succeed by training hard and pushing myself to hitherto unexplored limits. Here was a sport in which what you got out of it so clearly depended on what you put into it.

My subsequent rowing career was rather fragmentary, as although I loved the sport and wanted to be successful in it, I also wanted to keep it in proportion and allow my career and some other interests to have their proper place. Despite this reservation I was able to taste a rewarding share of competition success, to travel widely in pursuit of all sorts of competition, and also to make a lot of friends in the sport. Now I am in the happy position where rowing is a part of my job and I have the privilege and pleasure of introducing youngsters to the sport and helping them to be as successful as they want to be. This book is intended for those of you who, as I was, are making your way in the sport and looking for ways in which to improve your skill, enjoyment and success.

Many people helped me on my way with advice and coaching, and in turn, like many good club members, I tried to help others. Perhaps because of my scientific training I always wanted to know more, and in particular as a biologist I wanted to know more about how and why my body responded as it did and just what was the scientific basis of the training that I undertook. I read all the rowing books that I could, and quickly discovered that there were very few good, up-to-date ones. Many of them were clearly very opinionated and lacked any clear foundation for the assertions that they made. At one stage my job took me to Switzerland, where I joined Basler Ruder Club and was greatly struck by the progressive attitudes and logical approach evident in continental rowing, and the contrast with the insular and old-fashioned views still prevalent in British rowing at that time.

Something of a revolution was sweeping through the rowing world, with the separate organisations of East Germany and West Germany in the van. It took some time for British rowing to catch up, but now it can also be numbered among the very best, and benefits from the new scientific approach that is found in most modern sports. A tremendous amount of research has been carried out in many fields concerned with human performance, and also in boat design and other items of equipment. The modern coach and competitor must endeavour to keep up to date not only with advances in this sport but also with the findings of others where the results might be relevant. We are all on the lookout for that extra something that will give us the competitive edge.

What I have tried to do in this book is to survey the whole of the complex of factors that make a rowing boat go fast. We need skill, and that skill consists of applying our limited bodily resources in the most efficient way to levering the boat through the water with oar or scull, and at the same time steering the thing on the optimum course. We need strength, endurance and speed, and thanks to research we can now plan our training to get the maximum from our bodies. We need good boats and they must be adjusted or rigged for maximum efficiency, or critical amounts of effort will be wasted. We need to know how to race, how to arrive at the startline in the best possible condition, and how to get the most from ourselves during the race. And we need to know how to look after ourselves so that we are not debilitated by avoidable hazards and can make the most of our training.

This is the book I wish I had read when I was setting out on my rowing and sculling career – I trust that you will find it useful, however much you already know. And Good Luck – you will need that as well!

CHAPTER 1

Rowing and sculling – an introduction to the sports

It is an inevitable human characteristic, it would seem, that if there is some way in which we can compare ourselves with others, then we are likely to set up some sort of competition to test ourselves. No doubt early man in his dugout or coracle raced his friends just for sport, and may have enjoyed seeing his children doing the same – and at the same time been pleased at the value of the sport in developing the childrens' skill and physique for more serious purposes. We know that the classical civilizations had formalized crew rowing races, and the many old-established races all over the world where rowing boats are used confirm the antiquity of our sport. The more modern form of racing for rowing and sculling evolved during the nineteenth century and quickly spawned the development of specialized racing craft, training methods and the various regatta organizations and clubs.

Although this wonderful sport is suitable for nearly all ages and both sexes, its history until relatively recently was marked by a very snobbish attitude by its administrators which sought to exclude the working man and those 'in trade', and also greatly restricted women's rowing. The result was a definition of 'Amateur' that restricted competition in domestic regattas and even international events to a self-chosen élite. Thankfully all that has gone and with rare exceptions our clubs are open to all, irrespective of background, and the majority also have women members. Similarly, it is now rare to find all-male regattas or head races, and events are open to all those who qualify by age or experience.

It is of course possible to train entirely alone in a single sculling boat, and I suppose that an individual could found his or her own rowing club to satisfy the administrators, but most people want to be sociable and to enjoy the benefits of club membership. Apart from the social aspects of club life, which are greatly esteemed by many, there are the undoubted advantages of club crew rowing or sculling, and of having an administrative and financial umbrella organization. The majority of readers will row or scull as members of such a club, whether it is part of their school or university organization, or an independent organization, yet at the top level

of the sport, crews are more likely to be drawn from a number of feeder clubs and row as composites or under a flag of convenience. Those of you who are moving on from school or college, or whose ambitions are outgrowing your existing local club, will be looking

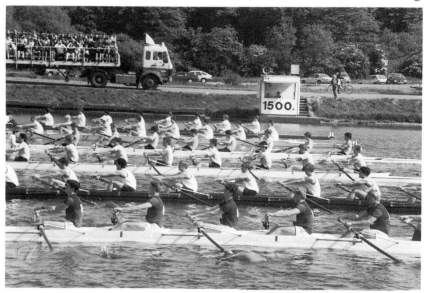

Fig. 1 British school rowing at its best – the excitement of multilane racing in the National Schools Regatta at Nottingham.

to see how best your needs may be met, and will be choosing your club with your future in mind. You will want to be sure that the facilities and equipment are adequate and that there will be enough like-minded athletes to form really worthwhile crews, as well as be sure of the availability of inspiring coaches. If there are not, go elsewhere – it is your future at stake!

Clubs and the administrative organizations such as the Amateur Rowing Association (ARA) are also responsible for issuing and implementing advice on water safety. It is essential that you are fully conversant with the latest safety regulations promulgated by your club, and essential for everyone's safety as well as your own that you adhere strictly to them. Rowing is a safe sport, but as with any water sport, there are hazards, and perhaps we run a special risk because we are not looking where we are going most of the time, and we can travel rather fast. Reference to safety matters is made in various sections of this book, but in particular it is essential that you are able to swim well before you even think of going afloat. Not only must you be able to swim well, but you must also be confident, so that if you are suddenly pitched into freezing water on a dark night you do not panic, but know what to do. Inevitably rowing tends to breed tough-mindedness, and we

become used to training in unpleasant conditions – but don't let an excess of enthusiasm take you out in unsafe conditions when prudence dictates otherwise. Unless you are very sure, always seek experienced advice, and still be prepared to err on the side of

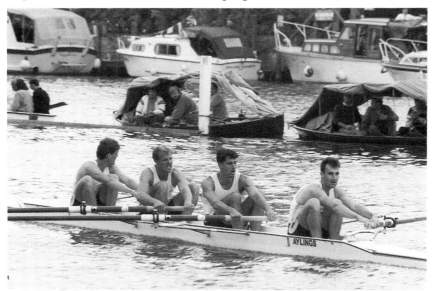

Fig. 2 In recent years, Leander Club has been the focus for ambitious competitors determined to row with the best.

caution if you are in doubt. Blanket advice can never be entirely adequate; you must do all you can to learn the special hazards of your stretch of water and to understand its daily vagaries.

Types of competition

In common with many other sports, rowing and sculling are able to offer a very wide range of competitions for practically all age groups and for both sexes. The diversity is further enhanced by the common provision of separate events or classes for competitors of differing abilities, usually categorized on the basis of past successes. In recent years the provision of lightweight events for both men and women has become increasingly popular and recognizes that (at the top senior level at least) there is an advantage to those who are significantly above average in height and weight. Races are held over a range of distances from the 500-metre 'sprint' to the timed processional head-of-the-river races covering several kilometres. There are even some much longer 'marathon' events such as the Lincoln to Boston Marathon, or the Tour de Lac Léman. Competition can be found for all types of boat, and thus there is room in the sport for everyone, from the

young beginner to the wily octogenarian, to measure themselves against their peers, to try to improve their own standards, or simply to enjoy taking part.

In each country the national rowing federation publishes its own rules for domestic competition, and in Great Britain these are found in the indispensable annual British Rowing Almanack published by the ARA. The various national federations are affiliated to the Fédération Internationale des Sociétés d'Aviron (FISA), which is the governing body for international rowing and sculling competition and which issues the rules applicable to such events. Many of the domestic rules are based on those of FISA, although there are some significant differences, and in both cases the intending competitor must beware of the frequent amendments. A summary of the principal categories of events under FISA rules is given in Table 1.

Table 1 FISA racing classes

1 Junior Not attained age 18 before 1st January of the current year.

2 Senior A Open to all competitors.

3 Senior B Not attained age 23 before 1st January

4 Lightweight men Maximum weight for a rower or sculler is 72.5 kg, but the average weight for a crew shall not exceed 70 kg (excluding cox).

5 Lightweight women Maximum weight for a rower or sculler is 59 kg, but the average weight for a crew shall not exceed 57 kg.

6 Veteran 27 years or older in the current year. Further categories are as follows for the average age of crews (excluding cox), or for scullers attaining that age during the current year:

A Open to any veteran; **B** 36; **C** 43; **D** 50; **E** 55; **F** 60; **G** 65; **H** 70.

7 Coxes The rules concerning Juniors apply also to coxes, and for those events the minimum weight (including deadweight of up to 10 kg) is 50 kg. For other events the cox is not classified, but the minimum weight for men's events is 55 kg, for women's 45 kg, and in mixed crews it is 50 kg.

For domestic competition it is necessary to have additional classes such as novice (never having won a race), and other categories based on experience and success, so that fair competition is available and there is a ladder of success which the novice or youngster can climb as he or she develops in the sport. The ultimate to which talented and dedicated competitors can aim is to represent

their country in a major international event – an experience which could well be the memory of a lifetime. For those who do not reach those heights, there is still an enormous amount of pleasure to be derived from striving (and sometimes succeeding) to do your best against others.

In order to get the most out of your sport, you must be aware of the standards of current performance, the way in which those standards are changing, and what factors determine performance. Then you can not only choose the most appropriate races but can also best seek ways in which to improve the chances of success.

Improvement in performance

Competitive rowing and sculling are sports which, since they require the sustained application of muscular power, reward personal effort – effort applied not only in the competition but perhaps more importantly in the preceding preparation and training. Competitive standards for men, women and juniors have risen by extraordinary amounts in recent years, for three main reasons, all of which owe much to the greater application of scientific principles. Firstly, the equipment used has improved – boats, oars and sculls are lighter, and more efficient both hydrodynamically and ergonomically – and this in turn has permitted important changes in technique. Secondly, the physical standards of the athletes entering the sport are increasing – partly as a result of the general improvements in nutrition, health and physique in much of the world, but also as a result of improved recruiting and selection procedures. Thirdly, the science of physiology has made great strides and consequently today's training methods have a much sounder scientific basis and are much more effective.

Winning times fluctuate greatly from year to year, reflecting the great importance of wind and water conditions at the time. Nevertheless it is possible to calculate a regression line showing the probable trend of reduction in average race time year by year. From this we can calculate that the average yearly reduction in race time is a little over 1 second (1.3 sec/yr or 0.32%/yr). This may not seem very much at first, in view of the enormous expenditure of time, money and effort by all concerned with these pinnacles of competition, but in fact it represents a most significant advance. As an illustration, consider that the winning Olympic eight of 1988 would beat the winning crew of 1968 by six lengths – so the great Ratzeburg crew of 1968 might not even have qualified for the final of the 1988 Olympics!

That particular crew, and that year, in fact mark a significant point in modern rowing development. Ratzeburg Ruder Club, as

the spearhead of West German rowing under Karl Adam, pioneered methods of scientific training and composite crew selection which revolutionized rowing at that time and left a legacy that is still in use today. Furthermore, for the 1968 Olympics the West German eight had the use of a specially designed, short, slim and lightweight boat, fitted with the long slides and flexible shoes that are now universal. The oars they used may have been a few centimetres shorter than those used by the 1988 crews, but the blades were virtually identical to modern ones. In essence, then, the equipment has not changed fundamentally since then, though detailed refinements and the use of high-performance synthetic materials (see Chapter 5) may account for one or two of the lengths gained. Thus we can conclude that it is from the area of human performance and the greater understanding of applied physiology that the largest improvements have come in recent years. It is not the case that the eights rowing has shown more improvement than the smaller classes of boat, for the performances in all classes, whether rowing or sculling, have remained approximately parallel in recent years.

Because of the large variations in conditions in recent championships, it is not possible to give a reliable guide to performance trends from them, and it must be borne in mind that smaller boats are more affected by adverse conditions. If, however, we cast our statistical net further and examine the times set in good conditions in each year (for example at the Rotsee in Lucerne, where competition is fierce), we find that the suggested percentage improvement is borne out.

During recent years there have also been major improvements in the standard of rowing and sculling for women, juniors (both men and women), and for lightweights. Lightweight women's rowing was introduced only as recently as 1985. Because of the shorter time-scale for comparison, and also because the senior women's racing distance has changed from 1000 metres to 2000 metres, and that of junior women from 1000 metres to 1500 metres and then 2000 metres, all since 1984, it is more difficult to calculate reliable average improvements. It would at first seem from the times achieved in the last few years that the juniors are progressing at a prodigious rate whilst the lightweights are more erratic, but of course these time differences reflect conditions more than anything else. Nevertheless, they do show the very high speeds being achieved in modern rowing. Overall it seems probable that these three groups (senior women, juniors and lightweights) have shown a more marked improvement than the senior men, and calculations from a wider range of figures suggest this to be at approximately 0.5% per annum – that is, they are progressing nearly twice as fast. This compares with calculations of slightly

higher rates of change during the 1970s, but again with women and juniors improving faster than the men.

What then were the factors that determined the speed of the boat during such races? The answer to this question will be the subject of the succeeding chapters of this book.

Performance-determining factors

The overall speed achieved in a race is a function of five major factors:

1 Physical factors – air and water resistance
 – ergonomics and biomechanics
 – oar and scull propulsion efficiency
 – all-up weight
2 The athlete's physique and physiology
 – strength, endurance and speed
 – response to the environment
 – nutrition
3 Skill and technique
4 Psychology
5 Tactics – optimum use of resources
 – effect on other competitors

In this chapter we examine briefly the way in which these factors, either singly or in combination, limit performance. In later chapters more detailed analyses show how in our present state of knowledge we can optimise these factors. We also look at ways of making further improvements in the future.

PHYSICAL FACTORS

Air resistance

Aerodynamically a racing rowing boat is a mess, with different pieces of equipment and athlete sticking out to interfere with air flow. Air speeds are low, which might suggest that this factor is unimportant, say about 10% of total resistance to movement, but the effects of head winds show just what a major factor air resistance can be, and it is surprising that so little has been done to minimize it.

Water resistance
This form of drag is the principal retarding force on the boat. Racing rowing or sculling boats propelled by oars do not go fast enough to plane, nor can they sustain hydrofoil lift for long. Therefore the hull must displace water in order to float, and will disturb water as it passes through it. The main energy losses occur in the turbulent wake created by the friction of the boat's skin against the water, and in the waves made by the boat's shape and size as it pushes the water aside. Calculations suggest that modern boats are approaching the optimum hull shape, but many of these shapes have been arrived at empirically and there have been only a few attempts to improve their efficiency more objectively.

Ergonomics and biomechanics
The correct relationship between the athlete and the equipment is vital for effective power production and for skilled technical movements. The body's biomechanics react with the mechanics of the oar in a complex way, and the relationship must be carefully adjusted if you are to gain the best from your body and the equipment. There is little to be gained from a choice of theoretically ideal equipment if it is badly adjusted or unsuited to the individual athlete. Fortunately the modern boat is designed to make such changes relatively easy, and the rules that govern such things are becoming more clearly established (see Chapter 5).

The mechanics of oar propulsion
The details of the way in which an oar propels a boat are still not fully understood and are not simple. Gilbert C. Bourne's classic *Textbook of Oarsmanship* (1925) contains a clear analysis of the complex movement of the oar and its relationship with the oarsman. More modern analysis confirms that to a great extent the blade acts as the fulcrum of a lever by which the boat is levered past successive pieces of water. Using the blade as a spoon to hurl water sternwards in the hope that Newtonian reaction will move the boat forwards is demonstrably less effective!

There are an enormous number of variables in such a system, but fortunately years of testing have defined well-accepted parameters within which the most effective propulsion can take place. These are explored in more detail in Chapter 5, but it is worth reflecting here how commonly they are misunderstood, and even invested with some special mystique.

All-up weight
The weight of boat plus crew and equipment has two retarding effects. Firstly, as Archimedes tells us, the heavier the load the

more water must be displaced, and the more energy will be transferred to that water as the boat moves. Secondly, the boat does not travel at a uniform speed – it must be accelerated at the start, and must then be accelerated again and again in stroke after stroke as it loses speed during the recovery part of each stroke cycle. There is a common fallacy that the heavier boat will gain by its greater inertia so that less speed is lost between strokes, but calculation does not support this view – the heavier boat suffers more drag and requires more force to accelerate it. For example, a 10 kg saving on a 100 kg eight, with a 50 kg cox and 85 kg average crew, using conventional wooden oars at 4 kg each, gives a saving of 0.26% on time. Assuming a best race time of 5 min 30 sec, this 0.26% improvement represents a 0.86 sec advantage. Many races are won by less than that!

THE ATHLETE'S PHYSIQUE AND PHYSIOLOGY

Strength

Rowing and sculling boats are moved by muscle power alone, and the magnitude of the resistance encountered at speed is such that considerable strength is required to overcome it. However, strength alone is not enough, for it is essential to be able to overcome the resistance quickly, and this means *power*, a rather different quality. In addition, many athletes possess enough maximum strength to propel a boat at the required cruising speed at least, but far fewer can maintain that strength for the duration of a race. Maximal strength is only one component of the power in question; high levels are characteristic of the best performers, yet not diagnostic since high maximal strength values are even more characteristic of other sports which do not require so much endurance as rowing or sculling. Nevertheless one need only look at the difference between heavyweights and lightweights to appreciate that strength, usually correlated with body mass, is a vital factor (though the biomechanical benefits of greater height and longer limbs must not be forgotten).

There is no doubt that the most successful rowers tend to fall within a well-defined somatotype or body build (fig. 4), yet there are many exceptions even at international level. It is also true that most athletes, forced to operate close to their maximal strength, will then suffer from a lack of strength endurance. Specific strength training is of course the key to improving the athlete's capacities in this respect.

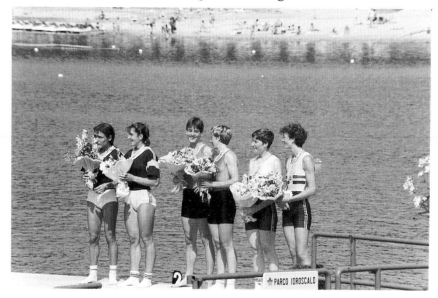

Fig. 3 The physique of the best crews in the world may seem daunting, but much smaller people are also very successful, especially in domestic and in lightweight events. These are the womens' lightweight double sculls medallists at the World Championships in Milan.

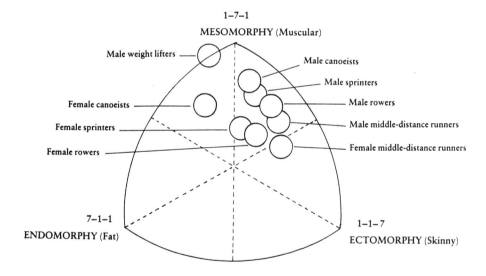

Fig. 4 Typical somatotypes (body build) of Olympic competitors.

Endurance

As explained above, the ability of the rower or sculler to make repeated powerful movements is critical to overall race performance. Three types of endurance can be identified and to some extent they have different physiological bases.

General endurance – characteristic of low-level power outputs maintained for a long time.
Strength endurance – the maintenance of a required high level of strength for a period of time.
Speed endurance – the ability to overcome a resistance quickly, but repeatedly.

The 2000 metre rowing course does require high levels of endurance, but this is of the type sometimes referred to as 'special endurance', i.e. specific to rowing that distance, and this is largely a *power endurance* – with strength and speed endurance as its principal components. The ability to row a long way slowly does not by itself win races.

It is fortunate that these desirable characteristics, whilst to some extent inherited, can be much developed by appropriate training – thus effort is rewarded. It is also important to realize that the response is specific to the type of training employed; what you get out of it depends on what you put into it. Nevertheless, the very best competitors are distinct physical types and are likely to be tall, with long limbs, well-muscled and with a high proportion of the right muscle fibres, allied to exceptional circulatory and respiratory systems.

Response to the environment

Our bodies function best within a quite narrow range of internal conditions, and although we have the adaptability to survive a wide range of different environments we cannot perform well if our resources are diverted, or we fail to adjust. Some of the consequent problems, and ways of minimizing them, are described in Chapter 9.

Nutrition

In a sense we are what we eat, although most of what we eat is quickly used up, and the rest is highly modified before it is incorporated into our bodies. Without good nutrition we cannot grow to our full genetic potential and we cannot release energy from our food in the optimum way for training or competition. I do not believe that there is any magic dietary formula that will ensure higher performance – after all, the many champions probably have almost as many different diets between them – but

there are dietary rules which you would be wise to observe. One international athlete once said that, like gamblers, we are always on the look-out for some special ingredient that will turn us into supermen, if not overnight, at least by next Saturday. I hope that after reading Chapter 9 you will not waste your time and money on the worthless search!

SKILL AND TECHNIQUE

Technique has the twin aims of enabling you to make the best use of your physique and physical capabilities, and to move the blade through the most effective pattern both in and out of the water. It is also a function of the techniques of rowing and sculling that these maximally efficient movements shall be carried out in a smooth and rhythmic way that minimizes energy loss. It is characteristic of the action that large masses move in ways that can prejudice the smooth flow of the boat through the water, and that both power output and speed vary during the stroke (fig. 5).

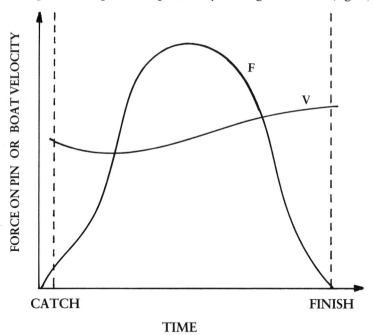

Fig. 5 Variations in force on the pin and in boat velocity during the stroke.

Fashions in rowing technique change from time to time, often not for any strictly objective reason but perhaps in imitation of some (perhaps ill-observed) idol. Points of 'style' are debated with almost religious fervour, and tendentious tracts are published, some even with the benefit of photographs actually illustrating that the movements advocated by the author are impossible to

execute efficiently! The dogma also grew that only the blade action was important, and many miles of film were taken of blades flashing in action with scarcely a glimpse of what the athlete was doing on the other end.

In the main stream of world class rowing today, it is apparent that eccentric styles have all but vanished, and there is remarkable uniformity of technique. The best athletes now show marked economy of movement and a lack of any exaggerated positions either of the legs or back; they are thus enabled to use their muscle groups over their most effective range. Bladework too, at its best, shows the simple attributes of a fast catch at full reach, a level drive through the water, and a fast, clean extraction – no frills or violent movements. Such deceptively simple skills are hard to acquire, and hard to maintain in the stress of competition. Again the fallacy that training is principally for fitness and that technique can be given scant attention has been demolished, and most would now concede that the best results are obtained by hours of patient attention to detail under all conditions and pressures.

For the proper development of technique you must appreciate not only the mechanical and biomechanical principles, but also the way in which the body generates and expresses its power during the stroke. There is, moreover, no doubt that the development of technique has been related to advances in the equipment used.

Coxing too is a physical skill requiring a great deal of practice in all conditions in order to acquire the necessary feel for the water and for the boat's behaviour. The good cox can follow the optimum course with the minimum disturbance to the boat's run and balance.

Skeletal muscles contract and relax according to the instructions they receive from the nervous system. Rowing is notable for the very large number of muscle groups involved not only in propelling the boat but also in the essential movements of technique and in balancing the craft. To achieve this complexity a phenomenal amount of sensory information must be interpreted by the central nervous system from the sense organs of touch, pressure, stretch, sight, and so on, and used to direct the appropriate responses of the muscles. Skilled movements are the result of the precisely timed contraction and relaxation of a myriad disparate muscle fibres.

We can assume then that the successful competitor will possess highly developed sensory and motor nervous systems, which will show themselves as technical skill and very effective movement patterns. The maintenance of this skill under race conditions or in hard training will be greatly affected by shortage of oxygen in the central nervous system and by a number of waste products of metabolism – particularly at the nerve-muscle junction. It follows

then that the competitors whose physiology, training or tactics spares them most from such ill effects will be at a further advantage. It is equally true that time spent learning and establishing skills under pressure is doubly valuable, but that basic technical grounding is best carried out free from these other stresses and debilitating factors.

PSYCHOLOGY

Competitive rowing and its essential tough training is very demanding not only on the physical abilities of the athlete but also on a wide range of personality factors. A detailed study of these factors is beyond the scope of this book, but it is clear that at the top level there is little to separate the physiques and physiologies of the potential champions, and their equipment may well be identical, so that the ultimate performance comes from those who combine those attributes with the most suitable personality and mental approach. Developing the physical attributes in itself demands dedicated and effective training over many years, requiring exceptional determination and persistance. Without the right psychological circumstances the learning process will not be effective. At the same time the psychological strengths must be developed to cope with the progressive training loads and increasingly tough competition. In the competition itself, the best competitor is not just very tough-minded, but has the ability to retain control under extreme pressure so that technique and tactics are optimized.

Essentially the successful competitor is selfish. Loyalty to state, club or friends may be important at times, but in the end athletes want victory for themselves to meet their personal need for satisfaction, whatever its origin. This is not to deny the importance of personal relationships in the athlete's psychological development, whether with coach, parents or other crew members. In the last case, it should be borne in mind that crew rowing must be the ultimate team sport, where much must be sublimated by the individual for the common good (fig. 6).

In the coxed boat the cox also has much to contribute to the psychological responses and morale of the crew, both during racing and in the long preparation for it. The cox's role can be a vital one in maintaining concentration on the desired training or competitive goals and in giving essential information and encouragement to the crew. Particularly in the larger boats, the cox does much to aid communication and hence cohesion, and is the essential mouthpiece of the stroke – and often of the coach too.

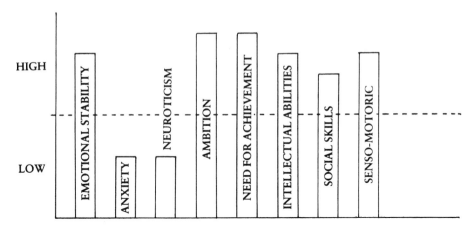

Fig. 6 Psychological characteristics of good competitors.

RACE TACTICS

Race tactics have both physical and psychological effects. To win a race against good opposition often means working close to your limits (or what you perceive to be your limits), and a wrong choice of tactics can mean that excessive fatigue comes too soon. It is characteristic of our sport that a very small increase in speed demands a disproportionate increase in power, and we must be sure that its benefits are really worthwhile. If you are confident in your race plan, however, and your tactical moves seem to be having their desired effect, then there will be a psychological boost for you and perhaps a blow for your opponent which can be worth more than any loss in efficiency.

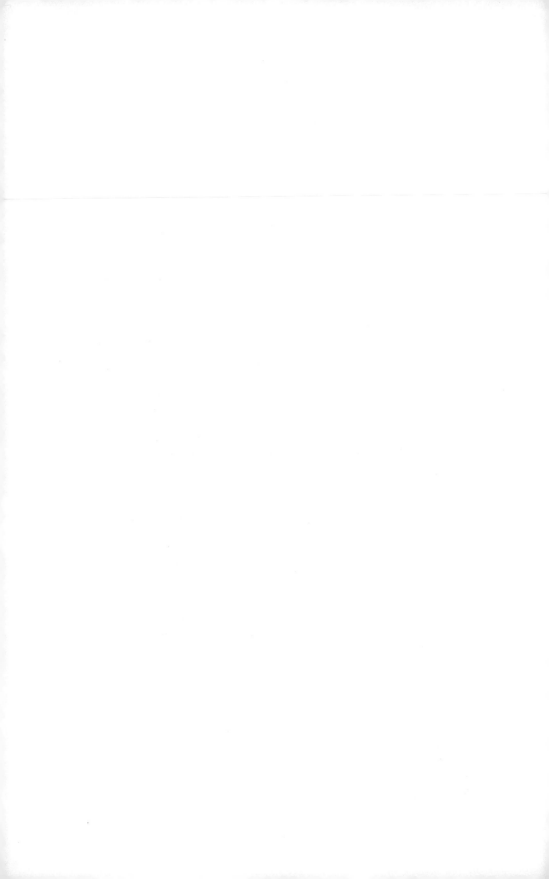

CHAPTER 2

Rowing technique

At its most basic, technique means simply the way in which you propel the boat through the water, but for competition purposes the requirement is for a technique that will use your physical capacity to the full in propelling the boat as quickly as possible. A good, efficient technique is essential for the best enjoyment of the sport, whether the aim is success in racing and knowing that you have made the most of your efforts, or just in the pleasure of mastery of your craft. In addition, a good technique will enable you to cope with adverse weather and water conditions. For the beginner the development of these skills is of paramount importance and will make an enormous difference to what is gained from the sport. For the experienced competitor a finely honed technique is still a vital component. For both, the ability to maintain form under pressure is very valuable, yet more difficult to acquire.

Good technique is essentially simple – it is the faults that cause the complications – but it is highly skilled and it can take a long time to refine and perfect, especially if bad habits have been learnt and are allowed to intrude. There is also often a confusion with 'style', which we will define here as the body movements which an individual uses in order to execute the technique. The fact that many different styles are demonstrably equally effective suggests that the differences are not important, but it is also apparent that all successful styles have an essential technique in common, and it is on this that you must concentrate.

For convenience of analysis we may divide the technique of rowing into four main areas:

1 The path of the blade into, through and out of the water – 'bladework'.
2 The co-ordinated muscular movements that produce the bladework and harness the athlete's power to move the boat.
3 Balance.
4 The rhythm of the stroke.

In the following pages I first of all describe what constitutes good technique in these respects, and suggest ways in which you can master it, and then go on to outline some of the reasoning behind it. Of course, in reality the stroke is a fluid and continuous integration of all four factors, and they are mutually dependant.

Position in the boat

Before a stroke is taken it is essential to ensure that you are correctly seated, that stretchers and riggers and oars are suitably adjusted, and that the oar handle is being held correctly. You are in contact with the boat through three points: the seat, the feet on the stretcher, and the hands on the handle. It is through these that both boat and blade must be controlled. The boat builder is responsible for providing much of the relationship between riggers, seat and stretcher, as is described in Chapter 5, but modern boats have considerable adjustment available so that they can be made suitable for most ranges of rowing styles and sizes of athlete. More will be said later in this chapter about the importance of the adjustments in determining the effectiveness of particular aspects of technique, and the whole question of rigging is explored in detail in Chapter 5.

For the moment let us assume that all is well: both buttocks are evenly placed in the hollows of the seat, and the stretcher is placed so that you can use all the slide required without hitting the stops (though some may prefer that the seat wheels are just in contact with the backstops when the legs are fully extended). For most rowers the aft edge of the seat should then be about 46–48 cm from a line across the boat through the pin. When sitting at that position the end of the handle should come to just beyond the side of the ribcage, and at about the height of the lowest full rib when the athlete is sitting tall and leaning back slightly. It should be possible to hold the end of the handle with the appropriate hand to the side of the ribs (not in front) by leaning slightly towards the rigger – this is the position that we should aim for at the finish of each stroke. Sitting at backstops with the arms straight and the blade just covered in water, the hands should be about 5–10° below the shoulders, and then, when the arms are flexed and the handle drawn to the finish position close to the ribs, it should be easy to extract the blade fully (square) by pushing down with the hands without them fouling the thighs.

If these basic positions cannot be achieved then the rigging is not right and should be corrected (after reference to Chapter 5) before going any further.

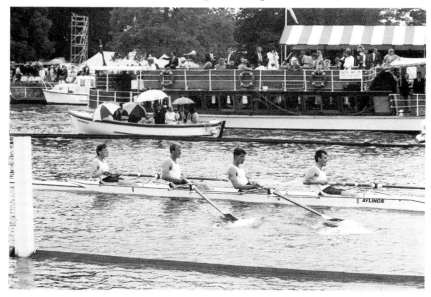

Fig. 7 This four shows good hand positions on the handles and use of the
outside arm, but all except stroke appear to be rigged too low.

Holding the handle

The correct hold on the handle is vital for the skilled movements of
rowing and even for full power expression, and even with very
experienced oarsmen technical faults and problems can often be
traced to this point. The hand furthest from the rigger (the outside
hand) should be hooked round the last few centimetres of the
handle so that the little finger can be tucked over the end – this
stops it slipping down the handle and makes it easier to maintain a
light outward pressure against the swivel. The handle will rest in
the base of the fingers with the wrist flat or slightly arched and it
does not really matter whether the thumb is above or below
(though I feel slightly more in control with the thumb below).
What does matter is that the handle is never gripped but is always
free to rotate in this hand. Tension and gripping with the outside
hand causes clumsy movements, problems with feathering, and
possibly blisters and wrist problems. The photo sequences (fig. 12)
of the rowing stroke show some good relaxed control of the oar.
Think of guiding the handle through its desired path with the
fingers of this outside hand, and use it merely as a hook when
pulling through the stroke – do not grip.
 The inside hand also should not grip the handle tightly – keep
the thumb as loose as possible. This is the hand for feathering and
squaring the blade, and all that is required is that the handle is

rolled out into the fingers to feather the blade, and then gathered back into the roots of the fingers with the wrist arching slightly in order to bring the blade square again for the next stroke. Again a tight grip will lead to clumsy actions and difficulty in feathering, and because the wrist will have to be used excessively, fatigue and cramp will soon set in, with the possible danger of tenosynovitis in the longer term. Even in rough water it is not necessary to grip the handle – the swivel face will hold it at the correct angle for you, and even if the blade does hit a wave it is better that loose hands and arms allow it to deflect rather than upset the whole boat. Most people find it best to have the hands about two hand-widths apart – a narrower placing constricts the finish action, whilst a wider one reduces control and power.

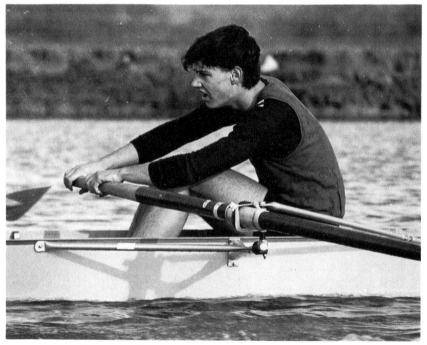

Fig. 8 During the recovery the hands should not grip the handle tightly, but as demonstrated here both hands and arms should be relaxed. Photo by C. Peregrine.

Bladework

The essence of good bladework is that the blade must be covered as quickly as possible, and power applied to it as it bites the water so that the minimum distance is lost. Then the blade is driven horizontally through the water with the blade just covered all the way, before a quick and clean release that neither allows water to strike the back of the blade nor throws water sternwards. During

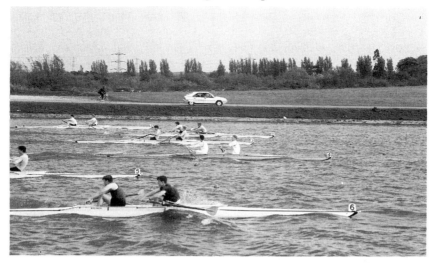

Fig. 9 In rough water it is important to remain relaxed so that if the blade does hit a wave the whole boat is not upset.

the recovery the blade should be just far enough from the surface to clear any waves, and to allow the blade to be squared without catching the surface. As the blade squares it should be brought close to the surface in order to minimise the vertical movement required for the catch. Figure 10 shows the ideal path of the blade, and the sequence of photographs in fig. 12 illustrates the movements of hands and body required to produce the desired bladework. It must be emphasized that the object is to anchor the blade in the water as quickly as possible at the beginning of the stroke, and that full power must be applied at that instant in order to lever the boat past that fixed point. To achieve this requires excellent co-ordination of the power muscles of the legs and trunk, together with the rapid lift of the hands that guides the blade into the water.

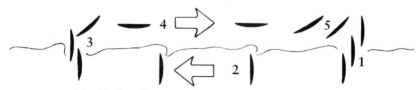

1 The blade is driven steeply and quickly into the water.
2 Blade just covered, constant depth.
3 Blade is extracted square, not feathered until clear of the water.
4 Blade kept clear of the water on the recovery.
5 Blade is brought down to the water as it is squared.

Fig. 10 Bladework.

If the catch is too slow water will be knocked forwards (backsplash), braking the boat; if the drive is started too soon water will be thrown sternwards (rowing it in) and length and power will be wasted.

Seen from the side, the hands tend to follow a curved path through the stroke, but any such vertical movements represent wasted energy – energy that is not propelling the boat forwards but upwards or downwards. A blade that is not quickly covered at the catch, or is too shallow later in the stroke (washing out), may make an impressive-looking puddle, but it is heating the water rather than moving the boat. If the blade is too deep, then part of the loom will be under water and will be dragged backwards by the moving boat, acting as a brake (fig. 11).

Styles

In the late 1960s, Karl Adam and his great Ratzeburg crews revolutionized thinking about rowing technique and the equipment necessary for it. The essence of his method was that since the leg muscles are the most powerful and most trainable, then most emphasis should be put on leg action, and less done with the upper body. In order to achieve greater leg movement at knee and hip, the slides needed to be lengthened, and the relationship between seat and feet altered. Inevitably when the athletes moved into the compressed forward position their heels rose from the stretcher, and so the fixed flexible rowing shoe was developed. Many crews copied the Ratzeburg style and equipment and it was undoubtedly successful, but meanwhile East Germany was coming to dominate world rowing with a style that was very different. The East German crews used shorter slides and consequently less leg compression and more body swing. As usual, many who copied these techniques exaggerated certain points (fig. 13).

Much of the controversy has now died down and at championship level it is rare to see extreme styles of any sort. Coaches are now much more aware of biomechanics, and the technique now common avoids acute joint angles as inefficient and at the same time attempts to maximize power production from both legs and upper body. It is now accepted that the two extreme styles have disadvantages and that a compromise between the two has most to commend it.

There is no such thing as a perfect oarsman, and the illustrations here are not meant to show perfection but the good application of principles. It should be remembered that every athlete is an individual and variations from whatever is regarded as ideal are not only probable, but may even be desirable to make the most of individual qualities. We should not attempt to copy slavishly, but to observe, learn and apply the lessons to our own circumstances.

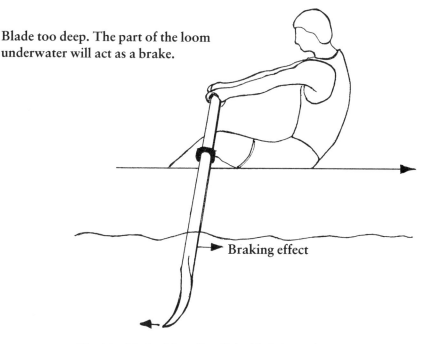

Blade too deep. The part of the loom underwater will act as a brake.

Braking effect

Fig. 11 The braking effect if the blade is too deep.

Learning good technique

Attitude is all-important, for it is essential to believe that technique is very important and can always be improved. With prolonged training the body adapts and movement patterns become automatic, and at the same time much easier and smoother; unfortunately incorrect actions are as easy to learn as correct ones. Remember that practice makes permanent, not perfect! The attitude to adopt must be that every stroke taken is an opportunity to improve technique, and this is a goal to strive for whatever the circumstances and however great the pressure. To do this unfailingly requires a lot of patience and much determination, but the dividends are great. It should also not be forgotten that the youngster and the novice simply cannot row in a mature way – the necessary muscle development, strength and co-ordination aren't there yet – but that doesn't mean that they should not try to get it right. With young rowers there is the added problem that growth will greatly affect their co-ordination and body proportions (for good or ill), and it is thus inevitable that their rowing technique must change.

There is no doubt that children learn motor skills much faster than older adolescents, who in turn learn faster than adults. Before puberty, children can learn skills such as balance very quickly, and

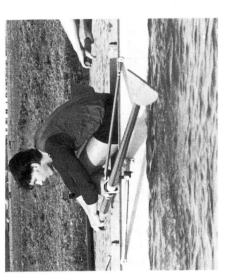

1

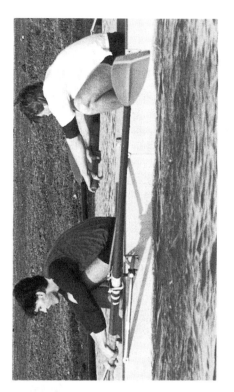

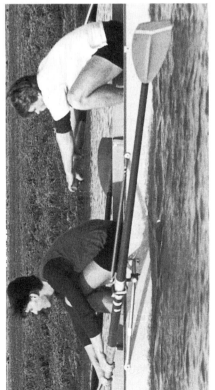

2

5

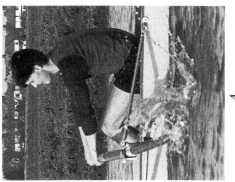

4

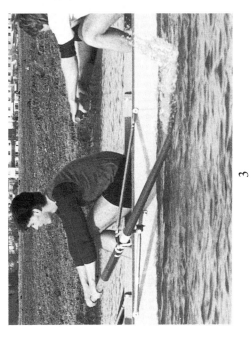

3

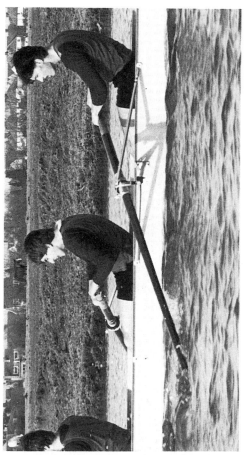

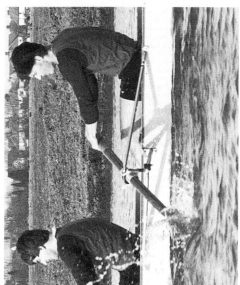

6

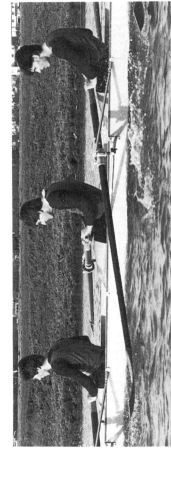

7

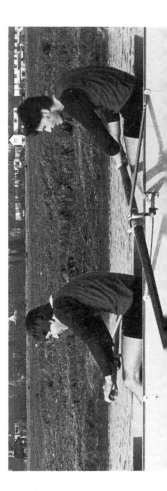

8

1 THE RECOVERY Body swings forward and hands lead well in front of the knees. Very relaxed as inside hand starts squaring, upper body leans towards trigger.

2 FULL REACH Shoulders swing round to give furthest reach with outside arm (inside arm also well extended). Shins vertical, chest up to thighs, head up. Hands a comfortable distance apart, as relaxed as possible.

2a Further body swing at frontstops can cause several problems.

3 THE CATCH Hands and upper body lift just enough to cover the blade as the legs drive very fast. Seat moves back but the firm back muscles carry the upper body with it, no 'bum shove'. Arms are stretched out by the force of the leg drive as the blade bites the water.

4 THE DRIVE Legs pushing very hard against the stretcher, driving body and back and forcing the boat to accelerate through the water. Upper body held firm to transmit the drive through stretched arms to handle.

5 THE DRIVE CONTINUED main force is from the leg muscles with a little help from the back.

6 THE DRAW As the legs finish the drive, the arms begin to bend and the shoulders are drawn back to maintain pressure on the blade in the final acceleration of the stroke. Shoulders now ahead of seat.

7 THE FINISH Upper body is supported by firm (not stiff) back, and leans towards rigger to give room for outside elbow to be drawn past side of body, knees fully down. Hands relaxed just in front of body, as outside hand pushes down to release blade (square) from water.

8 HANDS AWAY Inside hand feathers, outside wrist stays flat as handle rotates, both hands relaxed. Arms straighten and body swings over with knees still held down. Outward pressure on rigger at all times.

12 Technique of Rowing. Photos by C. Peregrine

indeed it has been said that older novices may never catch up! Be that as it may, it does mean that if possible we should be introducing far more children to the sport at the ages of 10–12. At that age the sport must be fun, and Schroeder of Hamburg University has led the way in showing how this can be done, particularly by starting out in sculling boats. One of the problems is in providing suitable equipment, for many youngsters will be too small and weak to handle even cut-down adult equipment. The other problem is finding somewhere pleasant and safe to practise.

The best teacher is the boat itself, but if the learners are to discover for themselves what they can do, they must have a responsive boat. The ideal vehicles are the single scull and the coxless pair, and every ambitious rower should aim to become proficient in both, and be able to row on both sides. In an ideal world everyone would start off at an early age in such boats, but even Schroeder admits this is not always practicable nor safe. At my school club we are faced with the problem of teaching some sixty 14-year-olds to row on a flooded river in January – and clearly the discovery method in sculling boats is out of the question. Our solution is to teach them the rudiments in much larger, stable craft, so that within a few weeks the faster learners are ready to go on to more challenging craft and develop a proper feel for the sport.

At any stage of the learning process you must have a clear mental image of what is required. It is also a useful trick to rehearse mentally what you are going to do and how it will feel before you attempt the action. A verbal description is rarely enough and there is no substitute for actual experience on the water. Most of us do not respond adequately to simply being told that what we are doing is correct or not correct, and it is most valuable to be able to see on video or film exactly what is happening. Every club should have access to a video camera and be able to play film back as soon as possible, preferably with good freeze-frame and slow-motion facilities. Video analysis of the technique of model athletes is also extremely useful in establishing the ideal mental image, and can often be more instructive than watching the real thing!

The whole stroke cannot be learnt at once and it is necessary to concentrate on just one small aspect at a time, and not to try to do too much in any one training session. We must never forget, however, that the stroke is a continuous cycle and the new skill must be well integrated with the whole. All the same, the old skills do not necessarily remain unaltered and they too must be reinforced frequently. Skills are best learnt when we are free of other stresses, and so greatest success will come when we are in a

stable boat having plenty of time to rehearse the action, slowly at first and then working up to full speed. On the other hand, part of the skill of rowing lies in being able to maintain technique in adverse wind and water conditions, and when under competitive stress and great fatigue. The skill must be learnt thoroughly first or it will break down, but many athletes do not do enough to train themselves to maintain technique under stress. Remember, every stroke of every outing is an opportunity to improve technique, however difficult the conditions or however hard the work.

Every outing should be preceded by a warm-up and stretching session on the land and should begin with a progressive physical and technical warm-up on the water. You should start with simple relaxed exercises and work up to more demanding skills and speeds. The particular technical points to be emphasized during the training proper should be rehearsed at this time while you are still fresh, but already warm and flexible.

SELECTED TECHNICAL EXERCISES

Holding and controlling the handle
- Rowing with the inside hand only, being careful not to over-reach; change to firm pressure paddling immediately the outside hand is replaced. This helps to give a better feel for the different roles of the two hands.
- 'Playing the piano' with the fingers during the recovery. Releases tension and shows there is no need to grip.
- Rowing with the thumbs hanging loose. Encourages a relaxed hold.
- Take off alternate hands and wave during the recovery. Encourages confidence and relaxation.
- Rotate the oar in the gate during the recovery. Increases dexterity and confidence in oar handling.

Rotating the shoulders and using the outside arm
- Slide the inside hand down the loom towards the button so that all the work is being done by the outside hand. This is a good exercise to promote flexibility, particularly if a special effort is made to rotate the shoulders, and it will also encourage proper emphasis on the outside arm together with the lean towards the rigger.
- Square blade rowing with the outside hand only is an excellent way of learning the correct outside arm action and of developing the appropriate muscles. It is difficult to balance the boat as well, so have at least two members of the crew holding the boat steady with their blades on the water.

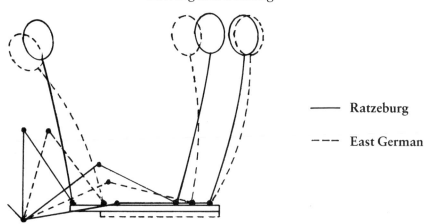

——— Ratzeburg

– – – East German

Fig. 13 Comparison of 'Ratzeburg' and 'DDR short slide' styles (after Klavora).

Improving the catch

- Build up the stroke with first 10–20 strokes using the arms only, then bring in the body swing, ¼ slide, ½ slide and so on. The aim is to make the catch very fast but in no way rough or violent and at the same time to improve the co-ordination of arms, back and leg drive. Particularly with the big-blade the catch should always be a smooth, clean beginning to the stroke; violent catches disturb the run of the boat and may contribute to back injury. As the stroke progressively lengthens there should be a conscious effort to slow the recovery and establish a good rhythm. A good variation is to build the rating smoothly at each stage and then reduce it again before moving on to the next stage of the exercise; with the shorter strokes very high ratings and fast actions can be achieved. Remember to stay loose and relaxed; the mental image of dropping the blade into the water is often helpful. This is also a good exercise for improving crew cohesion.

Improving the finish

- Square blade paddling. Good timing and balance is necessary to make this successful. There is a danger with this exercise of learning to cheat by washing out, so it can be counter-productive unless done well.
- Single strokes. There are many variations on this exercise but I generally prefer the pause to come at the hands-away, body-over position to encourage the correct sequence of hands, body, slide; it is often valuable to increase the number of strokes progressively to help this further. Crew co-ordination and balance is also improved by these exercises.

Improving the rhythm

- Paddling at various pressures with exaggerated rhythm, i.e. with marked slide control on the recovery. This is particularly useful in conveying the idea of 'sting and float' – that is, a quick drive through the water followed by a relaxed steady pace recovery.
- Firm pressure at varied ratings. Many coaches advocate variations in rating as an additional stimulation in long-distance training, but apart from its physical training effect it can also be a good way of learning how to maintain an economical rhythm despite increases in speed.
- Very low rate paddling. Maintaining a continuous stroke cycle at very low rates of striking requires great slide control and is not easy, and at the same time boat and blade control will require much concentration. The 1986 GB junior eight much enjoyed this fun exercise at the end of a hard outing, and managed to get the rate down to three (continuous) strokes a minute!

Improving speed

- Short bursts, say 10–20 strokes, at very high speeds and ratings, with longer periods of relaxed paddling in between. It is best to build the speed over about 3–5 strokes before each burst and to wind down gradually afterwards. The emphasis must be in trying to achieve the higher speed without losing control of the blade or the rhythm, and without losing length in the water. Even in the long slog of winter training, some judicious speed work is essential to maintain sharpness and to make the moderate ratings seem easier.

Fault correction

Faulty technique needs to be corrected as quickly as possible, not only because it is inefficient and may affect other crew members' technique, but also because it can quickly become ingrained and then be very difficult to eradicate. Most of us will not be able to appreciate what is wrong unaided, and very often it seems much easier to do it our way rather than the right way; this is where the role of the coach becomes essential. Before remedial action is taken, three basic points need to be checked:

1 Is the rigging right, and is it right for you?
2 Are you correctly adjusted and holding the handle well?
3 Are you fully aware of the fault and how it differs from the ideal?

Sometimes it will require video evidence before it is clear what is really happening, and many athletes are unable to appreciate what they are doing wrong until they have seen it for themselves. Often the true cause of the fault is not obvious and it is very common for

problems with one part of the stroke to be derived from an earlier incorrect action. For example, problems at the catch are often caused by a poor finish action.

There is a school of thought which suggests that only bladework is important and that only faults relating to it need attention, but this is nonsense. The way in which the body is used to produce the bladework and to apply power is equally important, if maximum efficiency is to be achieved. This is not to say that we need to be obsessed with irrelevant detail or with an unproductive effort to force individual athletes into a uniform mould in every tiny respect. We must beware of the psychology of fault finding. Nobody is perfect, and constantly dwelling on what is wrong rather than emphasizing the good points is depressing and potentially demotivating. Similarly, the athlete needs praise and encouragement when it does go right, even if the gain is very slight!

The list that follows cannot be exhaustive but is intended as a guide to the probable causes of some common important problems. Ideally you can then take appropriate remedial action, but it is likely to be necessary to use a suitable selection of the exercises given previously.

The problem	Possible causes
Skying the blade before the catch	Over-reaching with the outside arm
	Swinging too late on the recovery
	Dropped head and curved back
	Tension in hands, arms or shoulders
	Dropping the hands during squaring
	Balance problems.

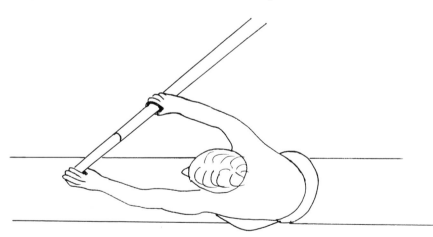

Fig. 14 Rowing with the inside hand down the loom and with exaggerated shoulder rotation.

Slow leg drive	Over-reaching or over-sliding Bent arm catch, or shoulder catch Lack of power
Blade driven too deep	Tension in hands, arms or shoulders Blade skyed at catch Poor co-ordination of legs and upper body
Wash-out at finish	Back curved and shoulders dropped Outside arm not drawing through Bum shoving Leaning away from the rigger Weak upper body

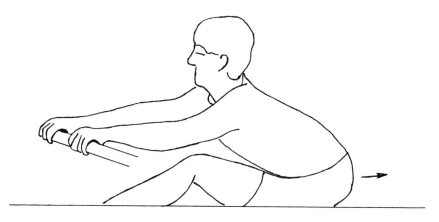

Fig. 15 Shooting the slide, or 'bum-shoving', uses up the leg drive without useful work on the handle, leaving too much for the weaker back and arm muscles to do.

Bum shoving	Weak upper body Poor co-ordination at the catch Over-reaching Curved back, dropped head
Leaning away from the rigger	Balance problems (real or imagined) Hands too close together Draw with inside arm, rather than outside

Fig. 16 Leaning away from the rigger at the finish makes the action very awkward and weak.

Anatomy and biomechanics – lessons for greater efficiency

Human movement depends on a jointed skeleton acting as a system of levers, actuated by muscles pulling on the bones via tendons. In fig. 17 the superficial tissues have been removed to show the principal muscles involved in these actions. In truth a very large number of muscles are involved, some of them contracting whilst others relax, to produce the final controlled and co-ordinated movements. For the sake of simplicity only the major power-producing muscles, and a few others, are illustrated. In fig. 18 more tissues have been removed to show the way in which these muscles are attached to the skeleton.

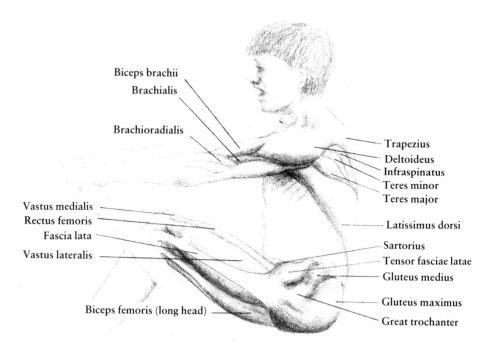

Biceps brachii
Brachialis

Brachioradialis

Trapezius
Deltoideus
Infraspinatus
Teres minor
Teres major

Vastus medialis
Rectus femoris
Fascia lata
Vastus lateralis

Latissimus dorsi

Sartorius
Tensor fasciae latae
Gluteus medius

Gluteus maximus
Great trochanter

Biceps femoris (long head)

Fig. 17 Some of the muscles used in rowing.

The force that can be exerted does not depend solely on the size and activity of the muscle, but also on its length, whether it has previously been stretched, the speed with which it is contracting, and the angles of the bony lever system concerned. Thus the force applied by the muscle to its insertion on a bone will vary through the range of movement. It is one of the aims of technique to find the best compromise of range of movement with power.

It is important to appreciate that muscles are not just contractile units; they are also elastic, and furthermore their contraction characteristics are related to this elasticity. This is important in a repetitive action like rowing where muscles are alternately stretched and contracted, for the effect can be exploited to increase power and efficiency of oxygen usage. Part of the increase in efficiency is explained by what is known as the 'stretch reflex'; that is, when a muscle is rapidly stretched it responds by contracting more forcefully. Another factor is the elastic energy stored in the stretched muscles and tendons. Some coaches have advocated a

rhythm embodying rapid leg compression to exploit this effect. Unfortunately such a rhythm creates problems of timing and co-ordination, but if nothing else one can see the value of continuous motion rather than pauses during the rowing cycle so that the stored energy can be used and the muscles generate greatest force.

The angle of flexion of the knee is very important in determining the force that can be exerted on the stretcher. We all know that it is more difficult to extend the legs vigorously when the knees are deeply flexed, whether it is rowing, weight lifting or just getting up from a low chair. In the rowing action a series of related principles apply to this problem (fig. 19). It is sometimes said that the optimum knee angle is 90°, but this is not a magic figure and has no special mechanical significance; in practice somewhere between 40° and 60° is usual. The choice of knee angle is a compromise dictated by other technical requirements, and is related to the individual athlete's leg length.

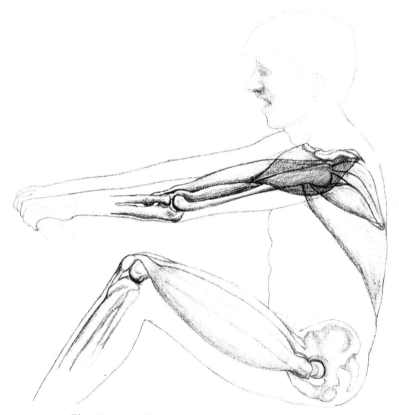

Fig. 18 Muscles and their skeletal attachments.

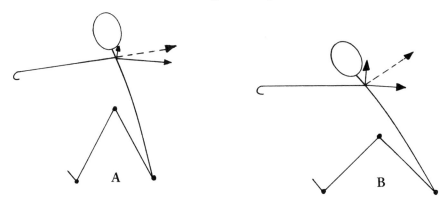

Fig. 19 Components of forces at different body positions. In B the leg muscles are not being fully utilized and energy is wasted in lifting the body.

Since extreme knee flexion is inefficient, the argument in relation to the best compromise centres around the extent to which this loss of efficiency can be accepted. This is the 'Ratzeburg' versus East Germany conflict mentioned earlier. Biomechanically it would seem that something between these extremes is likely to give best results. The lengths of thigh and shin differ from person to person and therefore for a given stroke length the joint angles will differ between individuals. Careful adjustment of the height of the feet as well as the stretcher position can be important in establishing the optimum angles for each athlete, thus accommodating a range of leg lengths, but we must be aware that changes in the height of the feet will then change the direction in which force is applied (fig. 20).

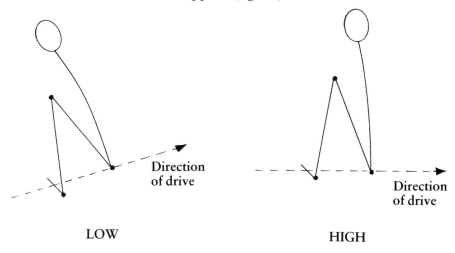

Fig. 20 The effect of the height of the feet on the biomechanics of the stroke.

A great deal has been said and written on this topic, most of it very subjective. Biomechanics suggests that a technique that avoids either extreme knee flexion, or great body swing with less use of the knee, will be most efficient, and it is not surprisingly rare to see extreme techniques in world class rowing. Obviously, taller athletes with longer limbs are at an advantage because they can row the required length of stroke without using inefficient joint angles. The style that is illustrated in fig. 12 enables a rapid leg drive to take the blade into the water quickly, and apply full power to it immediately, whilst allowing the upper body to remain firm and transmit the drive effectively. Early bending of the arms, during the most powerful part of the leg drive, is not advisable because these much weaker arm muscles will be doing unnecessary isometric work if the leg drive is transmitted through bent rather than straight arms. Moreover, such is the nature of nervous co-ordination that early use of the arms tends to inhibit full early commitment of the legs.

Arcs and angles of the oar

Because the oar or scull handle moves through a large arc during the stroke (about 88°–93° for rowing, 107°–112° for sculling), it is to be expected that the force applied to the handle is only at right-angles to the handle, and in line with the axis of the boat, when the oar or scull is perpendicular to the boat (fig. 21).

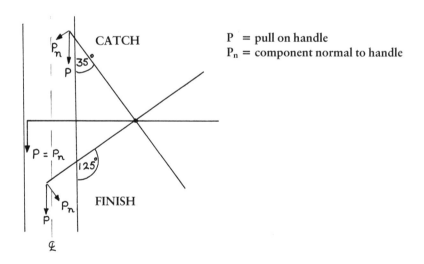

P = pull on handle
P_n = component normal to handle

Fig. 21 If the pull on the handle is along the axis of the boat then only some of the force will be at right-angles to the handle.

Naturally this represents wasted energy, but in practice the flexibility of the upper body can accommodate the changing angles to some extent, thereby devoting more force at a better angle to the handle. In rowing this is largely accomplished by rotation of the upper trunk, thus emphasizing the action of the outside arm. At the same time, of course, you can reach much further with the outside hand. It is very desirable to pay great attention to the action of this arm, for not only must that hand travel furthest, but that arm is in the best mechanical position for power application, especially towards the finish. The action is helped by leaning slightly towards the rigger, with the outside shoulder then just a little higher than the other throughout the stroke. If you put too much emphasis on work with the inside hand then the result is likely to be leaning away, a weak finish, and balance problems.

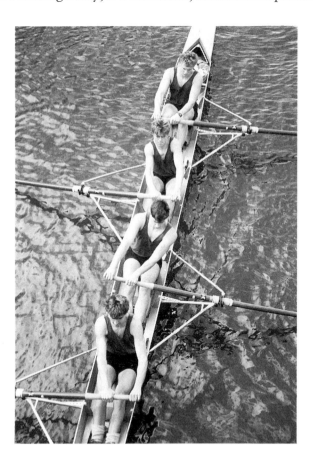

Fig. 22 In rowing it is desirable to rotate the shoulders and lean towards the rigger in order to maintain a pull at right-angles to the handle.

The remaining question is that of the optimum angle of the oar to the boat at the catch and finish. I suspect that we do not yet have the answer, but what we have is another pragmatic compromise! In fact the angles differ from one boat type to another, not for any subtle technical reason but because we use the same length oars on different rigs (more on this in Chapter 5), and nobody seems to mind. There is universal agreement though that the largest part of the total arc should be between the catch and when the oar is perpendicular to the boat. Thus for a tall crew in an eight the oar might be at 35° to the boat at the catch (thus travelling 55° to the perpendicular), and then go a further 35° past the perpendicular to the finish (fig. 21). These angles are principally determined by three things: the length of the stroke, the stretcher position, and the rig set on the boat.

It is a biomechanical principle that the greatest work should be done in the best, most efficient, mechanical positions; this precept can also be applied to the arc of the oar. One purpose in starting the stroke at such an acute angle to the boat is that it inevitably takes time (and distance) for the blade to build its full grip against the water, and equally it takes time to develop full power from the rowing muscles. Thus the maximum effective force on the pin occurs when the blade is at an angle of somewhere between 70° and 90° to the boat, which is where the majority of the athlete's effort is in line with the boat direction, and the blade is also at its most effective. Force on the pin reduces rapidly after the perpendicular; there is no doubt that the first part of the stroke up to 90° is more effective than the remainder.

It used to be said that such angles at the catch were 'pinching the boat' and must be inefficient, but results show otherwise. As explained more in Chapter 5, there may be advantages in reaching even further for the catch; Nolte and others argue for an important contribution of 'hydrodynamic lift', reducing blade slip when the blades enter the water at a very small angle to the axis of the boat. Entry of the blade more parallel with the stream direction will also minimize any braking effect from a slow catch. There is no doubt that crews and scullers using such angles at the catch have been extremely successful, and it could be that this lift effect at the beginning of the stroke is initially more important than the apparently poor direction of the force components, and compensates for them. Study of the figures in Table 2 in Chapter 5 may well raise the eyebrows of athletes and coaches brought up on older ideas!

Balance

It is impossible to row well unless the boat is stable, but it is equally difficult to balance a boat unless it is being rowed well! A rolling boat will also create more resistance and require appreciably more energy to propel it than one that is running level. As a starting point then, it is essential for you to appreciate that good balance is important and that every crew member must strive not to upset the boat. Earlier it was stated that the boat is controlled through three contact points – the seat, the feet and the hands – but there is always the special problem that rowing is a crew sport and therefore the crew members must work together to balance the boat. The rowing action is asymmetrical and therefore opposing crew members must act to cancel out the inherent imbalance. In particular we have seen that each rower should lean towards their own rigger, but it is very tempting to swing the body sideways in an effort to correct a loss of balance. Such movements are very undesirable as they are too crude and merely cause further balance and other technical problems. Concentrate instead on sitting still and maintaining an outward pressure on the rigger; variations in that pressure can then be used to steady the boat. Similarly, every action of the stroke must be synchronized with the other crew member(s), but most particularly at the catches and finishes so that the blades enter and leave the water together.

If the crew members are well together then the balance problems will be minimal and fine adjustments with the feet and hands are all that are required. Generally it is best if an even pressure can be maintained with both feet on the stretcher, but it can sometimes be helpful during the recovery part of the stroke to push down more with the foot on the side that is tending to rise. Although the oar only weighs about 4–5 kg, it is so long that it makes a very effective 'balancing pole', and small vertical movements of the hands can have a critical effect on balance. One of the primary tasks of the beginner is to learn the importance of blade control for this purpose. Pushing the hands down tends to make the boat roll towards your side and vice versa, but even the most experienced rowers find it all too tempting to push their hands down when the boat rolls their way – though this only makes the situation worse.

Rhythm

One of the characteristics of the best athletes in any sport is that they seem to make it look easy – they seem to have a natural flowing rhythm that gives them time and enables them to expend their energy in the most efficient way. Nowhere is this more true than in rowing and sculling, where not only must the athlete's

movements be as labour-saving as possible but also the smooth run of the boat must not be disturbed.

A fundamental requirement is that all movements are smooth, economical and unhurried, and fit together to form a continuous cycle of strokes. Within the cycle the stroke through the water is explosively powerful, but speed can be accomplished without violence. The boat must accelerate through each stroke from catch to finish, and it is important for you to strive for this feeling of a powerful (yet smooth) surge through the water and incorporate it in the mental image of the stroke. The terminal speed of the handle is maintained by the hands as they draw it to the finish and guide it round and away from the body. The aim is for a constant speed of the hands in a semi-circular path as the blade is released from the water and begins the recovery.

The age-old coaching cry of 'hands, body, slide' is still valid, partly for the practical reason that the hands must be clear of the knees before the knees rise, and partly because that sequence really is the best way to finish the stroke and start the recovery. Holding the legs down and the back firm gives the most stable basis for the action of the hands and arms as they complete the stroke and move the handle round the turn. Allowing the shoulders to move too soon prevents the muscles in that area from maintaining their force on the handle and a weak finish will result. And if the shoulders initiate the recovery rather than the arms, then the action will be slowed and the blade is likely to drag in the water at the finish. Although the arms should be well extended before the body starts to move, they should not be stiff – indeed it is very important that all parts of the body should be as relaxed as possible during the recovery. It is desirable that most of the body-swing is achieved before the seat moves away for three reasons. Firstly, it helps to transfer pressure on to the feet and thus stabilize the boat, secondly it avoids later changes in height of the shoulders which are the common cause of poor bladework in the approach to the catch, and thirdly the delayed sliding helps to minimize the effect of the changing centre of gravity of the crew on the boat speed.

All that is left now is to slide forward at steady speed and use the hands and arms to prepare for the catch. As already stated, any stiffness or rigidity is to be avoided but it is generally helpful to keep the head up as an aid to maintaining a good upright posture. A flatter back will be stronger when the catch is taken, and sitting tall helps to maintain the arms and shoulders in the best position for the catch (fig. 23). As the athlete compresses and reaches out for the catch, muscles and tendons are stretched, and we have seen that this effect can give extra power and efficiency. In the past some crews using a long slide technique have deliberately

compressed very fast, but this can create problems with timing and balance and tends to bury the stern of the boat. Modern thinking suggests that a controlled but unchecked approach gives the best result.

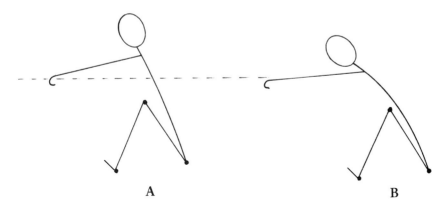

A B

Fig. 23 Sitting up at the catch gives a better position and helps avoid dropping the hands and skying the blade.

To sum up, the blade is driven quickly through the water, accelerating from catch to finish, and the hands maintain this final speed round the turn and away before the seat moves steadily down the slide. The recovery is therefore slower than the drive through the water, and a good rower will be able to retain this controlled and relaxed recovery even at a very high speed.

The objective of the rowing stroke is to accelerate the boat to maximum speed, and then slow it down as little as possible between strokes. It is easy to forget, however, that the movement of the blade, and the forces applied to it, are not the only factors affecting boat speed. The crew is much more massive than the boat itself (e.g. seven times more for a typical heavyweight eight) and consequently the movements of the crew up and down the boat have a large effect, by Newton's law, on the speed of the boat. Figure 24 shows the velocity variations that can be expected for boat and crew separately, and for the system as a whole. Such variations in speed are inevitable, given the nature of the rowing cycle, but they do represent an inefficiency because of the extra drag penalty of speeds greater than the average. It can be estimated that the total drag is increased about 3–4% as a result of this, and although it is difficult to see how any substantial improvement could be made, it is important that the technique embodies a smooth rhythm with minimal velocity changes by the crew. All the same, it should go without saying that blade entry and exit must be as fast and as clean as possible, and that power must be applied as quickly as possible after the catch.

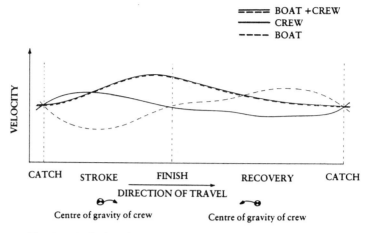

Fig. 24 Velocity changes of boat, crew, and both combined.

Forces during the stroke

Forces exerted on various parts of the boat can conveniently be measured by attaching strain gauges to them. Measurement of force on the swivel or end of the rigger is particularly relevant because it is through this point that the oar or scull drives the boat. Such studies have been very important in the development of modern rowing technique and can also be very valuable in ensuring maximum crew compatability. A typical result such as fig. 25 shows a small step around the beginning of the stroke as the blade is accelerated towards the water; if the blade enters the water *before* being accelerated sternwards then it will act as a brake and a negative force will be recorded. As the blade grips the water and begins its working arc, so the force on the pin increases rapidly. Just how rapidly depends upon how quickly the athlete

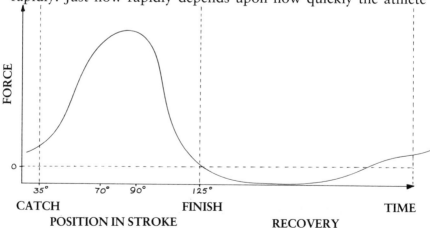

Fig. 25 Force on the pin during a complete stroke.

can mobilize maximum power. As the hands move away on the recovery, the force on the pin becomes negative and remains so until the athlete prepares for the next beginning.

Two alternative forms of the curve are shown in fig. 26. In the first (solid line), the athlete has committed full power very early; that is, before the most effective blade position has been reached. In the second (broken line), the build-up of effort is more gradual and peaks later, characteristic of a slow leg drive perhaps, and part of the most effective section of the stroke is therefore underused. With modern electronics it is quite feasible to record such force/time diagrams for each athlete and thus determine the effectiveness of their technique objectively. It is even simpler to attach the necessary instruments to a rowing ergometer than to a boat, and with instantaneous processing by a microcomputer the results can be displayed in real time before the working athlete. Such a device can be a great help to the coach who is attempting to optimize technique.

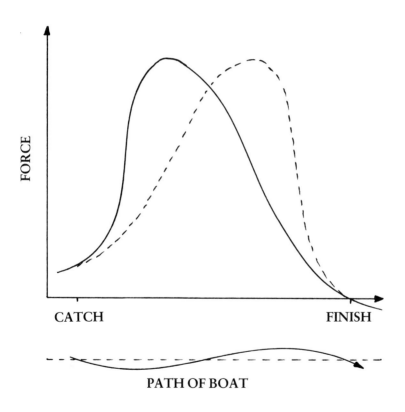

Fig. 26 Two different force profiles in one boat would cause the boat to snake.

If the techniques of the individual crew members differ appreciably then there may be a loss of efficiency for two reasons. Firstly the patterns of force production will not match and therefore maximum total force and speed may not be reached. Secondly, a discrepancy between bow and stroke side at any point will tend to turn the boat; this effect is particularly noticeable early in the stroke when a large component of the blade's work is towards the boat. In fig. 26 the two force diagrams have been plotted together. Let us imagine that one is now characteristic of stroke, and the other bow, of a coxless pair, and we can see that the boat will tend to snake during each stroke and thus lose speed.

Different techniques for different boats

Good rowers often show the ability to be successful in any type of boat, especially if much of their early training has been in small boats. Indeed the Great Britain team crews are selected primarily on their performances in small boats – a system common to many other countries. In general those who can perform well in a coxless pair will be very useful in any larger boat, though the converse is not always true. This is not because of any dramatic difference in techniques but because the smaller boat demands greater finesse, better balance and greater adaptability. Again as a generalization, the coxed four and pair tend to favour larger, stronger athletes because the extra weight of the cox is such a large proportion of the total. The lighter and more responsive coxless boats, however, give a greater premium to power/weight ratios and technical expertise.

The faster boats (8+ and 4−) require greater speed of movement from the athlete, and the eight in particular demands a very explosive catch and leg drive and a quick, clean finish, as well as the ability to row well at high ratings. The relatively heavy coxed pair and four, on the other hand, will not accelerate as quickly through the stroke and consequently the drive and draw must be particularly well sustained. Despite the different rigs that will be used on the various boat types, it is probable that the slower the boat the lower will be the most economical rating; that is, the rating that gives the best sustainable rhythm. Likewise the 4− and 8+ will respond to bursts and sprints at much increased ratings.

Particularly in the eight, the individual qualities of the athletes become important in deciding where they sit. Much of this has nothing to do with technique but depends on factors such as weight distribution or experience. Stroke must have an excellent rhythm, of course, but also a technique that is absolutely reliable under pressure, allied to a sense of pace and tactics, and the

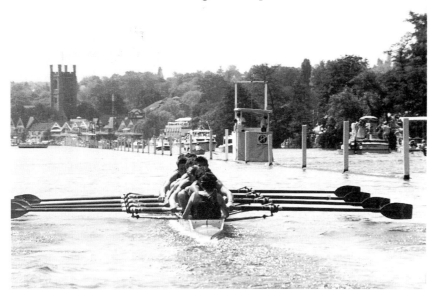

Fig. 27 The essence of crew rowing is cohesion and good timing.

psychological strength to get the most out of the crew. Seven must be the perfect follower, and must also be capable of imparting the rhythm. The heavies are usually in the middle of the boat (often well described as the engine room) – they need to be an utterly reliable and cohesive unit. Up in the bows the athletes need to be particularly quick and responsive, not because their bit of the boat is going any faster but because they are somewhat removed from the decision makers and rhythm setters in the stern. I once rowed in a four with the cox in the middle, and I found the sense of isolation in the bow half very peculiar. The same problem can arise in tandem-rigged boats where the widely separated crew members may find it difficult to follow the stroke.

Although there is no doubt that technique learnt in the coxless pair is particularly valuable, and whilst such boats show up the good boat movers, there are some dangers in relying too much on them for selection purposes. One obvious problem lies in steering, for an otherwise competent pair may be gravely hampered by poor steering. Good pairs seem to be made in heaven and it is not always the case that two excellent rowers will make a pair that goes exceptionally fast. Other pairs may go very fast with a variety of styles, and there is no certainty that they will be compatible in a larger boat. With the GB juniors we have found that coxless pairs will be most valuable in identifying the most promising group of athletes, but that ultimately the decisions must rest on seat racing individuals in larger boats.

CHAPTER 3
Sculling technique

The single sculling boat is both the greatest challenge and the most rewarding type of boat. Only your unaided efforts will move it, and in order to move it well you will require great skill and also understanding of the nature of wind and water (the qualities that are prized as 'watermanship'). As a learning vehicle it is often ideal, for it is so responsive that the sculler learns from it how to get the best results. The beginner is freed from the problems caused by clumsy crewmates and from the need to keep in time with others, whilst even the most experienced athlete can always learn more from its subtleties. The double scull and the quad are also very rewarding boats because they are so fast – faster than the same number of athletes rowing – but challenging because twice as many blades need to be co-ordinated!

Sculling technique differs significantly from rowing in a number of ways, primarily because the two arms describe two opposite arcs, and also because the handles overlap so the hands must cross at some point during the stroke. The movement of the hands is not quite symmetrical, nor is that of the two blades; because the hands cross they must pass either one in front of the other, or one above the other. Particularly in the single scull the balance problems are rather different to those for rowing; although the body does not rotate, and of course should not lean to either side as in rowing, the sculling boat is still at the mercy of wind and wave and is very responsive to the athlete's movements. Thus control of hand heights and movements becomes particularly crucial in sculling, but is doubly complicated by the fact that there are now two sculls moving rather independently.

The description of the sculling action that follows is partly based on the results of research into the biomechanics in both West and East Germany, for this is where most of our scientific knowledge has come from. For much more than a decade, international single sculling was dominated by Peter Michael Kolbe of West Germany and Perti Karpinnen of Finland, with East Germans never far behind. Karpinnen won the Olympic title in 1976, '80 and '84, and was 7th in '88, whilst his arch-rival for so many years, Kolbe, was denied his last chance of the gold in Seoul by the younger East German Thomas Lange. Karpinnen is so huge

that he cannot be the best role model for most of us, so the drawings that follow are based on a number of photos of Kolbe, the multiple World Champion and Olympic silver medallist.

Great Britain has a very strong sculling tradition and many rowers train in sculling boats as well. There have been many excellent British scullers in recent years and they include world champions among the men, lightweight especially, and lightweight women. Despite this there is no doubt that our international sculling record is not as impressive as it might be, and one reason may be the past lack of a cohesive coaching policy. Much is being done to put this right and the development of top-level sculling is being encouraged by the increasing emphasis on it as part of the national squad selection process. This has three objectives: to raise national levels of aspiration in sculling, to encourage rowers to do more training in single sculls, and to help spot potential crew scullers of a high standard. There is a pressing need to standardize sculling technique so that there is the best chance of getting together successfully in doubles and quads.

Getting into the boat

Make sure that both gates are undone and are hanging loose before the boat is put in the water, and that the sculls are within easy reach. Put both sculls into their gates (red in the right hand) and do up the gate that is nearest to you; don't crawl over the boat to try to do up the far gate. Facing the stern, grasp both handles firmly together in the hand nearest the boat. Making sure that the buttons are up against the swivels, push the seat towards the bows and step carefully on to the centre structure or deck between the main shoulders (some boats have a non-slip pad to stand on) with the foot nearest the boat. Expert scullers will now nonchalantly push off with the other foot before they sit down. Gently lower yourself on to the seat, if necessary steadying with the free hand at the point where the rigger meets the shoulder. Swing the free foot into place in its shoe, followed by the other. Change hands while you do up the other gate, but don't let go! Tuck the sculls under the armpits while you tie the shoes or make any adjustments.

Holding the sculls

The scull handle is small enough to fit nicely into the curved fingers and should be held there and never in the palm. The thumb is placed across the end of the handle, not underneath. The wrist should be kept as flat as possible, with the handles well out in the very loose fingers on the recovery. To square the sculls, roll the fingers round the handles so that they fit into the roots of the

fingers, rather than raise the wrists. During the catch and drive the wrists should stay flat or very slightly arched, and then it is possible for the lower (right) hand to fit snugly under the hollow of the upper wrist when the hands cross – this enables the hands to be kept close together without colliding (see fig. 28). Feathering should be done with the minimum of wrist work by opening out the hands so that the handles are rolled away under the fingers; this encourages essential relaxation. The upper (left) hand is always further from the body so that during the recovery again the hands may cross without interference. Many scullers in fact have the lower hand leading during the recovery, and this included the USSR and many other Eastern bloc sculling teams, who were extremely successful. Such an action has disadvantages in rough water where the hands can interfere with each other, and it also requires a reversal of leading hands at both catch and finish; I cannot recommend it.

Fig. 28 The perfect position of the hands as they overlap. Note also the excellent depth of the blades and the co-ordination of upper body and legs.

The cycle of the stroke

MID RECOVERY

The loose hands guide the handles so that the fully feathered blades are safely clear of the water but not too high; on smooth water 10–15 cm would be enough. The arms are well extended but need not be completely straight yet; they must be quite relaxed. Most of the body swing has already taken place so the

hands will be in front of the knees before they begin to rise. All movements now must be smooth, unhurried and steady with the objective of not disturbing the flow of the boat by any harsh acceleration or braking. The left hand will lead away so that it is comfortably ahead of the right and then ideally the hands can be on much the same level.

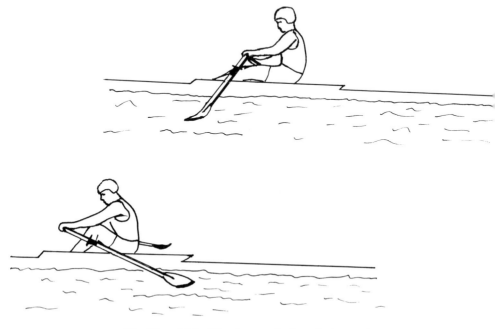

Fig. 29 and 30 Hands away before the knees rise.

FULLY FORWARD

Approaching this position the sculler will gradually fully extend the arms and shoulders, but without tension, and square the sculls as described earlier, keeping the bottom edge of the blade very close to the water. With the wrists flat or very slightly arched, the hands and arms will be in line on a slope down from the shoulders. The slide will slow as it approaches frontstops, gradually and without checking, and it is important that the upper body does not dive over the knees. The chest will be in light contact with the thighs and the legs will be slightly apart. At this point the upper body will be inclined forward some 10–30°, the hip angle will be about 25°, and the knee angle will be between 45° and 60°, with the shins vertical or nearly so and the heels lifted from the stretcher. The head should be held up so that the sculler is looking well astern. The hands will be a long way apart and the sculls will make an angle of about 30° to the side of the boat.

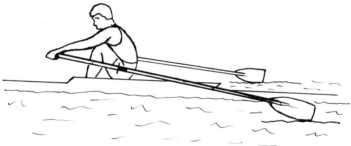

Fig. 31 Position just before the catch.

THE CATCH

A very rapid lift of the hands is required to cover the blades extremely quickly and this comes from a movement of the arms from the shoulders, not by bending the arms. Immediately the legs must start driving and the upper body also start its swing. As in rowing the blade is being dropped into the water, but it must be done so quickly that very little of the effective length of the stroke is lost. Performed correctly there will be only a small splash of water upwards from the blade. Too slow an entry and water will hit the back of the blade and be thrown forward; too shallow an entry and water will be thrown sternwards off the face of the blade. Gripping the handles before the catch tends to make the movement slower and clumsier and the sculler should try to be particularly relaxed. Because of the acute angle of the sculls to the boat at the catch, a fast beginning in a sculling boat gives the feeling that the hands move towards each other very fast, as indeed they do. Of course the two blades should take the water exactly together and this requires that not only is the boat well balanced but that the sculler is too; you should be 'on your feet' and confident in the location of both blades and their relation to the water – the catch must not be tentative.

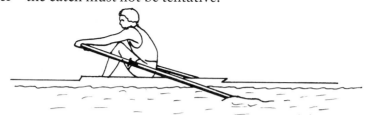

Fig. 32 Co-ordinated arms, leg and back for the catch.

THE DRIVE

Particularly in the single scull the drive is somewhat more sustained and progressive than in rowing, but as in rowing the drive is initially through straight arms and with a firm back to link the leg action to the handles. The principles of bladework are exactly the same and in this phase the two blades must be driven

through no more than fully covered. It is now commonly accepted that the rigging height should be more than was generally recommended before, and for most people heights of 16–18 cm or more are usual. Such heights give an efficient angle of pull and at the same time help prevent the blades going too deep.

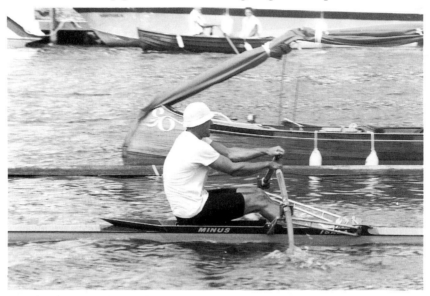

Fig. 33 Tall scullers will need a much greater height of the swivel above the seat than usual if they are to operate at maximum efficiency.

As the sculls approach the right-angle to the boat the handles will begin to overlap. The right hand should be nearer to the body than the left as described earlier, but as near as possible to the same level. In practice most scullers have the left higher than the right during this manoeuvre and it is common to set the left rigger a little higher to allow for this (the German rule is to allow 1 cm). If the hands can be kept on the same level then this may be better, and in Britain level rigging is advocated. The right-hand knuckles tend to get scraped and it helps to keep the left-hand fingernails short.

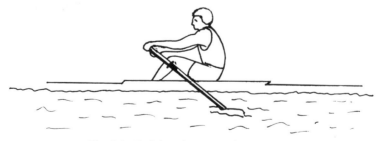

Fig. 34 Left hand crosses above right.

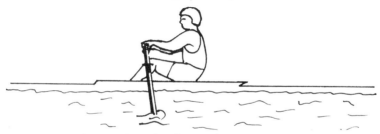

Fig. 35 Arms bending as the scull passes 90°.

In sculling the arms will bend earlier in the stroke than in rowing, but there should be no deliberate attempt to use the arms early; otherwise a slower initial drive may result and the arms will certainly fatigue sooner.

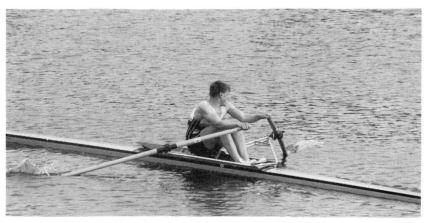

Fig. 36 This sculler is bending the arms too early in the stroke. Not only will his arms fatigue earlier but there may be some related slowness in his leg drive.

Analysis of expert scullers and rowers in action reveals that the two groups have somewhat different patterns of co-ordination of their legs, upper bodies and arms, though the reasons for the difference are less obvious. The difference shows even when the same athlete changes discipline – Steve Redgrave's sculling style is not the same as his rowing style! The essential differences in technique have been extensively studied (using video) in the former East Germany, and Klaus Filter presented a paper on the subject to the 1986 FISA coaches' conference. He showed that from the catch in sculling the upper body moved faster relative to the seat than in rowing; that is, the body angle opened more quickly in relation to the leg drive. Additionally the sculler's arms bent at an earlier position in the stroke (fig. 37).

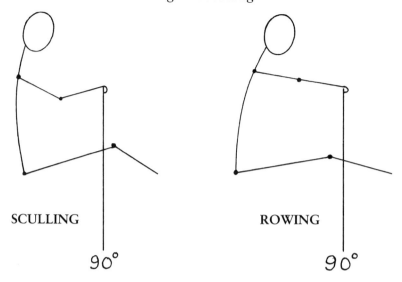

Fig. 37 **Video analysis shows that the body position in sculling does differ
from that in rowing.**

There does seem to be more load on the sculler's arms for two
reasons. Firstly, at the catch the sculler will be reaching to a more
acute angle and the angle between his arms and the scull will be
more disadvantageous than in rowing (fig. 38, but see also fig. 21).
Secondly the sculler is provided with a much greater blade area,
giving less slip than a rowing blade, and this does mean that the
arms and back need to do more to transmit the leg drive through
the scull handles.

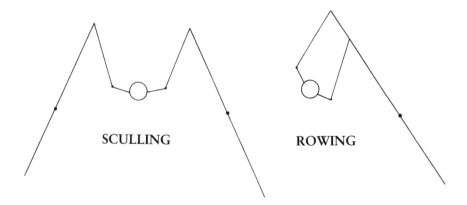

Fig. 38 **The angle of the arms to the handle is different in sculling as
compared with rowing.**

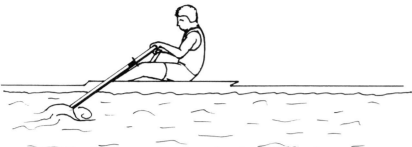

Fig. 39 Arms and legs complete the stroke together.

THE DRAW

From the right-angle position to the finish the sculls will sweep through about a further 30° arc. Although as in rowing the force on the pin is diminishing rapidly during this phase, the aim is to continue the steady acceleration of the system. Some leg drive will remain to be used up because the vigorous opening of the body angle in the first part of the stroke prevents bum-shoving. The arms now bend quickly and the hands are drawn rapidly towards the body with the right hand leading. The elbows should be kept low so that the stronger muscles can be used fully, but with high riggers this becomes more difficult and it helps to draw the hands down a little lower. There is then a danger of washing out and the blade must be covered completely – fortunately the blade now has a mound of water in front of it which helps to keep it covered, and also the slides slope upwards from frontstops towards backstops, thus reducing the effective rigger height towards the finish. On the other hand it is actually desirable that the blades are not excessively covered at this stage so that the weaker arm muscles can maintain the rapid sweep of the sculls.

Fig. 40 Bucking the finish means that power is reduced as the sculler collapses forward rather than maintains the draw to the end of the stroke.

THE FINISH

Pressure must be maintained on the blades until the last possible moment so that the mound of water remains on the face of the blade, and the fast movement of the hands towards the body must be maintained. The forearms and hands push down rapidly to lift the blades (still square) very quickly and cleanly from the water, and they will even continue sternwards a fraction as they do so. As the bottom edge of the blade leaves the water the blades start to feather as the hands unroll helped by a small and brief deflection of the wrist. When the blades leave the water the thumbs will be about 10–15 cm apart and the hands will probably separate a little more as the finish is completed.

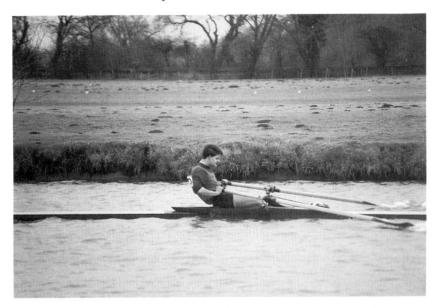

Fig. 41 For good balance the hands should finish at the same level, unless the left rigger is set higher. Dropping the wrists (as here) will reduce the amount of room at the finish and make it more difficult to clear the blades.

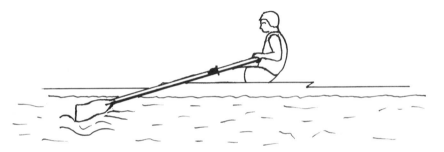

Fig. 42 Blades are kept square until the last moment.

THE RECOVERY

The hands should start to move away without pause from the finish while the back is held firm at an angle of layback of some 20–30°, and the legs remain straight. As the arms extend, the upper body begins to swing over but the legs remain flat. The hands should be very loose on the handles and the wrists by now can have regained their flat position. Throughout the stroke the head should be up so that the sculler can look well astern. At first the knees will be close together but they should separate a little as the seat approaches frontstops.

Balance

A bicycle is much more unstable than even the finest sculling boat, yet most people learn to balance the machine very quickly and once learnt the skill becomes automatic and unconscious – indeed it is only when we no longer have to think about it that we do it well. So it is with sculling. The skill of good balance is vital to enjoyment and good performance, but knowing the theory is no substitute for practice in the boat until the necessary actions become second nature. The overriding principle is that sloppy technique which detracts from the smooth and level run of the boat must never be allowed or practised.

If the sculler swings straight, keeps the head steady, sits evenly on the seat and takes catches and finishes simultaneously with both sculls then, in calm conditions, the boat should run level. In practice of course things are not that easy! There are some common faults that can lead to balance problems, and the sculler or coach should check these first.

UNEVEN FINISHES

Because of the way in which the hands cross, it is often the case that the hands finish at different heights or at different times, and inevitably the boat will tip at the finish and will not be stable for the recovery. The correct hold and position of the hands as described earlier will therefore need to be reinforced. Again because of the asymmetry of the hand action before the finish, it is not uncommon for one scull to be cleared from the water and feathered more quickly than the other, and this is sufficient to upset the boat at this critical point. Even worse is the sort of lazy finish that allows the water to catch up with the blade or drags the blade out across the surface. I believe that crisp, clean and well-synchronized finishes are the most important factor in establishing good balance in the whole recovery.

HAND HEIGHTS

A 30 cm wide sculling boat is greatly affected by the relative positions of the sculls during the recovery. I have already advocated a technique whereby the left hand leads the recovery, so that if the boat is level then the hands can be too. More than this, the independent hands allow the sculler to make fine adjustments to the boat's equilibrium by adjusting their height. As the full reach position is approached the sculls are closing in towards the sides of the boat and balance becomes much more sensitive as the stabilizing effect of the protruding sculls is lessened. The hands will be rising at this time and the blades will be squaring; discrepancies will lead to a loss of balance which may well cause uneven catches and an unsettled stroke.

UNEVEN PRESSURE ON THE SWIVELS

Sometimes the sort of dragged finish that is described above will actually cause the button to be pulled away from the swivel. This is easy to spot, but less overt differences in outward pressure can also mar the recovery. In fact pushing out more on one side is one of the ways in which the sculler can legitimately correct a wobble or even a persistent crosswind, but this is best done with just the hands and arms rather than a crude lean with the whole upper body.

UNEVEN PRESSURE ON THE FEET

Sculling with one hand markedly in front of the other can cause a rotation of the shoulders and perhaps a slight turn of the pelvis so that the legs do not quite move together (fig. 43). Many scullers do in fact partly balance the boat by sideways movement of the knees in the later stages of the recovery, and by adjusting the pressure of their feet on the stretcher. This is a valid technique but the snag is that the ideal catch and drive comes from evenly placed, indeed firmly planted, feet on the stretcher – so it should not be overdone.

Crew sculling

As was mentioned at the beginning of the chapter, the double scull and the quad are faster than their rowing equivalents, so one of the requirements for success in these boats is the ability to maintain good sculling technique whilst moving very quickly. Synchronization of all the actions is also vital and it is often helpful if the crew sculler has also had experience of crew rowing. The best crew scullers will also be good single scullers and the more sensitive single is a better vehicle for learning balance and watermanship, but on the other hand single scullers often devleop idiosyncrasies and some can find it hard to adapt to the different discipline of the

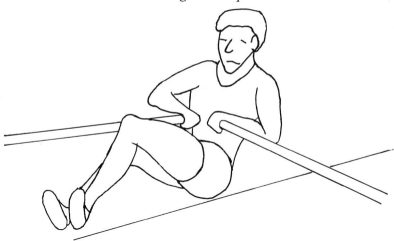

Fig. 43 The legs should go down together or efficiency and balance will be lost.

crew boat. Experience in the larger boats is important and the quicker action can in turn help the single sculler to be lively. Because the quad in particular is relatively stable, it is an easy boat for beginners and youngsters, and it also makes coaching for a uniform technique much easier than four singles.

Because there are so many technical points to watch for in a more advanced quad or double, I would suggest that very frequent use of the video is essential. I do not believe that the coach's unaided eye can cope with so many things happening at once, and the athletes need all the feedback they can get if they are to integrate perfectly.

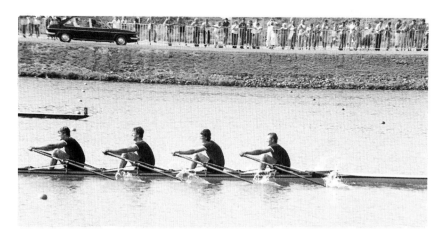

Fig.44 This West German quad demonstrates the precision necessary in this fast class of boat.

Learning to scull

In the previous chapter I advocated that all rowers should also learn to scull. Many coaches would go further and say that all beginners should learn sculling first. There are very good arguments to support the idea that young beginners should scull rather than row. On the technical side these include the fact that youngsters before puberty have an exceptional ability to learn quickly how to balance the craft, and that because sculling is a symmetrical action the young athlete does not learn an early preference for one side of the boat. It has been claimed that the asymmetry of rowing can be harmful to the developing spine, but there is little evidence of this, or that rowers have more back problems than scullers.

I have been much impressed by the work of Professor Schroeder of Hamburg who has long been a strong advocate of sculling as an introduction to the sport, and he has done much to promote the 'discovery' method for very young scullers in singles. Even he would be first to admit that there are practical difficulties, for as he has said, it is essential to have good safe water and weather conditions and suitable equipment. I am not convinced that contraptions like the playboat are the answer, even though they are great fun, because they are too unlike a real sculling boat and too insensitive to give good feedback. In ideal conditions the young beginner, well supervised, will quickly learn to handle a narrow but short and light boat, though older and more anxious novices would in my experience be better off gaining basic skills and confidence in a more stable boat before progressing, when they were ready, to a fine boat.

In order to make progress the sculler must develop confidence in controlling and balancing the boat before trying to move it quickly, and exercises and games such as the following will help to achieve this.

1 Familiarity and confidence in the stationary boat. Keep the scull blades flat on the water, lean from side to side while holding the handles together – the boat does not tip over. Raise and lower alternate hands – the boat tips but is easily recovered.

2 Lean the boat slightly to one side so that it is supported by one scull. Sitting at backstops, scull the boat round in a circle with the other hand, practise feathering and squaring at the same time; now change over and go round the other way with the other scull supporting.

3 Scull in a straight line with both sculls together. It will be necessary to hold the handles correctly and to cross left over right as described above. At first the sculls may be recovered along the surface, but as soon as possible the attempt to balance the boat with blades clear of the water should be made. There is no need to hold the legs straight – most beginners will use a little slide straight away and will soon progress to using more and more.

4 Games, exercises and simple tests appeal particularly to the young beginner and are an aid to learning. Such things as slalom round some buoys, relays, backing-down races, stationary boat balancing and so on increase motivation, skill and confidence.

Once these elementary skills are mastered, the need is to refine the full technique still further and to make the skills automatic. 'Mileage makes champions' perhaps, but not if the prospective champions do not have a clear image of what they are trying to achieve and how to achieve it, and not unless they are given lots of reinforcement and feedback. In single sculling in particular it is all too easy to develop idiosyncrasies and trick movements, often without realizing it. So every outing must have a technical objective and the success of the effort must be felt and seen, while at the same time the other skills must not be allowed to deteriorate.

CHAPTER 4

Steering and coxing

Our boats have a natural tendency to run straight as a result of their long, slim shape, and this is greatly aided by the fin which reacts to any deviation by producing a side force, tending to push the boat back on course. Without the fin there might be less drag slowing the boat, but it would tend to skid about and would be difficult to keep straight, as well as being less stable. Fins are often flat plates, which work well, but aerofoil sections are also common and might be marginally more efficient. Particularly on eights the fins can be quite deep ('shark's fin') so that they cut into less turbulent water away from the hull, but these have the disadvantage of being more easily damaged. Despite all this our boats do not always go straight because we do not pull evenly on both sides (variations in length of stroke or pressure on the blades being the commonest cause), or because the boat is being moved around by water currents, waves and wash, or by the wind. At other times of course we do not want the boat to go straight but to follow some more elaborate direction, and we therefore have to have some way of steering the thing. It is important to appreciate that every deviation from the ideal course, or use of the rudder, represents extra distance or wasted energy and is a handicap in competition.

Single sculls and doubles do not require rudders because it is easy enough to steer by pulling harder on one side or the other, but quads and all the other rowing boats are more difficult to keep on course that way, and are fitted with rudders. The rudder works by pushing the stern of the boat sideways when the rudder is turned, and the whole boat then turns around the fin. The snag is that the rudder also produces drag and slows the boat when it is used, so the less it is used the better. Moreover, because the rudder is below the boat it will tend to tip the boat if it is used clumsily. Modern fin rudders are much more efficient than the great slabs of wood that used to be hung on the back of our boats, but they are not very big and if turned through too great an angle they lose effectiveness except as a brake.

Fig. 45 Three types of rudder. The aerofoil at the top is the most efficient.

Where to steer

The first task is to know where you are going, and if on unfamiliar water you must have a good look around and if possible ask for local advice before you even go afloat. Safety must always be paramount and you must always follow the safety rules and procedures set out by the rowing association and your club; you must also make absolutely sure that you know of any special local rules or hazards. Even on your home water you must always be vigilant, for conditions change and new obstructions can occur; on the Rhine in Switzerland I once sculled into the back of the Motor Vessel *Mary*, 5,000 tonnes, from Amsterdam, not because it was

difficult to see but because it was moored where nothing had ever been before! During your warm-up, if you are on the same bit of water that you are later to train or race on, look round a lot and try to memorize the landmarks and any potential obstructions or hazards.

The usual rule of the river is to keep right (as seen facing in the direction of movement, i.e. starboard), but this tends to be modified on most flowing water to keeping close to the right-hand (starboard) bank whilst going upstream, and then following the centre of the stream when coming downstream. If you are being overtaken or if you meet another craft you should keep to the right (to starboard), and if you are doing the overtaking you will normally move left (to port). Figure 46 illustrates these normal rules of the river but you must be aware that there are often local variations, for example on the Tideway and on the river at Henley other than at regatta time.

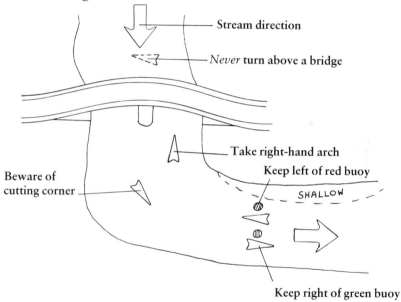

Fig. 46 Some elementary rules of the river.

Heads and regattas will have their own special rules for proceeding to the start and for conduct during the race. In most heads the boat being overtaken must move over ('give way') so that the faster can follow the best course; if racing downstream then the slower boat would usually move to the right, but it does depend on the positions of the boats at the time or perhaps the desire of the faster boat to take the inside of the bend. For upstream courses it depends on which bank the racing line is supposed to follow as the slower crew moves out into the stream.

Multi-lane courses and lakes will have their own rules and circulation patterns and you must follow these to the letter.

Fig. 47 The bow steersman in this pair, having hugged the bank up to the corner is now looking to cross to the other bank in this upstream race.

On a straight course with still water there is little problem in deciding where to go, but on flowing water the right strategy can help your steering during training and be a great advantage during a race. Going upstream you get there sooner if you can stay sufficiently close to the bank to be in the slower-moving water, and it is often worthwhile going a longer distance in order to achieve this. To get the full benefit you need to be very close to the bank but you will then have the added danger of hitting something, and it does not seem worthwhile taking too many chances in training. You will find that downstream of islands and bridges there are eddies and backflows which break up the force of the stream and can be exploited to advantage (fig. 48).

The problem with being close to the bank or below a large obstruction is that the water flow is uneven and not only does this make the boat move about but the blades on the two sides of the boat are operating in different speeds of water – this can give some very odd sensations and make it difficult to steer. As you round a bend while steering upstream there is a tendency for the bows to stick out further into the stream, and as a result the force of the stream will tend to push the whole boat further out from the bank and make it much more difficult (sometimes impossible) to get round the bend close to the bank (fig. 49). The secret is to keep the bows tucked in as close as possible, and if it is a tight bend you can start the bend from a little further out and deliberately steer in towards the bank a bit, or it is often necessary to ease off on one side and pull it round with the blades on the outside before the current catches the bows.

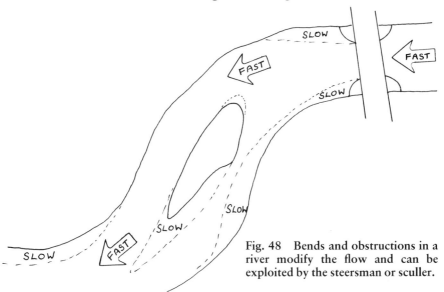

Fig. 48 Bends and obstructions in a river modify the flow and can be exploited by the steersman or sculler.

As a general rule the fastest flow downstream will be approximately in the middle of the river but with a tendency to sweep towards the outside of bends, especially at the exit (fig. 48). There is no substitute for local knowledge, but it is well worth while watching the surface of the river and any objects floating on it to get an idea of the direction of the fastest water. An upstream wind will make the faster water the roughest and there may come a time when you might choose to lose the advantage of the stream for the benefit of calmer water. Sometimes, as on the Tideway at low tide, you can see where the deep water channel is and remember this for later use, or you may be able to watch some really expert coxes or scullers and see where they steer. The aim is to try to keep your boat pointing in much the same direction as the water is flowing and not to get across the stream, though it is

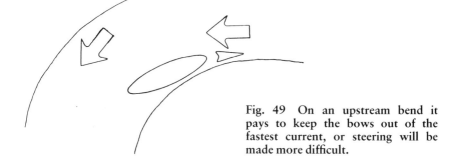

Fig. 49 On an upstream bend it pays to keep the bows out of the fastest current, or steering will be made more difficult.

generally useful to move towards the inside of bends to take the shortest route as long as you don't go out of the stream.

The speed of the boat relative to the water is the same whether you are going up- or downstream, and the common illusion that it is harder work rowing upstream is a delusion born of the fact that it takes longer to get anywhere and the bank seems to be slipping by so slowly – close your eyes and you would not know the difference. In fact your higher absolute speed downstream means more wind resistance! Do not forget that this greater downstream speed means that it will take you longer to stop, and you must allow for this if there is likely to be anything in the way. Every year crews and scullers (but more usually crews because it takes them longer to react and turn) get into trouble at weirs because they have underestimated the speed of the stream and how long it will take them to stop and turn. The same applies with bridges, and it is important *never* to turn just upstream of a bridge. Remember that the current is likely to accelerate through a bridge or towards a weir, and always allow a generous margin of safety.

Steering in races

In side-by-side racing on a winding course without marked lanes there are certainly advantages to be gained by cunning steering, even without being brutal and forcing your opponent out of the best water. If you have the inside of the bend then it is legitimate to approach the bend as wide as possible to ensure that your opponent has to go the long way round. If you turn in late, this not only holds out your opponent but also moves you forward in relation to the other boat. This is good for your morale, and if you can hold on to the lead as you come out of the corner, this gives you a real advantage – it is called 'making a corner' (fig. 50).

Some courses are notoriously difficult to steer, and oddly enough this includes the straight Henley one, where the penalties include not only the sanctions of the umpires, but also the potential disaster of hitting the wooden booms lining the course. Here the problem is that although the course is straight the river is not, and consequently the boat is being pushed sideways by the stream in different ways at different places. Added to this are the very patchy wind shadows created by the large trees along the banks, and the fact that the course varies in its distance from the bank. Most years the stream is too slow for it to have much effect but there certainly have been times when there has been a distinct advantage to the Berkshire station. The Tideway course for the Oxford and Cambridge race, the Head of the River Race, the Women's Eights Head, and the Scullers Head, as well as those

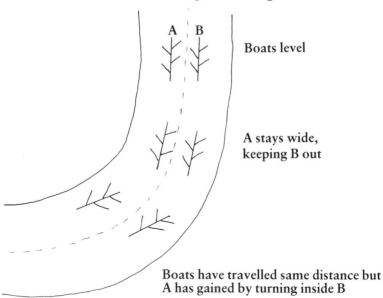

Boats level

A stays wide,
keeping B out

Boats have travelled same distance but
A has gained by turning inside B

Fig. 50 Making a corner gives the crew on the inside a great advantage.

parts of it used for the Schools Head and the Fours Head, is a great challenge because its apparent width lures so many competitors into leaving the fairly narrow optimum racing line, whilst so often its wind and waves present the dilemma of sticking to that line or aiming for more shelter. The good competitor will learn as much as possible about such courses and will try to get lots of practice on them.

Steering the sculling boat

If you have followed the advice in the last chapter your sculling boat should run straight and level most of the time and you should also be able to move your hands independently of one another. Most of the time you will be able to steer simply by applying a little more force with one arm than the other for a stroke or two, so that that blade comes through to the finish a fraction more swiftly. For tighter turns many scullers make the mistake of trying to lug the boat round with a longer and harder finish. It is much more effective to reach a little further with the hand on the opposite side to the way you want to turn, because the extra reach will put the blade in nearer the bows and will help to pull the bows in the required direction. For really tight turns, or to spin the boat round, you will have to stop sculling and then use just your arms to take the first part of a stroke on one side, while balancing the boat or backing down on the other.

The double scull is steered in the same way, although of course you do have to be of a like mind with your partner as to which way you want to go, and it is usual for one of you to say something like 'harder with the left' if you seem to be going astray. Quads will respond to the same methods, but these longer and very fast boats are usually guided by foot steering and a rudder while the crew continue to row evenly except on tight turns. As in coxless fours, it is important to have one person in charge, and this is likely to be bow because of the better view forwards, even if the rudder is actually controlled from somewhere else. When racing on a straight course there is no need for anyone to turn round, and there may be advantages in giving the job to stroke who has a clear view behind.

You have three points of reference for steering: the view astern, your proximity to the banks or lines of buoys, and what you can see when you look round. In training you should be in the habit of looking round a lot, say every ten strokes, as much for safety as for anything else. It only takes a quick glance over one shoulder at the finish of the stroke and with practice will not affect your sculling. The banks or buoys can usually be seen well enough from the corner of your eye to give you an idea of whether you are the right distance from them, but if you are trying to follow one bank closely then it will pay to turn that way when you look round. The view astern is your best guide as to whether you are running straight, or whether you are turning smoothly. You should choose a point on the horizon when you know that the boat is pointing in the right direction and then keep the stern pointing at that for as long as you want. On straight regatta courses there are usually steering markers behind the start and you should be able to keep these in line until they get too far away, and on two-lane courses where the umpire has a launch, that launch should stay in the middle and be a useful guide.

Steering the coxless boat

The pair or four can be steered from any position in the boat where the special swivelling steering shoe is fitted, and in most boats it does not take long to change from one place to another. Traditionally, bow is the steersman because from bow you have the best view of what is coming, and not only may this help steering but it may also be the safest. On the other hand, stroke has an absolutely clear view astern and, as in the single scull, this can be a positive advantage in maintaining a straight course. Particularly in the pair, stroke can also glance over one shoulder to check where they are going, and there is no reason why bow

should not also be on the look-out for possible dangers, especially in training. The most likely reason for either two or three steering the four is that your best steerer happens to be in one of those seats, but such an arrangement is not ideal. In some ways it is best if the person steering is also in overall charge of the boat and gives all the orders, but if that person is not bow they will certainly have to have plenty of feedback from the bows. It is also worth remembering that in a four at speed it may be difficult for the rest of the crew to hear clearly what anyone except bow says.

For best control it is important for the steering gear to be in good condition and well adjusted. Sit in the boat and adjust the stretcher correctly, then if necessary adjust the steering wires so that they are neither slack nor under undue tension. It is also wise at this juncture to check that the upper extension of the steering shoe does not foul the person in front of you when they are at backstops – if it does you may have to bend it out of the way. Get someone to hold the rudder straight while you check that the shoe is correctly aligned, i.e. at the same angle as its partner, and then check that you can comfortably swing your foot both ways to get an adequate amount of rudder both ways. If not, on most designs you can easily move the clamping position of the wire on the end of the shoe. It is conventional for the rudder wires to be crossed over at the rear, so if you point your toe to the right (as you look at it), the boat will turn the same way. The pivot on which the shoe turns is often very badly made and likely to wear and come loose, which is difficult to row with and does not help the steering; tighten it up if you can, or replace it so that it operates smoothly.

As with the sculling steering described above, you have information on your course to steer from the view astern, from your position relative to the banks or buoys, and from what you can see when you glance over either shoulder. It is much easier to look over the outside shoulder at the finish, but you should learn to do it both ways and in particular to keep a good eye on the nearest bank that way. Take a good look before you move off, and if you are not giving the orders make it quite clear whether or not you are ready and it is safe to proceed. If you are giving the orders, as I have suggested, then make sure you can be heard, and be clear and authoritative, for a sloppy start makes it difficult to control the boat. If you are not accustomed to giving the necessary orders I suggest that you read the coxing section that follows, and try to adopt the principles that are outlined there.

The coxless boat is very responsive at high speed, but most fin rudders are rather ineffective at low speeds, and if you turn them too much to try to get more effect they are likely to stall and become almost useless. You need to anticipate when you will be

turning so that you can begin to use the rudder early and gently. Similarly, in holding a straight course you should aim to keep the boat on line at all times by using the rudder little and often; if you let it stray too far then you will have to use inefficient amounts of rudder to get it back. Some fours tend to skid and you may need to allow for this by turning in a little earlier than you might otherwise expect. In the first part of this chapter we saw how the current could affect the boat, and you must be aware of what is happening all the time. In difficult conditions or on sharp bends you may need your partner or the rest of the crew to help you, by easing off or hitting the catches harder as appropriate. You will also find that if you take the catch a fraction early you can nudge the bows round, as you can if you reach a bit further than usual, but beware of upsetting the rhythm and timing.

All this sounds rather daunting and it can be very difficult to do all this and to remember to row well at the same time. However, like learning to ride or drive, it usually falls into place for most people with practice and then becomes an almost automatic skill. There is no doubt that practised scullers learn more quickly because they are already used to looking after their own steering and being aware of wind and water conditions.

Outings in the dark

Many crews and scullers have to train in the dark, particularly in the winter, and far from being unpleasant this is often the best time of the day, when the wind has dropped and the pleasure boats have gone away. It is rarely completely dark on most rowing courses in Britain because even when the sky is cloudy there is stray light from buildings and street lights, and the water reflects what light there is. Once your eyes have become fully accustomed to the dark (which can take up to half an hour), you can see quite well enough to steer, but you must already be familiar with the course in the light. Do check in advance what other boats are likely to be out at the same time and be certain to keep to the local rules of the river, and of course be extra vigilant and observant. Do not go out if it is foggy, if there is an unusually fast stream running, or if there is a danger of hitting driftwood or ice. All boats used at night must carry lights as specified by the local water authority, or in the absence of that as specified by the ARA from time to time; this will include at least a white light shining forward. In addition, the person in charge of the boat must carry a powerful waterproof torch, and a coaching launch must also have a warning klaxon or something similar.

Coxing

Ideally the cox should be much more than just the person who steers the boat; he or she should also be the person in charge throughout the outing, who makes the crew perform as a unit, and gets the best from them, while at the same time being the coach's on-board mouthpiece. To do this successfully requires much skill and a strong personality, but all too often the cox starts with the disadvantage of being not only the smallest in the crew but also the youngest and least experienced. The cox is also the one whose mistakes are noticed by everyone else and who tends to be the butt of jokes and a scapegoat for misfortune – yet at the same time this is the person who has enormous responsibility and power, and who can make all the difference in a race and win the affection and respect of the crew. Unfortunately the cox is often the one member of the crew who gets the least coaching and practical tuition but who needs it as much as anybody – so I make no apologies for getting right down to basics in this section.

Before you start you must consider the question of safety. If you suffer from epilepsy, blackouts, or any other medical condition which might at any time affect your control of the boat, you should not cox, and if you are in any doubt you must seek medical advice. As with any water sport, you might fall in, and it is therefore essential that you can swim at least 50 metres wearing light clothing. The ARA publish safety guidelines as a Water Safety Code, which your club will be able to tell you about, as well as the club's own rules. The Code states that you should wear a life jacket of approved type, and describes the need for you to wear adequate warm and waterproof clothing in cold weather; this matter is gone into in more detail in Chapter 9. The Code goes on to state the importance of competence in boat handling, and vigilance, to ensure not only the safety of your boat and crew but also that of other water users. All this does sound rather daunting and of course we must be careful, but most of the Code is good common sense and in practice large numbers of youngsters quickly learn to be competent coxes, and the sport is really a very safe one.

The important thing for a new cox to appreciate is that the crew want and need someone in charge. Even the most experienced rowers would prefer to concentrate on their rowing and leave the boat handling up to you. They want someone who knows what to do, and who tells them what they have to do. Inexperienced crews are in even greater need of a leader and will flounder without firm guidance. Thus your first priority apart from steering is to learn the orders you must give to make things happen, and the second is to learn how to give them in such a way that they are quickly obeyed and inspire confidence. Let us follow through the series of

orders that you might use in a typical outing and see how they should work. Before you do anything else, though, make sure that you are ready, in that you are appropriately dressed (see Chapter 9) and have everything you need such as microphone, amplifier, stopwatch. Listen to the coach as the crew is briefed and make sure that you know exactly what is going to happen during the outing, if necessary writing down the key things that you will have to do. You should also think about getting the blades out first and putting them in a safe but accessible position. Clubs vary in their systems for this, but I think that it should be one of the cox's responsibilities.

1 GETTING THE BOAT OUT OF ITS HOUSE

First make sure that you have the whole crew assembled and then say clearly and firmly, 'Hands on the boat'. It may be necessary to specify where they should stand, and if both sides of the boat are accessible with the boat upside down on the rack you would probably say, 'Opposite your riggers'. More usually only one side of the boat is clear and the crew will have to lift the boat off and hold it while half of them duck underneath – it does rather depend on how high the rack is and how much room you have got. You should always work this out in advance, asking someone who knows what to do if you don't, so that there is no delay or confusion when you come to it. Most boathouses are very crowded and it is vital not to damage the boat, so it is usual to remind the crew to 'mind the rack/riggers above', for example. You may also have to edge the boat out on the half turn, and it is your job to tell them to do this, and when to turn the boat level again when you get safely outside. You must also make it plain to the crew whether you want them to carry the boat on their shoulders or at waist height – you only need the single order, 'Shoulders!', or 'Waists!'

2 GETTING THE BOAT ON THE WATER

Make sure that you know which way the boat must face when you put it on the water (usually, but not always, with the bows pointing upstream so that you have the best control as you move off), and if it is not pointing the right way turn it round carefully before you get to the water's edge. When you get the boat down to the water it will have to be turned over and then placed carefully in the water. An experienced crew will lift the boat above their heads, step back in line, lower it to their waists and then place it on the water. The orders would be: 'Throwing the boat, stroke-side (or bow-side as appropriate) moving; one, two, three, up! and lower; on the water!' Inexperienced or weak crews will not be able to do

this and will have to use the more undignified procedure of first turning the boat, then one side holding it while the others scramble underneath, and then all placing it on the water. While all this is happening you should be standing at one end of the boat facing the crew so that they can hear your orders clearly. As soon as the boat is on the water, move so that you can hold a rigger firmly, and if the stream is apparent you should take a hold near the bows to prevent them swinging out.

3 GETTING THE CREW IN THE BOAT

If there is a strong stream or it is very windy it is best to get half the crew to help you hold the boat while the others fetch the blades. When they return, get the crew to place their blades across the boat, and take their shoes off if there are shoes fitted in the boat. The safest system now is for the rowers whose blades will be on the bank or raft side to hold their riggers, while those on the other side climb in and immediately put their blades in the swivels and do up the gates. Only then should you allow the remainder to get in, and meanwhile you must hold on tight to a rigger – if the boat tips over it will be your fault! The orders will be: 'Stroke-side (bow-side) hold your riggers, bow-side (stroke-side) in! Blades out! Do up the gates!' Then, when you can see that all is ready, you order the other side in. Continue to hold on to the boat while the crew settles in and adjusts, and then have a roll-call from bow to check that everyone is ready. Tell them to hold on to the raft or bank while you get in and sort out your equipment, but do it quickly.

4 MOVING OFF

As was described earlier in this chapter, you should have made yourself well aware of any rules, regulations, hazards, safety precautions and so on before you go afloat. Have a good look round, and when you are ready tell the crew to 'push off'. You must be ready to get them paddling straightaway so that you have some steerage way, and it is usually best to get the bow pair or four to paddle on at this stage while the stern group sit the boat level. You should already know what sort of warm-up procedure the crew are expecting, but you may be reminded what to do by the coach or by someone in the crew who is in charge. It is now up to you to relay these instructions to the crew, and it is right that you should be in charge of the boat, and the crew does what you tell them. On the other hand, if you or your crew are very inexperienced it may be better for an accompanying coach to issue all the orders directly at first. The common orders you will have to use are: 'Come forward; paddling light/half-pressure/firm, etc.; are you ready? Go!' If you want to make a change while the crew is in

motion it is best to warn them with 'next stroke, paddle firm/light (or whatever)'. When on the move your orders must not only be loud, clear and incisive, but should also fit in with the rhythm of the stroke, so that the end of the order coincides with the finish of the stroke. To stop the boat you say, 'Easy all!' The crew should balance the boat until you give the order to lower or drop the blades on to the water. If you want to stop, the order is 'Hold her up' or 'Hold her lightly' for a gentle stop. In an emergency, shout 'Hold her hard!' For turning, while the boat is still moving after the 'easy' you can say 'Hold her stroke-side (bow-side)', and the boat will turn that way. You can then continue the turn by getting the other side to paddle on. This makes a rather shallow turn, and if you want to turn the boat in more or less its own length you will get one side to alternate paddling forwards with the other side backing down.

Be determined not to tolerate any sloppiness and to maintain discipline however senior your crew. It is in their interest as well, and if you show that you expect high standards they will respect you for it.

5 STEERING

If you have read the first part of this chapter you will now know the general principles of steering, but above all you must be safe on the water, and this means thinking ahead, following all the safety rules, and keeping a good look-out for other boats or other potential hazards. The aim is always to know where you are going well in advance and to go there in the smoothest way possible, keeping your boat on line all the time, with frequent but minimal use of the rudder. Boats do differ in the way in which they respond, depending on the shape of the hull and the size and position of the rudder, but in all cases use of the rudder slows the boat and affects its balance. Try to get into the habit of applying rudder only when the blades are in the water and then its adverse effects will not be so noticeable. Most boats skid outwards on bends taken at speed and it will be necessary to allow for this by starting your turn a little early, and especially on upstream bends you must keep the bows tucked well in or the current will tend to push you wide. Rowers get very peeved if you take them out against the stream and equally anguished if you don't stay in the stream in the other direction.

If you are in a stern-coxed boat, particularly an eight, you probably cannot see very much straight ahead, so you will have to have a quick look either side at frequent intervals. Do not lean out when you do this because it upsets the balance, and it is best to do it when the blades are in the water. Make sure that you are firmly braced in your cockpit, for if you flop around it will disturb the

balance and will also give you a less comfortable ride. Some padding behind your back is also a good idea because you can get quite bruised by the jolting. With practice you can actually help to correct the balance by bracing yourself against the side of the cockpit or pushing more with one leg. In a front-coxed boat you have a much better view ahead, of course, but you are somewhat out of touch with your crew and what they are doing, and it is much more difficult to be aware of what is happening behind your boat and whether you are being overtaken. Not a pleasant thought perhaps, but do make sure that you know how to get out of a front loader in the unlikely event of a capsize. The technique is the same as escape from a kayak; that is, remain calm and relaxed, don't struggle with your legs, but put your hands on the rim of the cockpit and lift yourself out of the cockpit with your legs trailing by levering against the top.

6 TALKING TO THE CREW

As you gain in experience of rowing, and listen to what the coach has to say to the crew, you will gain a better rowing vocabulary and will learn what to say and when. Do be positive and constructively critical and not a nag, and avoid too much repetition. Say things like: 'We can do better than that, let's really go for it next time,' rather than be abusive if a piece was not good, and be fulsome in praise and encouragement if they have done well. Do look out for the technical points that the coach is

Fig. 51 A well-wrapped cox urging his crew on in a winter head.

emphasizing and remind the crew or individuals of those from time to time, but don't interrupt while the coach is talking. If the crew is working hard you need to sound confident, aggressive and demanding, yet at the same time encouraging and praising as much as possible. Do not feel that you have to talk non-stop; if you do, after a while the crew will cease listening.

7 COMING BACK IN

At the end of the outing, and indeed after any piece of hard work, you must allow your crew to wind down rather than stop abruptly. The outing should finish with a few minutes' light and relaxed paddling as you approach the landing stage, and you must always come in against the stream even if it means going past and turning. Come in slowly and judge when to easy so that you can glide the last few metres with the boat balanced and the blades raised, and meet the landing at minimal speed. It looks very neat if you steer in towards the edge at first and then use the rudder to turn away at the last moment – then the boat slides in sideways as it comes to a halt. Make sure that you are disentangled from things like microphone leads, and as soon as the boat is docked leap out and grab a rigger to hold the boat steady.

The safest procedure for disembarking the crew is the most disciplined one, in this strict order:

1 Tell the side nearest the stage to get out together and hold their riggers: 'Bow-side, one foot, out, together! Hold the riggers, bow side!'
2 Order: 'Blades out everyone!'
3 'Stroke-side, one foot, out, together!'

The crew can now put their blades away and put their shoes on, leaving you to hold the boat.

Lifting the boat out of the water must be done with care, and it is a good idea to tell the crew to put one hand under the boat so that they do not scrape it against the edge. When the crew are in position, tell them: 'Hand across, one hand under, are you ready, lift!' The expert crew will once again throw the boat, one side moving across, while the novices will have to repeat the procedure of one side holding the boat while the other side duck under before they can turn the boat and carry it. Do make sure that you have the boat pointing the right way before you enter the boathouse – it would be so embarrassing to have to come out again!

There is a lot to learn and remember and if the crew's coach does not help you and supervise you, as should be done, then do not hesitate to ask, and also enlist the help of the crew in

determining how they want things done. After all, you are a vital part of the crew and your performance is as important as theirs. It pays to make yourself useful in other ways too, and if you are the one who checks that boat and blades are in good condition and correctly adjusted before the outing, and you are the one who remembers what is to be done during the outing, then you will earn their respect and improve their performance in your charge. There is no doubt that every cox should also learn how to scull at least, and to row if possible, so that they know at first hand what it is all about. You should not neglect your own needs for exercise either, and who knows, when you grow too big for coxing you could become a first-class rower yourself, as many have done before you.

Coxing in a race

Well before you go racing you should read Chapter 8 so that you know what to expect, and understand what the crew must do. Of course, your main duty is to get the crew safely to the start on time and then to steer the best course to the finish, but a good cox can do so much more than this and really can win the race for the crew.

Do make sure that you and your crew are absolutely clear as to the arrangements and timing for your race, and if you are not staying together, exactly when and where you are to meet. Before the race you must find out as much as possible about the course, and this includes how to get to the start and where you can do your warm-up. Check over the boat and blades, making sure that every bolt is tight and that the blades are adjusted correctly, and also that you have all your coxing equipment and that it works. Often you will have to be weighed, sometimes before a specified time, and you will probably be given a certificate which you must keep safely with you in case an official wants to check it before or after the race. In British domestic events the minimum weight for a cox is 40 kg for juniors and school events, and 50 kg for senior men's events, 40 kg for women's and 45 kg for mixed. In international races the minimum for a junior cox is 50 kg, of which not more than 10 kg may be made up of dead weight, and the officials are very strict in checking that your stripped weight is not less than 40 kg. In Britain if you are below the minimum weight you may carry as much dead weight as necessary in the boat, but on no account may any of it be fixed to your person.

Try to keep an eye on whether the event is running to time, and also see what sort of queue there is to get on the water – do make sure that you allow plenty of time. Check that the necessary numbers have been collected and attached to you, your boat and

crew as specified. Keep calm, for the crew will be getting edgy and the more people around them who are calm and sensible the better. Make sure that the blades will be easily to hand when you boat so that you do not hold up others, and it is usually courteous to push off as soon as possible and complete your crew's adjustments out on the water. Be very vigilant as you go to the start or warm-up area because you may not have much room and there will be lots of other craft on the water. You will already have worked out what you are going to do in the warm-up and where, but you may have to show some flexibility and initiative in this. Do be very careful; I have seen many accidents when crews are trying to warm up in a restricted space; do not assume that other crews know what they are doing. You must also keep a very careful eye on the time so as to ensure that you arrive at the start or marshalling area with just a few minutes to spare.

In a head you will be told when to start paddling down towards the start, and you need to ensure that you are a sensible distance behind the crew in front if you are not leading off. It may well be that in prior discussion of tactics you will have decided to start close to, or as far as possible from, this crew. As you approach the start, make sure that you are exactly where you want to be and can see where you want to steer. It is usual to get the crew to start accelerating before the start signal, and there is usually a few strokes' worth of distance between that and the timing line so that your crew can be up to full speed as it crosses the line.

Make sure that your crew settles well into its pre-arranged race plan, and all the way over the course tell them where they are. Try to do it in an encouraging way: 'Hammersmith Bridge, let's go for this last stretch!' – not like a cox I once heard announcing in a voice laden with doom: 'Barnes Bridge, you've got a long way to go yet!' Do keep an eye on what is happening behind you, and if necessary move out of the way of a faster crew smoothly and with the minimum loss before you get back on to your optimum course again. Tell your crew if you are catching ones in front, and when you come to overtake them make sure that they know you are there, and if possible stick to your best course. Give the crew plenty of general encouragement and from time to time remind them of important technical points; you may also be expected to keep stroke at least informed of the rating. With a minute or so left of the course you will be driving the crew to really go all-out for the line – make certain you know exactly where it is and do not wind down until the whole boat has crossed. Do not stop near the finish line but paddle on lightly until you are clear.

In a free start at a regatta you have to ensure that you are in the right position and in no danger of clashing with your opponent, and if you do not think you are properly aligned, or are not ready,

Fig. 52 Steering close to the bank in an upstream head race saves precious time. The cox must, however, be on the lookout for obstructions and anglers!

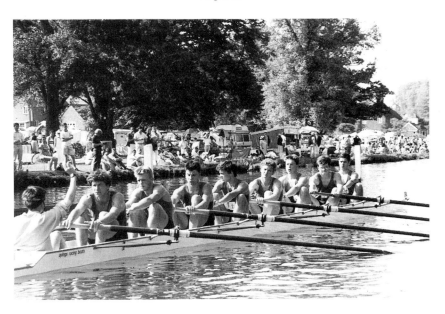

Fig. 53 The cox has responsibility for ensuring that the crew is ready and the boat is straight at the start.

then put your hand up and call out so that the starter knows. For a stake-boat start or pontoon you must back on to the start, and then keep the boat straight, as described in Chapter 8. Talk to the crew in a businesslike and reassuring way, and ensure that they are ready when it matters. Your crew's tactics for the race will have been pre-arranged and you must not forget them, but it is also likely that you will have to react to changing circumstances in the race. Until you get well in front you will probably have the best view of how the race is progressing and if you keep the crew well informed they will be less tempted to look round. During the race you will need to vary the tone of your voice and what you say to cater for your crew's needs, calming and steadying them if they tend to rush, driving them aggressively if they are not well ahead, responding to your opponents' moves, and whipping them up for a last dash for the line if it is necessary. If you are loud and positive it is both good for your crew, who will be encouraged and distracted from their feelings of discomfort, and off-putting for your opponents.

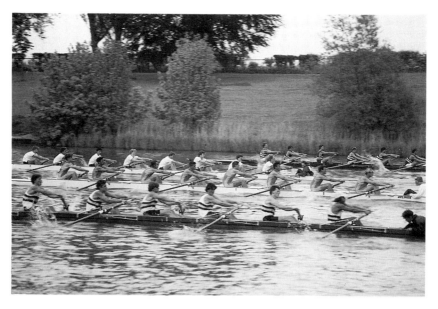

Fig. 54 On a multilane course the cox must keep strictly in the lane and at the same time keep the crew fully informed of their position.

CHAPTER 5

Boat and oar design, construction and rigging

Every sportsman or woman should understand their equipment so that they may make the best choice from what is available, be able to use it in the best possible way, and know the importance of looking after it well. In rowing, understanding the principles of the design and construction of the craft helps you to adapt your technique to the way in which the boats best respond. Modern boats are very adjustable but it takes more than just a knowledge of how to make the adjustment in order to get the best result – you should appreciate what effects a change might have, and why. The equipment is delicate and expensive and all who use it must realize the importance of maintaining it in first-class condition. Many readers will at some time have to make their own repairs and modifications and will need to know something of the way in which boats are constructed. Similarly many of you will be involved in decisions about which boats or blades to buy.

Resistance to movement through water

The movement of a boat through water encounters two kinds of resistance or drag: the energy transferred to waves made by the hull, and energy transferred to the water by friction against the hull surface. These sources of drag are both affected by the displacement of water by the boat in order to float, and by the speed. The displacement depends on the weight of the crew, boat and ancillaries, and larger displacements will mean increased wave drag. At the same time the large craft will have a larger wetted surface and will therefore experience more friction drag. For any given crew weight, then, it is desirable that the boat and its ancillaries are as light as possible, and that its shape is the best compromise that will make the smallest waves and have the smallest wetted surface.

As a general rule for the long narrow boats that are used in rowing, and within the usual speed range, the wave drag is the smaller of the two resistances. The exact proportions are difficult to estimate precisely and in any case vary with the class and speed of boat, but the general view is that wave drag might be about 10% of the total. Extensive testing is generally far too expensive

for the rowing world, and few tank tests have been carried out. Wave drag does not increase with speed in an even fashion, but it does increase very rapidly with increasing speed, especially when the bows are meeting a crest and the stern a trough. The boat is then going uphill! This critical speed is known as 'hull speed', and so much extra energy would be needed to exceed it that it effectively limits the speed of a human-powered displacement boat.

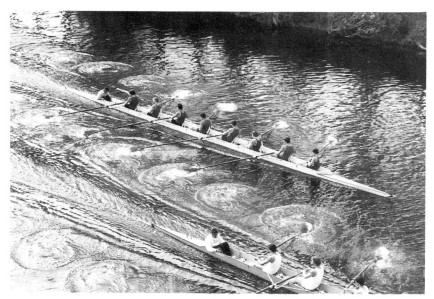

Fig. 55 The V-shaped waves from the bows and sterns of these eights can be seen, as well as the turbulent wake left by the friction of the hull against the water.

As far as wave drag is concerned, a minimal value will be achieved if the faster boats have greater length which to some extent they do. However, at modern speeds some of the shorter boats are approaching values where the resistance increases very rapidly with speed, and manufacturers are experimenting with longer boats, especially in the smaller classes.

In shallow water, for example the 2–3 metres of many artificial courses, there are critical wave speed interactions with the bottom. In essence this means that the shorter eights, for example, would be at a minute advantage in such shallow water, but longer eights have a distinct advantage in deep water.

As far as hull shape is concerned, calculation and experience suggest that the long, narrow, finely pointed boats with which we are familiar are already close to the optimum shape. In any case practical considerations intrude; for example, some VEB designs with short hulls are very narrow at cox and bow seats. The latest

Empacher eights overcome this problem with a wider stateroom above the rapidly narrowing hull. FISA have promoted the idea of boat shapes with nearly parallel sides, which would provide plenty of room for wide hips at all positions!

Bearing in mind that wave drag is only a small proportion of the total, it would seem that the possible gains from new shapes will be small, but they might be critical for success. Development of the optimum shape will be very expensive, and FISA are rightly concerned that the better-funded Federations may gain an unfair advantage. It is reported that the USA spent $250,000 on the unsuccessful eight used (briefly) by their women's crew in Seoul. FISA are investigating the idea of a standard 'one-design' hull shape, but the boat manufacturers are not keen, and it would be difficult to check. Perhaps we should beware of the example of the America's Cup rules for 12-metre yachts which appeared at first to be a relatively simple equation, but which had to be accompanied by twenty-five pages of small-print interpretation!

Friction drag is largely governed by the area of wetted surface, the smoothness of that surface and the viscosity of the water, as well as of course by the speed through the water. A rounded short boat like a coracle will have a small surface area but its wave drag would be unacceptable. For a longer hull a semicircular cross-section under water will give the minimum surface area to volume ratio, but this will need to change to a parabolic or V section for best surface cutting at the bows. All modern boats are deeper and more rounded in the underwater mid section than hitherto, and at the same time this shape enables a slimmer hull to be developed. A wider, shallower section boat will be more stable for the novice, but young athletes in particular will soon learn to balance more demanding and potentially higher-performance craft.

Fig. 56 The deep and rounded centre section of an Aylings E mould eight.

Surface finish is critical. Any roughness can make the water flowing over the surface turbulent and will dramatically increase drag. A completely smooth painted or plastic finish is best, and it must be kept clean, and free from scratches. Many claims have been made for specialized friction reducing finishes, but extensive testing by the yacht syndicates has failed to find any that work. Wax or silicone polishes are not desirable since the hull will then not be wettable, and instead it is common practice to wash boats with copious detergent before racing to ensure the best surface. Some polymers will affect the properties of the water in a way that greatly reduces friction, but such substances have long been banned by FISA. FISA also acted swiftly to outlaw the application of polyester micro-grooved film to the hull, another offshoot of the America's Cup Campaign, but one which possibly owed its origins to research into the remarkable properties of dolphin skin.

Fig. 57 The cox washing down the hull of the GB coxed pair with detergent before a race at the World Championships. Note the very small aerofoil fin and rudder.

Nature has come up with some similar solutions to the friction problem and we might get away with growing some slimy microbes on our boats. Alternatively lessons can be learnt from the dolphins whose shape and skins have intriguing qualities. Lastly there is the question of water temperature where it is clear that the lower viscosity of warmer water greatly reduces friction drag. The differences can be substantial, commonly amounting to 2–3 lengths for an eight over 2,000 metres between winter and summer in England.

Although little data is available from precise tank testing it would be foolish to ignore the self-evident qualities of the winning boats. Whilst the crew or sculler may well be the most important factor, champions do not choose slow boats and in many cases

they have arrived at that choice after careful trials of several different boats. Championship results indicate that several makes are likely to show very similar performance, which is not surprising since some of them are copies; so choice may be made more on grounds of national loyalty, individual preference, or cost.

Official weighing of boats at FISA Championships shows that boats from a large number of different makers fall well within 10% of the FISA limits. Few eights can approach their particular limit, but it does not seem to be very difficult to produce small boats to the minimum weight using the new materials and construction techniques. Not surprisingly the boats from any one manufacturer do differ somewhat in weight, partly due to differences in detail specification, but also due to differences in material usage inevitable in a handmade product. Progress in boat construction continues and the majority of manufacturers now offer boats close to the FISA minima.

The FISA weight limits may lead to the intensification of the search for better hull shapes as the manufacturers strive for alternative ways of gaining the competitive edge. We may expect a rash of interesting prototypes and it will be intriguing to see if any offer real advantages over the more conventional craft.

Air resistance

Because of the low air speeds and small forces involved, not much attention has been paid to the importance of air resistance (aerodynamic drag) in retarding the boat. A figure of about 10% of the total drag from all sources is commonly guessed at. If true this is actually highly significant, and if one bears in mind that a headwind can easily double the air speed experienced by the boat without making the water unrowable, then it is not surprising that headwinds have such a dramatic effect on race times.

There is no doubt that a well-fitting racing vest or stretch body suit, and short hair, help reduce air resistance significantly, and we may also consider ways of reducing the drag caused by the equipment. A prone coxwain in the bows not only lowers the centre of gravity but also keeps him out of the airflow and must be advantageous. Concept claim that the slimmer looms of the Dreissigacker oars reduce their drag by 35% compared with a conventional wooden loom, and this must be valuable. Aerofoil section outriggers have been used and could doubtless be made even 'cleaner' to give a useful reduction in drag. Further gains could also be made in smoothing the shape of the above-water parts of the boats.

Boat construction

The design requirements which the racing boat must satisfy are now clear. The boat must be strong enough, of course, to withstand the forces exerted on it by its crew and the wind and water. It must be as light as possible (or as allowed by the rules). At the same time the boat must be stiff enough to withstand the applied loads without appreciable distortion (though just how stiff is a matter of debate). The hull must have an excellent exterior finish and must be shaped to give the best compromise between minimum wave drag and minimum friction drag. The above-water parts should be shaped so that aerodynamic drag is minimized. Finally, the configuration of the boat and the details of its internal construction must afford the athletes the most efficient working positions.

The greatest stresses imposed by the athletes on the structure are principally on the foot stretchers and the outrigger attachment points, and these are the parts that most commonly fail under repeated stress. These local forces are likely to be in the order of 50–100 kg in sustained rowing (but will be much greater at the start), and those parts of the structure must indeed be strong to withstand repeated strain. The general forces on the hull are of a much lower order, however. The hydrostatic pressure on the hull in supporting the boat plus crew will be only of the order of 200 kg/m^2 and very thin skins can withstand that – not however without distorting considerably unless they are otherwise supported. As far as the tensile strength of the hull is concerned it can again be met adequately by the very thin skins of the materials commonly in use.

It is not difficult to make a strong, stiff, heavy boat, but it is difficult to make a very light boat both adequately strong and stiff. By and large the final consideration in choosing materials and construction for a light boat is not whether it will be strong enough but whether it will be stiff enough. To put this another way, with modern materials a boat that is adequately stiff is certain to be adequately strong for all normal purposes. The prospective purchaser can then turn attention to other considerations, such as the impact resistance, longevity, ease of maintenance and repair, and so on.

The hulls of modern boats can be made from a range of materials offering the required combination of strength and stiffness. It is possible to make very light, strong and stiff boats with wooden hulls that will perform at least as well as any made with synthetic materials. Wood has its problems, however. It must be given an impervious coating, to keep out moisture and to give the required smooth surface, and this coating may help to

overcome the other problem of a soft and easily damaged surface. Such coatings add to the weight but can also add to the strength, especially if they impregnate the wood and help bind the fibres. Wood is also weak across the grain and has a tendency to split along the grain on impact; but this can be alleviated by reinforcement with a synthetic cloth or by laminating to form a plywood with alternating grain angles. Unless very thin veneers are used, perhaps laminated on a male mould piece by piece (cold moulding), wood can be reluctant to conform to the shapes demanded by modern hull designs. Good wooden boats require high standards of craftsmanship and are expensive because of this labour-intensive requirement rather than because of the material cost.

Fibre-reinforced plastics (sometimes polyester but more usually the tougher, more adhesive, but more expensive epoxy resins) have been used in boatbuilding of all types for many years. Plastics reinforced with high-quality glass fabric (to about 50% of their mass) are quite cheap and have adequate mechanical properties, but they are rather dense for our purposes, so it is increasingly common for high-performance boats to be made with the superior but more expensive fabrics such as Kevlar and carbon fibre. The great advantage with most fibre-reinforced plastics is that they are very easy to form into complex shapes whilst the resin is still liquid. In addition it is possible to achieve excellent surface finishes easily by using a highly polished female mould.

Perhaps surprisingly, fibre-reinforced plastic is not impervious to water and tends to absorb it along the fibres. In the long term this absorption will not only increase weight but may lead to delamination. The solution is to protect the outer surface with a thin layer of tough resin called the gel coat, which also gives damage protection and a good finish. It is therefore most important to look after the surface and to repair damage as soon as possible.

One disadvantage of the synthetic boatbuilding materials is that although they may not be susceptible to rot they can be adversely affected by other environmental factors. Both polyester and epoxy resins deteriorate and crack under solar ultraviolet radiation, and these hairline cracks slowly spread. Temperature also affects plastics, and the mixture of materials used can cause distortion if boats become too hot. There have been many instances of plastic boats softening in the heat and suffering subsequent delamination or distortion. It is important that such boats should be light in colour and kept out of the sun as much as possible, and manufacturers should choose more stable resin systems.

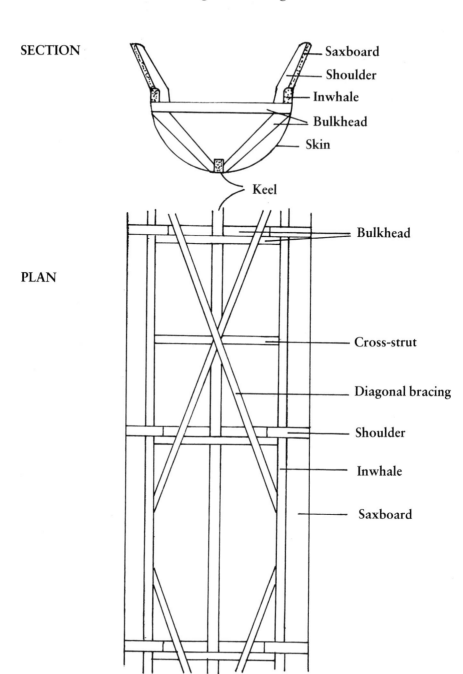

SECTION

— Saxboard
— Shoulder
— Inwhale
— Bulkhead
— Skin

Keel

PLAN

Bulkhead

Cross-strut

Diagonal bracing

Shoulder

Inwhale

Saxboard

Fig. 58 Traditional wooden frame construction.

Construction methods

Most boats follow one of a small number of design and construction strategies. Traditional boatbuilding methods were necessarily limited by the materials available: wooden joints needed nails as well as glue, while hull skins made of thin cedar veneer required much additional bracing and could withstand little stress. Modern materials remove these constraints and efficient designs are possible with very lightweight constructions which owe more than a passing resemblance to aeronautical practice.

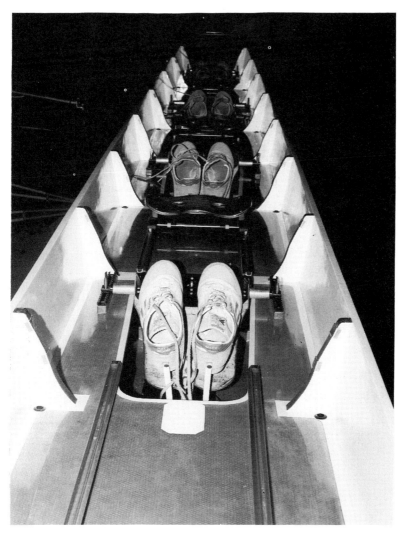

Fig. 59 A monocoque construction eight made from sandwich laminates of carbon and Kevlar on a honeycomb core, giving great stiffness and strength with minimum weight (Aylings E mould).

This method of construction has the beauty of simplicity and because of it offers the prospect of minimum use of material and the most straightforward and least laborious assembly. If only we could all agree on a standard design of boat, or if FISA imposes one, it ought to be possible to mass-produce unitary construction plastic boats of very high performance at much reduced cost. In the long run this must be to the benefit of the sport, but it is resisted by the competitors who always want something different (and hopefully, better). The manufacturers too are fighting to preserve their identities, and under the present circumstances it is very much in their interest to continue to offer an individual service to their customers.

Racing boats are really much too expensive already and most purchasers are buying refinements that are of minimal use for their restricted talents. FISA's efforts at standardization have so far met with limited approval, at least partly because they tended to fossilize outmoded methods of construction which might be neither the best nor the cheapest.

Boat ergonomics

In order to work at maximum efficiency the athlete must be placed in the boat in the optimum way, and the parts of the structure involved must be arranged to best advantage. To some extent this depends on the latest ideas on rowing technique and rig but also depends upon the dimensions and weight of the athletes. The boatbuilder must necessarily depart from the ideal structure in order to accommodate these needs. For example, a higher deck in the centre of the boat will help to stiffen the structure, but the height of the deck determines sitting height, and there is an optimum (rather low) position of that relative to the water line. Quite small differences in such dimensions have effects not only on performance but also on how comfortable the athlete feels in the boat.

Figure 60 shows the layout of these crucial parts of the 'stateroom' and gives some typical dimensions which long experience has shown to be of the right order. One characteristic of the modern boat, dating back to the Karl Adam eight of 1968, is the provision of copious adjustment which enables the final marriage of boat and athlete to be optimized. Precisely how those adjustments should be made and how they relate to the movements we call technique are discussed later in this chapter.

Oars and sculls

Essentially, oars and sculls are drag devices; they produce thrust

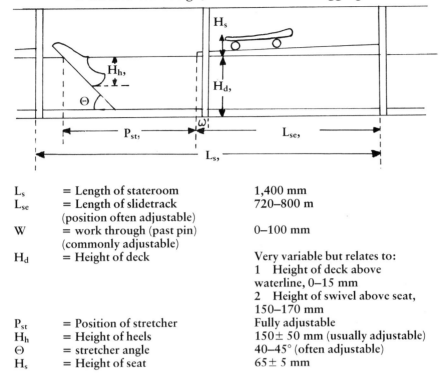

L_s	= Length of stateroom	1,400 mm
L_{se}	= Length of slidetrack (position often adjustable)	720–800 m
W	= work through (past pin) (commonly adjustable)	0–100 mm
H_d	= Height of deck	Very variable but relates to: 1 Height of deck above waterline, 0–15 mm 2 Height of swivel above seat, 150–170 mm
P_{st}	= Position of stretcher	Fully adjustable
H_h	= Height of heels	150 ± 50 mm (usually adjustable)
Θ	= stretcher angle	40–45° (often adjustable)
H_s	= Height of seat	65 ± 5 mm

Fig. 60 Dimensions of the rowing 'stateroom', side view.

by slipping through the water and the water reacts against the blade. However, the slippage represents an efficiency loss and although it can be reduced by increasing the blade area there are practical and even aerodynamic constraints on the maximum size. Calculations of efficiency (useful power output in relation to human power input) put the value between 65 and 75% – the rest of the human input goes into disturbing the air and water with the oar.

As with so many other advances, modern oar design owes much to Karl Adam. Study of the mechanics shown in fig. 61 shows that the oar is pivoting about a point some way inboard from the tip of the blade. For rowing this point turns out to be about 60 cm from the tip (and for sculling something approaching 50 cm), though the exact figures depend partly on just how far the blade is slipping. The significance of this is that any part of the blade inboard of that point will be moving through the water in the same direction as the boat, thereby creating unnecessary drag as well as failing to propel the boat. Adam proposed that the blade should be shortened to 60 cm, and at the same time widened to 20 cm to maintain area.

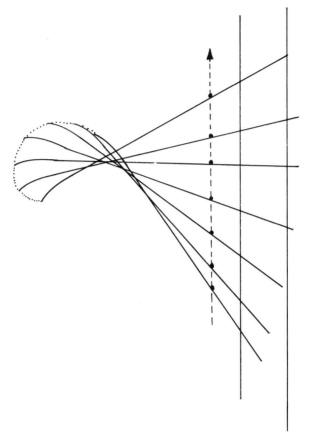

Fig. 61 Movements of the oar during the stroke. Note that with the catch
at 35° the initial movement of the blade is in the same direction as the boat
is moving. The blade effectively rotates about a point some way inboard.

Two other features were also considered. When the blade
approaches or leaves the water it is more efficient if its lowest edge
is nearly parallel with the water surface, so although the blade is
narrowest at the neck (the turning point) it should not be widest at
the tip but at a point about 20 cm inboard (fig. 62). This also
moves the centre of pressure on the blade inboard, which is a
further factor to be considered in relation to leverage. The new
shape of blade was used very successfully by Ratzeburg at the
champions in Macon, and, christened the 'Macon' blade, became
almost universally adopted. A similarly shaped but smaller blade
was developed for sculling.

Since the blade is intended to create maximum drag with
minimum slip, attention has been given to the precise shape and
dimensions of the blade in other ways. Increasing the area by
increasing the width has been found to make improvements to

efficiency but does cause technical problems because of the reduced water clearance during the recovery. If the wider blade does slip less then the point of rotation moves outwards; this means that the blade should be shorter – which would reduce the area again! Since flow of water off the face of the blade during its peculiar motion through the water represents lost efficiency, the curvature of the blade also helps to grip the water and create more drag and thrust. Excessive curvature is counter-productive and leads to messy blade extraction, and it is usual for sculls to be flatter than rowing blades. Subjectively it is tempting to believe that deeply dished or odd-shaped blades may offer some advantage, but in practice little is gained, as indeed theory predicts.

There has been work, particularly by Nolte in Germany, which suggests that the curved shape of the blade acts as a useful aerofoil when the blade enters the water. At this point the blade is being carried forward by the boat and enters the water at about 30–40° to the side of the boat (in sculling even less). A large part of the water flow at that instant may be thought of as flowing along the blade from tip to neck. During the next part of the stroke the blade moves along an outward path which tends to continue this relative movement along the blade (see fig. 61). If this is the case and nothing else changes, then the blade might develop pressure differences on its two sides amounting to a useful lift in the right direction, i.e. a force which would reduce slippage. It could be that some newly developed blade shapes can exploit this effect further and offer greater efficiency. There are interesting parallels with the theory of competitive swimming where the complex movement of the swimmer's hands through the water helps to provide dynamic thrust.

Commonly accepted oar lengths changed little in the hundred years since the invention of the outrigger, and the factors determining the choice of dimensions are dealt with in the section on rig that follows. It is perhaps surprising that so little change has occurred despite major innovations elsewhere, and it may be that bolder experiments would pay dividends even though the theoretical benefits are small.

As with all parts of the equipment it is necessary to balance the requirements of minimum weight with adequate strength and stiffness. However, since the big-blades slip less it is necessary to reduce the outboard length. Carbon fibre reinforcement of lightweight wooden shafts has proven worth in maintaining stiffness, but the greatest weight savings have come with all-synthetic construction. Because of the outstanding properties of carbon fibre it is possible to make very thin-walled, slim looms, with good strength and stiffness as well as weight saving of 1 kg or

more. Further weight savings can be made with carbon fibre-faced blades of sandwich construction. Such oars and sculls are now in widespread use and offer significant advantages in weight and strength for a moderate cost penalty. It is worth reflecting that the weight saving is equivalent to at least a quarter length's advantage for an eight over 2,000 metres. Apart from the obvious benefit of lighter equipment, the lighter oar also saves energy as it is moved about and rotated each stroke.

An oar must be torsionally stiff so that it maintains its proper angle in the water. If the loom is flexible it will be difficult to row with and will be inefficient because, particularly at the beginning of the stroke, energy that should be propelling the boat is being stored as strain in the oar. On the other hand a very stiff shaft feels harsh and is tricky to handle because of its instant response and rather unforgiving nature. Most manufacturers therefore offer a range of reasonable stiffnesses to suit individual preference. It should be borne in mind that the feel of the oar or scull also depends on its point of balance outboard.

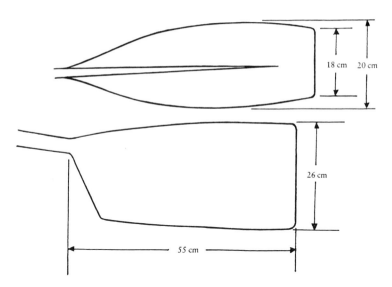

Fig. 62 Macon and big-blade.

Research has shown that the most efficient diameter for a handle is about that of the usual sculling grip, which implies that most rowing handles are too thick. They do in fact have to be thicker in order to be strong enough, but ought to be of a size that hooks nicely in the curved fingers. Too fat a handle is hard to hang on to, encourages tension and can lead to cramp and clumsy bladework.

Fig. 63 The start of a coxed pair race at Ghent. The strain in the loom of
the oars is apparent as maximum power is applied.

Rigging and adjustments

The purpose of individually adjustable equipment is twofold.
Firstly to ensure that you are in the best relationship to your
equipment, and secondly so that you can maintain the optimum
length of stroke, rating and rhythm.

POSITION IN THE BOAT

As explained earlier, in Chapter 2, the position of the stretcher,
and to some extent the height of the feet on it, determines your
position in the boat, but the best point of reference for this is the
position relative to the pin, because this then determines the
important angles at catch and finish. For a first approximation, it
is usual to place the stretcher so that with the legs fully extended
the aft edge of the seat will be 46–48 cm from a line through the
pin (the line of work). This will give something like the correct
blade angle at the finish, depending on the degree of layback
chosen. Assuming that a suitable combination of inboard and TD
has been chosen (see page 112) to give the appropriate arc and
gearing, then the desired angle at the catch is obtained by sliding
and reaching out with the arms. Further checks can be carried out
by marking the saxboards with coloured tape to show where the
oars or sculls should be at catch and finish, and then getting
someone to observe or video from the side or above. I find it
particularly useful to watch crews from the vantage of a high
bridge.

At the FISA coaches' conference in 1986, figures were presented to show the total arcs and angles of catch and finish being used by top internationals. These figures, shown in Table 2, were obtained by analysis of video – they may come as something of a surprise to those brought up on the idea that any angle beyond 45° must be 'pinching the boat' and therefore be inefficient.

Table 2
Measured arcs and angles for rowing and sculling

	Total stroke arc (degrees)	Angles to boat° (degrees,catch–finish
Men rowing	85–93	35–125
Women rowing	80–85	45–125
Men sculling*	107–112	30–137
Women sculling	100–106	37–137

* It is reported that Kolbe reached to 25°, and Karpinnen even further! Whilst such extreme angles may exploit hydrodynamic blade lift even more, they do create problems of balance and require great skill.

The height of the feet can be adjusted in most boats to enable you to achieve comfortably the desired compromise between body swing and leg compression with the best joint angles. If you have long legs – and many youngsters have long legs in proportion to their height – then you may find it helpful to lower the feet. There is sometimes a problem with long slides rubbing on the backs of the calves, and raising the feet a little may help with this. Stretcher angles are usually about 42–45° and are adjustable in some boats, but in fact this adjustment is so rarely used that some manufacturers have done away with it for simplicity and weight saving.

The height of the swivel above the seat is important in dictating the direction in which you pull the handles and also affects the likely depth of the blade in the water; if the height is too great the blade is more likely to wash out, and if too low the blade may go too deep. A low rigger also makes it more difficult to extract the blade at the finish and may cause you to lean away from the rigger in an attempt to compensate. The height is measured by placing a straight edge across the boat on the top of the saxboards, then measuring down to the lowest part of the seat and up to the middle of the sill of the swivel. More sophisticated rigging sticks are available for the same purpose. A height of about 16 cm is a good starting point for most boats but will have to be adjusted to suit

you. It is worth checking that the two saxboards are in fact level – in older boats particularly they may not be. The other problem is that the boat may be twisted, so that although all the rigger heights are set correctly in relationship with their seats, the riggers will be at different heights from the water. This problem is not uncommon because boats may twist with time, especially if they are racked badly, but it also happens with new plastic boats because they are rarely fully cured by the time they are taken out of their moulds. The twist can be seen if you put a straight edge across the saxboards at both ends of the boat and then sight along from one end. A slight twist can be compensated by different heights say for stroke and bow, but a more severe twist requires drastic remedial action by the maker.

Fig. 64 A straight edge across the saxboards will enable the height of the swivel to be checked in relation to the seat.

GEARING

The oar is a lever which pivots round the blade in the water when you pull on the handle, and pushes the boat along at the point where the loom bears on the pin – though from your point of view sitting in the boat it may seem that the oar pivots round the pin and levers the water past the boat. Geometrically it does not matter which way you look at it. The overall length and the position of the button will therefore determine how far the boat moves for each stroke you take. It is a bit more complicated than say the gearing on a bicycle, because the angular length of your stroke also enters into it – that is, the total arc that you sweep the blade through on each stroke from catch to finish. This depends on four major interacting factors.

 1 The inboard length from the button to the end of the handle.
 2 The distance of the rigger pin to the centre line of the boat (the thwartship distance or TD).
 3 Your height and arm spread.
 4 Your range of movement, which in turn depends on your flexibility and style of rowing or sculling.

These gearing dimensions are of great importance in determining how quickly you can move the blade and how hard it feels, and thus are crucial to your ability to maintain your desired rating and rhythm in the prevailing conditions.

Experience shows that for each boat type there is a small range of settings for the TD and inboard length which will give good results. Too light a gearing and you will not be able to move fast enough to reach maximum boat speed, whereas if the gearing is too severe the work will be too hard and you will tire more rapidly or be unable to maintain a high enough rating. For any given oar or scull length, light gearing means more inboard and perhaps also a greater TD, whilst the most severe gearing will come from a combination of short inboard and short TD. For adverse conditions such as a headwind it is usual to leave the TD alone and perhaps extend the inboard by 1 cm.

If the purpose of rigging adjustments is to ensure that the crew or sculler can cover the course at an optimum rating and rhythm, it is probably true that the commonest mistake is 'overgearing', either because of an ill-founded optimism about strength or stamina, or in the macho belief that bigger oars and more severe gearing will necessarily make the boat go faster. If a crew or sculler is already at the limit, then a rig that imposes even a half-stroke a minute drop in rating can lose 1–2 sec over a 2,000 metre course, even though the blade is moving further in each stroke.

There is a common fallacy that changes in TD alone will have an effect on gearing (e.g. 'changing the TD by 1 cm is equivalent to moving the button 3 cm'), but on their own they do not, though they may have a significant effect on the biomechanics of the stroke. It is true, however, that the relationship of TD and inboard length is critical and has a profound effect on the length of stroke and gearing (fig. 65).

Irrespective of these other considerations there is one parameter that has become well established. This is the value called 'overlap' (fig. 66). In rowing this is the amount by which the inboard (measured from button to end of handle) exceeds the TD, and it is almost universally set at 30–31 cm. Values very far from this will place the outside hand in an awkward position, and can lead to a number of other technical problems such as leaning away from the rigger at the finish.

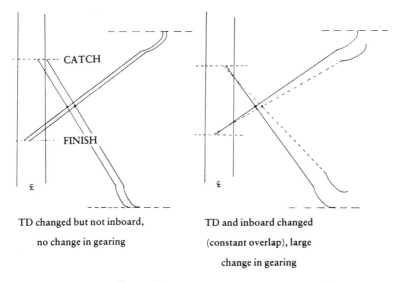

TD changed but not inboard, TD and inboard changed

no change in gearing (constant overlap), large

change in gearing

Fig. 65 Effects of changes in TD and inboard length.

In sculling the overlap can be defined in the same way, though it is more commonly expressed as the actual overlap of the two handles. A value of 8 cm would be usual when measured in the first way, and this should give a true overlap of 16 cm – but this does not allow for the extra distance between the button face and the centre of the pin (from where the TD is measured) caused by the width of the swivel. In reality, therefore, the actual overlap of the two handles will be about 19–20 cm (and in rowing perhaps we should add 2 cm for the same reason), but you will be glad to know that these details are usually safely ignored.

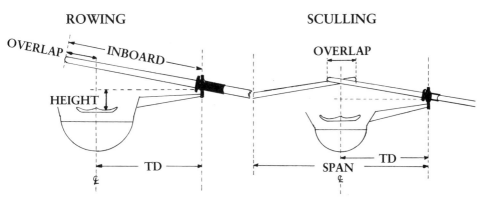

Fig. 66 Overlap in rowing and sculling.

The rigging tables that follow (Tables 3 and 4) illustrate current practice. The great danger is to apply them too slavishly – they are guidelines only.

Table 3
Suggested Rigs

TD is given from the centre of the pin, and for sculling boats the total spread or span from one pin to the other is used. All dimensions are in cm.

	Overall (Macon blade)	Overall (Big-blade)	Inboard	TD or span
Men				
1X	298–300	290–292	88	159.5
2X	298–300	290–292	88	159
4X	298–300	290–292	88	158.5
2+	383–385	375–378	117	87
2−	383–385	375–378	116.5	86.5
4+	383–385	375–378	115.5	85.5
4−	383–385	375–378	115	85
8+	383–385	375–378	114	84.5

(*Lightweight men will use overall lengths at the lower end of the range given*)

	Overall (Macon blade)	Overall (Big-blade)	Inboard	TD or span
Women				
1X	298	289–291	88	160
2X	298	289–291	88	159
4X	298	289–291	87.5	158.5
2−	380–382	372–375	116.5	86
4+	380–382	372–375	116	85.5
4−	380–382	372–375	115.5	85
8+	380–382	372–375	114.5	84.5

(*Lightweight women will use overall lengths at the lower end of the range given*)

Junior 1X	Overall	Inboard	Span
age 17–18	298	87–88	159
15–16	296	86–87	158
13–14	294	85–86	157
9–12	285	83–84	156

These figures are based on the rigs used by a number of the most successful teams in recent years, and they are typical of the dimensions employed by the characteristically tall and powerful athletes of the best crews. For those shorter in stature, the principle is that in order to retain the overlap and desired angles of the blade at catch and finish, the inboard and TD should both be reduced by about 1 cm, whilst the overall length needs to be shorter by about 3 cm to retain the appropriate gearing.

Fig. 67 Overlap in a sculling boat can be measured in a number of ways –
be careful when reading rigging charts!

Table 4
FISA suggested rigs for club crews

	Overall	Inboard	TD or span
Men			
2–	382	116	87
2+	382	117	88
4–	382	115	85
4+	382	116	86
8+	382	114	84
1x	298	86–88	158
Women			
2–	378	114	86
4–	378	113	84
4+	378	114	85
8+	378	112	83
1x	296	86–88	156

RIGGING FOR SMALLER PEOPLE AND SLOWER BOATS

Amongst single scullers it has long been accepted that their own

boat and sculls should be appropriately adjusted to their body size, and the principle is that the smaller sculler has shorter sculls overall, but with a reduced rigger span and inboard on the sculls. In this way it can be arranged that all scullers sweep their sculls through much the same angles but without significant differences in gearing. Boys and girls who are exceptionally tall for their age would use a wider span and a greater inboard, but their lesser strength means that they should use a shorter scull than their older peers.

The same principles can equally well apply to crew rowing, but in practice a rather different philosophy has grown up that we should adjust the rig according to the boat type and its expected speed rather than to the individuals in it. There are good pragmatic reasons for this in that it would be very expensive and awkward to have different length oars for each type of boat that a club uses, let alone different ones for every individual in the club!

Now it has become common to apply the idea of wider TD to smaller and slower crews, not just slower boat types. I think that there is a fallacy here and my experience suggests that the 'body size approach' may be better. I believe instead that we should be giving such crews shorter oars, with less inboard and narrower rigger spreads, so that they can move them through more nearly the same angles as their bigger brothers, but not be overgeared.

I'm afraid that there doesn't seem to be any easy or universal formula that will give the answers, for there are too many variables, so the best we can do is apply the principles and test for the best compromise.

ANGLES ON THE PIN, SWIVEL FACE AND BLADE

Because the pull on the handle is slightly upwards (5–10° was suggested earlier), there will be a tendency for the blade to be driven too deep in the water. This tendency is counteracted by a positive pitch (angle to the vertical) on the blade so that its top is tilted a little towards the stern. The angle of pitch required depends on the height of the swivel in relation to the athlete, and the individual's technique. For both rowing and sculling, experienced athletes would commonly use 4–6° of stern pitch, whereas novices may need 8°. If large amounts of pitch are needed this suggests poor technique, with a pull too far from the horizontal, and at the same time the blade will tend to lose some of its grip on the water. Under-pitching and a deep blade is also wasteful of energy.

There is a natural tendency to pull upwards more at the beginning of the stroke, and downwards at the finish as the arms bend. Thus there is a need for more pitch at the catch and less at the finish. This can be achieved by leaning the pin outwards a

degree or two – this is called lateral pitch to distinguish it from the stern pitch described above. At the catch some of the lateral pitch will be added to the stern pitch of the swivel face and any angle built into the blade, so giving more total pitch; at the finish the lateral pitch will subtract slightly from the total. This relationship holds good so long as the pin is vertical in the fore and aft plane, but inclining the pin fore or aft to achieve changes in stern pitch can have unfortunate effects on the way in which total pitch changes through the stroke. It is much better to make adjustments with a variable pitch swivel and to leave the pin upright.

Table 5
Effect on blade pitch of pin angle

Pin angle°		Pitch on blade°		
Lateral	Stern	Catch	Middle	Finish
Swivel face 4°, oar 0°				
2	0	5.2	4.0	3.2
2	1	5.6	5.0	3.8
2	2	6.0	6.0	4.4
1	0	4.6	4.0	3.6
1	1	5.0	5.0	4.2
1	2	5.4	6.0	4.8
0	0	4.0	4.0	4.0
0	1	4.4	5.0	4.6
0	2	4.8	6.0	5.2
Swivel face 4°, oar 2° (NB: This is the same as 6° on the swivel face, alone)				
2	0	7.2	6.0	5.2
2	1	7.6	7.0	5.8
2	2	8.4	8.0	6.4
1	0	6.6	6.0	5.6
1	1	7.0	7.0	6.2
1	2	7.4	8.0	6.8
0	0	6.0	6.0	6.0
0	1	6.4	7.0	6.6
0	2	6.8	8.0	7.2

The usual standard is to have 4° incorporated into the face of the swivel, and either 2° or 0° built into the oar or scull; 1–2° of lateral pitch then gives a range through the stroke which should suit most athletes. The effects of variations on these figures is shown in Table 5.

Unfortunately riggers are easily disturbed by bumps or scrapes and not all pitch adjusting devices are reliable, so it is wise to check regularly, but most importantly when a boat has just been re-assembled or before a race. Oars and sculls can vary quite a lot in pitch, even within a set, and do tend to change with time, so do not rely on them. On one coaching course I was trying to demonstrate the business of pitching an eight with blades to the students. Try as we might we could not get it right, and it was then that I discovered that the host club had been sold a set of used blades (freshly renumbered) which were in fact all for one side!

RIGGING A BOAT

If you are checking or altering the rig on a boat it is always wise to be methodical and not to assume things that you have not checked. The boat should be firm on sling trestles and if at all possible should be level both fore and aft and across (check with a spirit level). Although modern pitch gauges allow you to compensate it is much easier if the boat is level, and you are less likely to make mistakes. Prop the boat so that it cannot move while you are measuring. If I am doing a complete check I first

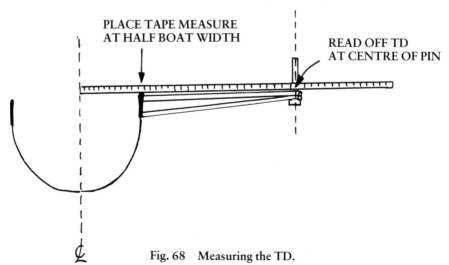

PLACE TAPE MEASURE
AT HALF BOAT WIDTH

READ OFF TD
AT CENTRE OF PIN

Fig. 68 Measuring the TD.

make sure that the rigger bolts are tight and then take off the pin topnut and lift off the topstay – this is because a maladjusted topstay can distort the whole rigger and it may have to come off

Fig. 69 Using a pitch gauge to measure stern pitch. The spirit level must first be set on a horizontal part of the boat.

anyway for some adjustments. Working on each rigger in turn, check first the TD by measuring the width of the boat, halving it and then measuring out from the saxboard to the centre of the pin (fig. 68). When the TD is right, mark it so that you can see at a glance in future whether it has altered. Next use the rigging stick to check the rigger height before going on to check the pitch.

Some prefer always to measure pitch on the blade itself with the button being held in place in the swivel by an assistant; indeed in the days before pitch gauges this was about all we could do by dangling a plumbline over the end of the blade. The argument is that this is the most relevant measurement since what ultimately matters is the angle of the blade in the water, but I feel that it has too many drawbacks. It is not easy to do accurately and I feel that it may mask oddities in either the blade pitch or that on the gate, and I would rather know that both were right. So check the pitch on the blades by resting the tip face down on a level surface and putting the pitch gauge on the back of the sleeve next to the button – use a marker pen to record each blade's pitch somewhere, and reject any that are too odd. Now check the stern and lateral pitches on the swivel, remembering to set the pitch gauge on an appropriate flat surface on the boat, and refer to Table 5 if necessary to see what the final result should be. Make sure that everything is done up tight, then finally adjust the topstay so that it will just drop back into position without any strain, and do up its retaining nut or bolt.

Fig. 70 The Martinoli pattern gate allows separate adjustment of pitch, height and TD, and keeps the pin vertical.

CHAPTER 6

General principles of training

The human body is remarkably adaptable and if properly trained will become capable of physical feats which can only be dreamt of at the outset; what was once difficult becomes easy, and what was impossible comes within reach. The great Czech distance runner Emil Zatopek said that by an effort of the will it was possible to change the whole body. To a considerable extent he was right, but we are all also prisoners of our inheritance, so we cannot hope to do more than improve through training to the limit of our inherited abilities. Fortunately rowing and sculling are very rewarding sports in this respect, for no one, however great their athletic potential, can have any success without training and everyone, however young or old, will improve with appropriate training, often to a remarkable extent.

In the earlier chapters on techniques of both rowing and sculling, I made the point that all training should be regarded as an opportunity to learn and improve the skills, even if its prime purpose was to increase fitness or strength. Thus we can see that 'training' has a number of objectives and effects, which is only to be expected when the sport requires a unique combination of skill, endurance, strength and speed. The principal objectives are as follows:

1 *Skill* It is useless to be strong and fit but unable to row or scull efficiently. Of course the beginner needs to devote most time and effort to the development of this quality and will gain most from it, but even the most experienced athlete can refine skills still further. To row or scull well requires adequate strength in all the muscles used, and to keep on doing it demands endurance – so skill training cannot be divorced from the other aspects of training. Learning skills is best done when the body is free from fatigue, but on the other hand the maintenance of technique under stress is vital in competition, so that too must be rehearsed. As in many other sports it is possible to reach a stage where despite continued training there is no further measurable improvement in physical fitness, and yet the performance on the water does get better still. This effect is most likely to be due to further improvements in skill; that is, that efficiency with which the muscles are used to propel the boat, and also perhaps in the realms of psychology.

2 *Endurance* Rowing and sculling events are certainly biased towards endurance, for even the so-called sprint events are usually at least 500 metres and require hard work for anything up to two minutes, whilst the standard regatta distances of 1,500–2,000 metres clearly require a lot of stamina. The longer-distance Head races of Autumn and Spring were introduced largely to help promote desirable endurance training, but have now become an enjoyable part of the competition scene in their own right. The objective of most of us is to get there first, not just to arrive, and the ability to row a long way slowly does not by itself win races. What is needed is a combination of endurance with speed and with strength – 'general endurance' has a part to play but the athlete needs training that will also develop 'speed endurance' (the ability to maintain speed of movement for a long time), and 'strength endurance' (overcoming a significant resistance repeatedly).

3 *Strength* Because its weight is being supported by the water, a boat and its occupants can be moved very easily at low speed, but the resistance increases very rapidly as the speed goes up (the power required increases roughly as the cube of the speed). To go that little bit faster than the opposition when you and they are already near to maximum means that much greater force must be exerted. To reach the desired speed demands strength enough to overcome the resistance, but more than that there must be something in reserve – otherwise the effort cannot be sustained. Sheer maximal strength of the type shown by weightlifters is not what we want, but rather the 'strength endurance' referred to above, and, since at

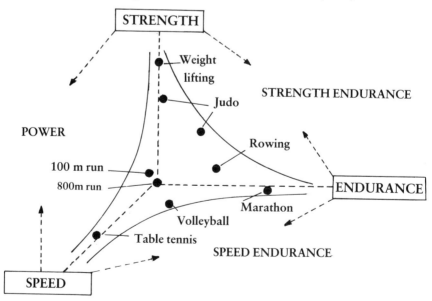

Fig. 71 Relationship between speed, strength and endurance for various sports (after Ikai).

speed the movements must also be very rapid, almost explosive, so the athlete must be able to use strength with speed. Figure 71 shows diagramatically how the different components contribute in rowing as compared with some other sports.

4 *Mobility* Rowing and sculling require the ability to work efficiently through a very large range of movement. If you are inflexible it will make the effort seem harder, will reduce the length of your stroke and may reduce your skill.

Fig. 72 One of the components of fitness for rowing is flexibility and the ability to work effectively through a large range of movement.

5 *Psychology* The beginner in sport needs to learn how to train, and it often takes a long time to appreciate just how much hard work is both necessary and possible if success is to be enjoyed. Some training is enjoyable or rewarding in its own right, but much of it is frankly a means to an end, and that end may seem a long while coming! To make the most of the opportunities you must develop qualities of determination and persistence, and one of the objectives of a progressive training scheme must be to help that development. Young athletes in particular will need to learn that effort is rewarded, that greater or more prolonged efforts bring greater rewards, and that perhaps some sacrifices may be worth making.

One of the effects of training is to change the perception of effort so that a given level of performance seems easier, and at the same time tolerance to fatigue will also be improved. Some of these effects are due to adaptations in the body systems, but much is also a reflection of the athlete's psychological make-up and the way that it is modified by experience of training and competition. It is known that brain chemistry is significantly changed by the release of

'natural opiates' within it during stressful effort, and the brain becomes so used to the more pleasurable sensations that result that we can become almost addicted to exercise! Young children have a much lower perception of effort than teenagers, who in turn would rate an equivalent effort as less demanding than would an adult, and the children also recover much more quickly. It is not clear why this should be so – it may be because children are naturally much more active in play and games, or it may be that they are in some way less able to stress their bodies.

What happens in our bodies when we train

When we work hard to move a boat a large number of changes occur in our bodies in order to meet the increased demand for energy and to dispose of the extra waste products and heat. If the effort exceeds that which we are used to for long enough then the body cells and systems will be stimulated to adapt and change to meet the challenge. As a result the body will be better equipped next time, which means that the same task will be achieved more easily, so if further improvement is required then the effort should be increased once more. The way in which the body adapts is rather specific to the demand placed upon it – if we lift a light weight many times we improve in endurance but not in strength, whereas a heavy weight which can only be lifted a few times will increase strength but not endurance. Thus we have three fundamentals in training which must be followed if the training is to be effective:

> 1 *Overload* The effort required must be significant in relation to your present capacity or the body will not be stimulated to adapt. This does not mean that we have to believe slogans such as 'no gain without strain', or 'if it doesn't hurt it can't be doing you good', which are not necessarily true and could actually be harmful.

> 2 *Progression* If continued improvement is to be made then it will be necessary to progressively increase the load in training in response to your increasing capacity. Adaptation happens gradually, though more rapidly at first, and there might therefore be some progression from week to week at one end of the scale and certainly from year to year at the other. Since many of the adaptations are the same as growth, we might expect young athletes to make much more rapid progress. As the body adapts, so the priorities in training will also change, for example, from the long-term development of strength and endurance towards more emphasis on speed as the competition period approaches.

3 Specificity To a considerable extent what you get out of your training depends on what you put into it; that is, the body responds in a specific way to a particular type of training. For example, training in a series of short, high-speed bursts with lots of rest in between will develop speed and strength but have little effect on endurance. There is an enormous variety of possible effective training methods, varying in the type of work, its duration, its speed, the strength demanded, the number of times it is repeated and the length of rest periods – and so on. These possible methods can be grouped according to their probable specific training effects and then a selection made according to the athlete's needs. In practice since a combination of abilities is required the answer is likely to be mixed training, in proportions and at times chosen to bring out the best results at the right time.

One of the most important differences in the way our bodies respond to different types of training lies in the energy production systems that can be used in rowing or sculling:

Anaerobic system I does not use oxygen but relies on stored energy in the muscles. These stores only last a few seconds at maximum effort but they are briefly important at the start and finish of a race.

Anaerobic system II also works without oxygen and enables high levels of power to be maintained at the start when that from other sources is not yet adequate, and it can also be called upon for extra power in the final sprint. Unfortunately it produces lactic acid as a waste product and if this accumulates it will cause great fatigue, so we cannot use it extensively for very long.

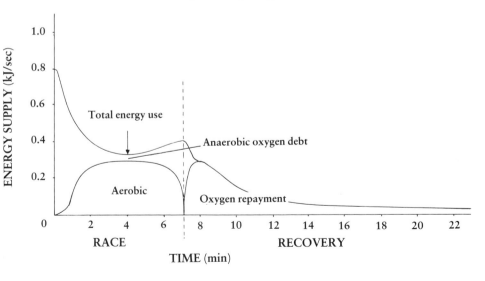

Fig. 73 Aerobic and anaerobic energy supplies during a race.

Aerobic respiration using oxygen is the most efficient way of producing energy for our muscles and this must cover the bulk of our energy needs in all but the shortest of efforts. Moreover, the greater our capacity for aerobic work the less we have to call upon the fatiguing anaerobic systems. Figure 73 shows how the proportions contributed by these energy systems change during a 2,000-metre race.

The specificity of training applies very much to the way in which these systems are developed – short intense efforts will favour the anaerobic systems, while more prolonged training at lower speed will encourage the aerobic side not just in the muscles but in the equally important provision of oxygen to them via the lungs and circulatory system. Since aerobic endurance takes longer to develop, this means that the major part of the training must be directed that way.

Finally, the concept of specificity must apply to you as an individual; each of us responds to stress in a different way, so the training programme should be tailored to the individual – but this is less than easy in crew rowing!

The young athlete

A very large proportion of competitors enter the sport in their teens or even earlier at a time when skill learning will be most rapid and effective, and when attitudes and habits that will stand you in good stead for the rest of your life can best be established. Before puberty, skills such as balance in the single scull can be learnt very quickly, and it would be a waste of opportunity to spend too much time in things like playboats. Physically, though, the pre-pubescent child responds rather differently to training than does the teenager or adult. Research shows that aerobic training for the youngest age group has most to commend it, for the prolonged but low-intensity exercise will have many benefits for the development and maintenance of a good circulatory and respiratory system and will have a general stimulatory effect on growth. Although even at this age the strength and effectiveness of the muscles will increase, we cannot expect much growth of the muscles until the hormonal changes of puberty have occurred. Anaerobic training does not seem to have the same effect as in adults and in any case very intense training with heavy loads cannot be recommended for children who have yet to grow and who have incomplete reinforcement of the skeleton and other supporting tissues.

After puberty, training loads can be progressively increased and progress is likely to be very rapid in all respects as growth and

maturity advance. Weight training will be beneficial to muscular development now, but care must be taken not to damage the developing skeleton with very heavy loads. The evidence is that the emphasis must still be on aerobic training and that too much anaerobic training could be harmful to the developing systems, or at least unsatisfactory in the longer term. For this reason the standard racing distance for juniors has been increased to 2,000 metres.

At this age parents and teachers often become concerned about the time and effort being expended on rowing. I firmly believe that the benefits to physical and mental health are so important that active participation in sport must be positively encouraged, and I do not believe that enough time cannot be found in the day for adequate training at even very high levels without harm to academic progress. My own experience over many years matches that of others who have found that well-organized participation is in fact beneficial. For example, a recent Scottish Sports Council sponsored study of 10,000 children showed that those who were most successful and active on the sports field also tended to do better academically and to find the most worthwhile careers. This is not to say that sport must become an obsession, but rather it should be an enhancing part of a full life and deserving of a high priority.

Female athletes

I do not believe that anything in this chapter does not apply equally to both males and females and I think that it would be very wrong to assume that a female's ultimate capacities are very different to the male's. Indeed, it is the unfortunate view of the 'weaker sex' that has greatly retarded women's progress in sport. Nevertheless there are differences which should be taken into account in devising training schemes that are tailored to individual requirements.

On average – and one should stress that exceptional competitors are by definition *not* average – women have a smaller proportion of muscle mass, smaller hearts and lungs, and smaller blood volumes and haemoglobin levels than equivalent men. As a result they have less strength and lower oxygen uptake values. However, all the evidence suggests that women respond to training in much the same way as men and with the same beneficial results. The difference between trained and untrained subjects is much greater than the inherent differences between men and women.

Are there any special dangers for women? Well, some worry about developing 'unfeminine' muscle bulk, but it seems that with

weight training women are able to make very substantial strength gains without in fact increasing muscle mass. The fit female athlete has a lower proportion of body fat than her untrained sister, and thus her muscles may be better defined, but who is to say that this is unattractive, and in any case it is easily reversible. Some women who train very hard find that their menstrual cycles become irregular or may even temporarily cease (amenorrhoea), and this condition must be avoided by girls. Even where this state is maintained for many years it would seem to be easily reversible by a reduction in training, and is not likely to result in any permanent loss in fertility. There is some concern that prolonged amenorrhoea may lead to loss of bone mineralization, but again this seems to be reversible in young women, although the full explanation is not yet clear and it does not seem to rest on proportions of body fat, as was at one time thought. In other women, and particularly in older ones, the evidence is that exercise is important in maintaining the mass and strength of the skeleton.

Methods of training and their effects

In Chapter 7 the physiological effects of training are discussed in much more detail, but at this stage the aim is to outline the methods so that effective programmes can be put together according to your needs. Referring again to the concept of specificity, it is essential to define the intensity, duration and rest intervals for each type of work, for these will determine precisely what effect the training has.

The maximum capacity of the body to use oxygen (maximum aerobic work) is expressed as VO_2 max., and it is invaluable to be able to define the intensity of a training session in terms of the percentage of your VO_2 max. that is demanded. Training intensities below 50% of this have little effect in improving any form of endurance, whilst very high intensities (above 100%) can improve anaerobic but not aerobic endurance. The most effective intensity for training aerobic endurance is around the level known as the anaerobic threshold, when the demand for energy in the muscles means that some contribution begins to be made by the anaerobic system on top of that from the aerobic process. Continuous work at this level is difficult even for very experienced athletes and it is usual to use some form of interrupted, repetition, or interval training – that is, periods of hard work alternating with periods of easier effort or rest. Work above this threshold increases lactic acid rapidly and this in itself will limit the length of the work periods. Interrupted training prevents excessive lactate build-up and allows these higher work levels to be repeated – and

in effect enables the body to be trained at higher intensities for longer.

For most of us it is not practicable to measure oxygen uptake directly, but fortunately it is known that there is a close relationship between heart rate and VO_2, and although the figures differ somewhat from person to person, the heart rate can be used as a practical guide to training intensity. These matters are explored more fully in the next chapter. Table 6 gives these rough heart rate and VO_2 equivalents. The anaerobic threshold for many athletes is likely to be in the region of a 170–180 bpm heart rate.

Table 6
Heart rate and VO_2 equivalents

Heart rate bpm	% VO_2max.
130–150	50–70
160–180	70–90
190–210	90–100

With experience it is possible to relate these measures of training intensity to speed over a certain distance whilst training, to rates of striking, or to otherwise subjective estimates of 'pressure'. There is an enormous choice of possible combinations of length, intensity and number of work periods, length of rest intervals, and frequency of training. To an extent it is the intensity which is the most crucial factor, at least in so far as frequent and/or prolonged training at too low intensity will be tiring but actually rather ineffective, whilst greater intensities have their specific effects on the body systems. Table 7 summarizes the likely effects of those methods most commonly used in rowing training. It is up to you and your coach to assess how much time is available, what the requirements and priorities are, and what is physically and psychologically possible.

Variety and periodization in training
Because of the specificity of training it is neither possible nor desirable to attempt to improve all aspects of performance optimally all at the same time. In the training year, or in your training and competition career as a whole, it is desirable to emphasize different aspects at different times. As a general principle the most effective system is to develop endurance first, followed by strength, before going on to more competition-specific

Table 7
Some methods of training and their effects

Intensity	Duration of work periods	Repetitions	Length of rest	Effect
Rowing, sculling, ergometer, running 1 Low <50%VO$_2$max.	1hr+	Continuous	0	Slight (possible psychological benefits) Basic technique
2 Moderate–high, up to anaerobic threshold	½–2hr, or 10 min–½hr	Continuous, or 2–4	0 or 5–10 min	Very good aerobic capacity and endurance
3 Alternate moderate/high (below and above anaerobic threshold)	1–8 min each, total <2hr	Continuous	0	Very good aerobic capacity and endurance
4 High, 85–95% VO$_2$max. or a little above anaerobic threshold	5–12 min	2–4	5–10 min	Mostly aerobic capacity and endurance, some anaerobic depending on intensity
5 Race pace	1.25–4 min, total <20 min	4–8	2–8 min	Aerobic and anaerobic, speed endurance, pace judgement
6 Sub-maximal, 100–105% race pace	1.25–2 min Total 7.5–16 min	6–8	2–3 min	Aerobic and anaerobic, speed endurance, pace judgement
7 Near-maximal	0.75–1.25 min	10–20, often in sets	0.75–1.5 min	Anaerobic, power, speed, speed endurance
8 Maximal	15–45 sec	10–20, often in sets	1–2 min	Anaerobic capacity, power, speed, little endurance effect
Free weights or machines 40–60% 1RM	Total <1hr	15–30+ per exercise	0 (continuous circuit)	Small strength gains, aerobic endurance if work exceeds 50% VO$_2$max.
60–75% 1RM	3–5 sets	10–30+	1 min between sets	Strength, power and anaerobic endurance
80–90% 1RM	3–5 sets	5–7	1 min between sets 30 sec	Strength/power Anaerobic endurance

work which will tend to emphasize speed. However, because many training effects are reversible, it will be necessary to maintain qualities developed earlier by using appropriately mixed training. The principles governing the development of individual physical qualities are becoming much better understood, but arriving at the precise mix of training methods which will produce the optimum performance on the most important day of competition is a much more difficult problem.

Training must be varied. A large number of physiological systems must be enhanced and different aspects of technique must also be developed, and this cannot be achieved by repetition of one type of training. Equally, athletes need a variety of mental stimuli if they are to give of their best. Variety in training will also effectively relieve stresses on different systems in some sort of rotation, and in effect will give the systems a fuller recovery despite frequent training.

In most athletic sports we are now in the era of the full-time athlete, whether supported by state aid, sponsorship or private means. In the Olympics rowing and sculling medals were largely won by those who had devoted all their energies to their preparation for many years, thrice-daily training being quite usual. In common with the other full-time athletic sports, such a frequency of training and its attendant intensity raises special problems for the coach, who must devise a scheme that will exploit the athlete's potential to the full, freed from limitations of training time. Even for the amateur competitor who cannot train so often, the multiple requirements already outlined demand a carefully devised and monitored system of *complex* training.

Such mixed or complex training is common and appears to be essential in bringing about the mixture of physical qualities necessary in rowing and sculling. Recent research work has demonstrated some thought-provoking findings;

(a) Pure strength training did not improve endurance.
(b) Pure aerobic endurance work did also increase strength, but not by very much.
(c) A combination of the two types of training, following the same two schedules as for (a) and (b), gave the same strength gains as for (a) alone, as well as significant improvement in endurance (though less than when only schedule (b) was followed).

The universal solution to these problems is the *periodization* of training, within which there are defined *cycles*. In this context a cycle is a series of programmed training sessions which can be repeated over a period of time in order to achieve the desired objectives; for example, a series of six training days in a week,

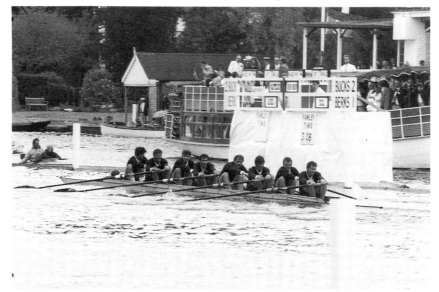

Fig. 74 A Soviet eight at Henley. State support for the top Eastern Bloc crews enabled them to devote much time to reaching very high standards.

each day perhaps emphasizing different qualities, then a slightly different following week, with the two weeks being repeated twice each month. These repeated (or repeatable) cycles will make up each of the major phases of the training year, which phases may be loosely defined as: 1 development of general ability, 2 development of specific ability, and 3 competition specific. Year on year, further development should also be programmed – say on the four-year Olympic period or through a youngster's school career.

The cyclic – or perhaps more accurately, wavelike – variation and progression of training effort and nature is common to many sports. At any time, however, it is necessary to alternate periods of intensive effort with those of a less demanding nature. Training schedules of unremitting ferocity are not only potentially harmful but are demonstrably less effective. It will usually be the case that the waves of recovery will be timed to coincide with major competition. Prior to those competitions more emphasis will be placed on quality than on quantity. The best training schemes must include a large element of flexibility to allow adaptation to changing external circumstances – particularly important in an outdoor sport. In a different sense the flexibility of the schedules must also allow adaptation to the rate of progress of the athletes – and this implies regular objective measurement and assessment. Above all, every session must have clear objectives and must be part of an overall plan.

Putting together a training schedule

It is not within the scope of this book to provide detailed training prescriptions for all (in any case, individual variations in ability and circumstances would make that impossible). It is notable that even in their general advice, different coaches or different federations come up with a variety of recipes based on a range of premises. For example, in the late 1980s, Mike Spracklen's schedules emphasized the development of technique, particularly through variation in pace, and used control of rating as a way of controlling intensity of effort. In contrast the Italian squad programmes had a strong physiological basis for their regularly repeated weekly microcycles, and intensity was expressed as a function of heart rate. Some authors have published elaborate programmes of wondrous complexity which are supposed to be widely applicable. Without being cynical, one wonders what objective research can support such Byzantine detail, and whether individual needs are being taken properly into account. The best advice is not to copy the methods of successful competitors or coaches but to study them, and to apply the lessons learnt to one's own special circumstances.

Nevertheless, experience and research show that there are valuable guidelines which are applicable to all athletes, and that there are frameworks of known efficacy on which successful schedules can be based. Let us turn now to the more general rules that govern successful training and the development of longer-term strategies. Before any plans can be made, some very basic questions must be answered:

1 What types of competition are to be attempted, when, and at what level? Just for fun, part of training, experience of competition – or as major competitive peaks? You may also need to consider very carefully the timing and nature of any trials or selection sessions.

2 What do these target events demand in terms of endurance, speed, technique and experience?

3 What is your present status in relation to the likely demands? It is necessary to evaluate your abilities as objectively as possible, and reference should be made to the later part of this chapter on that topic. For overall performance it may be possible to consider past competitions or to conduct special time trials on the water, whilst the single most revealing land test is likely to be on the ergometer. However, these are blanket measures, and at this initial stage it would be preferable to have separate estimates of endurance capacity, strength and so on in order to highlight both strengths and weaknesses. It is necessary to be realistic in estimating

potential, for a carthorse is never going to win the Derby, even if you call it 'Desert Orchid'! On the other hand, it is essential to be ambitious and to strive for targets that at first seem far away, and with young athletes it is always best to be optimistic and to give them every opportunity to prove themselves. It is worthwhile considering that some of Britain's recent Junior World Champions and medallists would not even have been regarded as suitable for competition rowing in the East German system.

The objectives of training may now be defined.

4 What are the constraints on training time, facilities and equipment, finance? At this stage it is wise to reconsider the types of competition envisaged, and the training objectives that will need to be realized. It is unlikely that any except the very young or inexperienced will make progress on less than three substantial training sessions each week – though these do not all have to be on the water. At higher levels it has been said that prospective Junior Internationals will need a background of at least eight hours per week, whilst their senior counterparts may well be putting in thirty! The ambitious competitor will seek the very best in equipment, facilities and coaching, and if the existing ones cannot be improved then a change of club may be the answer. As demands on training time increase and as individual requirements become more important, so the popularity of the single scull has risen; there is also no doubt that sculling is beneficial to both technique and to physical and psychological training at all levels.

The training programme can now be constructed.

It has already been shown that training for rowing or sculling must have a very sound endurance base, and it must also be recognized that to establish this base will not only require many hours of dedicated training but that in each year such training will take up a major proportion of the time available. As a result the usual pattern for the year in the UK will be as follows:

September to January Preparation phase, general ability – with the emphasis on the development of aerobic endurance (water and/or land training), and the development of strength and power through weight training.

February to April Preparation phase, special ability – increasing quality and emphasis on speed, yet still with the retention of endurance work.

April, May Pre-competition – in particular developing anaerobic capcity, speed and racing techniques.

June to August Competition specific.

As has already been stated, it is best to divide each of these periods into cycles. One week could be a useful cycle but it is often found that two weeks is more satisfactory because it allows more variety, because more obvious improvement will show from one cycle to the next, and because it becomes easier to adopt a system with the heaviest loading in the middle of the cycle leading to an easing off and final testing, trialling or competition on the final weekend. One-week cycles are much more hectic and certainly make it much more difficult to reconcile the demands of training and racing. The pattern of the year's training will then look like fig. 75, sometimes referred to as the 'Lydiard method' after the famous New Zealand coach.

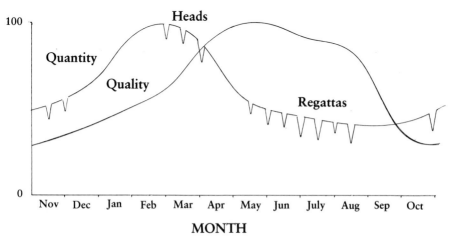

Fig. 75 Typical periodization of the training year.

It remains now to select a variety of suitable training methods to fill these cycles, based on the information in Table 7, and of course depending on the objectives that have been defined, the time available and so on. For most of us it is only possible to absorb very heavy training sessions two or three times a week, and such sessions will need to be followed by those of a less demanding nature for a day or two. If training can be carried out twice a day then it is usually best to make one of the sessions of low to moderate intensity – this will help to improve endurance still further while seeming less stressful. The exception to this can be when the double session comes, say, at the weekend, and can be preceded and followed by less demanding work. Similar arguments apply to combined training in one session, for example of water work followed by weight training for strength. In such a case it will often be found best to carry out the lower-intensity work first.

During each cycle there will be variation in both quantity and quality of work, as has already been discussed, but remembering the concept of progression, these values must increase in each subsequent cycle. In the early stages of training it will usually be found best to emphasize progression in quantity first – thus building up endurance before speed. Early progress is often spectacular, and it may be necessary to revise ideas on rates of increase; nevertheless all increases should be gradual. A different problem often seems to occur after a few weeks of training when progress slows and may even temporarily reverse. To some extent this may be inevitable and simply reflect the smaller gains to be expected as bodily systems adapt, but there may be other physical reasons and coach and athlete must consider what factors might be depressing performance. Psychologically this can be a difficult time and the athlete needs reassurance and perhaps some added variety or a new spur to motivation.

Regular testing and evaluation of progress is essential, and as a result of the evaluation, training objectives can be redefined and the training programme can be suitably modified. A flexible but well-planned approach is most important.

General training tips

- Don't train if you are ill.
- If you have been inactive for some time, start again at a lower level and build up gradually.
- Think before training in bad weather (and consult Chapter 9) – is it worth it?
- Wear appropriate clothing, and keep it clean to minimize skin infections.
- Don't run in unsuitable or worn-out shoes – it is an invitation to injury.
- Good nutrition and lots of sleep are essential adjuncts to training.
- Have plenty to drink before and after you train, and especially in hot weather take water with you and drink frequently. Dehydration is dangerous, and even mild dehydration lowers work capacity and motivation.
- Always warm up thoroughly and stretch well before any training session.
- Always 'wind down' gradually from any piece of work, and remember that active recovery (e.g. jogging or light paddling) is much better than complete rest. Coxes have a duty to ensure that their crews do not stop abruptly after a piece of work, and coaches must choose another time at which to stop the crew for a chat!
- Weight training, particularly with free weights, is potentially

hazardous and must always be overseen by a qualified instructor.

- However intense the work-out, never neglect technique – whether on the water, in the gym or even simply running. Bad technique wastes energy, wastes an opportunity for its improvement, may lead to injury, and bad habits are hard to eradicate.
- Don't be afraid to ease off well before an important competition. Hard training in the week before is too late to improve performance, but the fatigue can be disastrous. If in doubt, do less!

Warming up

It always takes time for our bodies to adjust to increased demands and we cannot perform well until our muscles have become warmer and our heart and breathing rates have increased. Sudden increases in effort before these preparatory changes have occurred will make you feel very breathless and tired and will increase the chances of injury. The warm-up can be carried out on either land or water, but it is advisable to do both before a water training session so that it can also be a form of technical rehearsal. I suggest the following scheme:

1 Jogging or body weight exercises for about 10 minutes until you are warm enough to start sweating and are breathing more rapidly.

2 Work through a series of stretching exercises covering all parts of the body. The principle is to stretch slowly to the beginning of discomfort and then hold the stretch for up to a count of ten before relaxing gently. Performed regularly, these exercises will greatly enhance flexibility and mobility.

3 Boat before you get cold and stiff again, and then spend anything up to half an hour working through a series of progressive technical exercises (see Chapter 2), with the most vigorous ones at the end.

Testing and assessment

Ultimately what really matters is performance in the boat, but as already stated it is important to assess current ability objectively and regularly in various ways as an aid to effective training. The following list of common testing procedures should prove useful:

1 *Circuit training for general endurance* Record times for a known circuit, increase load or repetitions when time is reduced by 25%. To test for ability on specific exercises it is common to see how many repetitions can be completed in one minute, and often half of this can then be taken as a training load.

2 *Weight training for strength* As is shown in Table 7, the maximum weight that can be lifted once (1RM) is a most valuable guide to your personal ability on each type of lift, and the training effect depends upon the percentage of this maximum that is used. It is essential that you are already very competent in lifting techniques and have built up strength and technique for many weeks prior to any such test. I do not believe that such heavy weight testing or training is appropriate for most children under 16, but of course individuals vary in maturity.

3 *Rowing ergometer* The ergometer is a great indicator of potential and usually correlates very well with performance in the boat. For overall performance it is usual to test for distance achieved in a fixed time (e.g. six minutes for GB Juniors), though time for a fixed distance, e.g., 2,500 metres, is also valuable. The ergometer can also be used to test, say, arms only as an indicator of upper body strength.

4 *Time trials* The problem with testing in the boat is that conditions are so important and also so variable. Side-by-side races on a fair course are particularly useful in comparing crews or scullers, and if individuals are swapped from one crew to another (seat racing) then we can get a very good idea of who are the real boat movers. One of the snags with seat racing is that other members of the crew may not be consistent, for some reason, and the ideal system is when everyone thinks they are being assessed and no one knows who is going to be next to change places. For absolute performance either one hopes for still conditions, or trials are timed in both directions and the average is calculated. If the difference is only a few seconds then a straight arithmetical average is reasonable, but if there is a bigger difference then one should calculate speeds and take the mean of those. Winds are a particular problem because a head wind slows you down much more than a tail wind speeds you up; for a rough estimate, take off two-thirds of the time difference rather than just halving it as in more even conditions. Most of us carry out regular training sessions over 500 metres or 1,000 metres, and it is very valuable to keep a good record of the times both as an indicator of progress over the weeks, or even years, and as a guide to probable race time for 2,000 metres.

Illness, injury and safety

A word of warning. Overload training is intended to place the body in a state of stress, and in this condition resistance to infection can be lowered, even more so if the state of overtraining has been reached. Coaches would rather their athletes were not ill and may miss the early warning signs, and many athletes will ignore symptoms because they are so highly motivated to train or

compete. Training whilst infected is not just unwise but can be dangerous, and this applies particularly to viral diseases such as the common cold and 'flu. We have the additional concern of waterborne diseases such as Weil's, and all those who go out on the water must be aware of the hazards and must make sure that their doctors are informed promptly of the circumstances if suspicious symptoms develop.

Frequent hard training naturally places the athlete at risk of injury, and weight training is one of the most frequent causes. Safety precautions must always be rigorously observed and this includes constant attention to the principles of good lifting. Many injuries must be rested if the best chances of recovery are to be obtained, but most athletes and coaches are reluctant to accept this. The only wise solution is to obtain good professional advice, and follow it.

When on the water we must be constantly vigilant as to the danger of collision and must not only keep a good look-out but also ensure that we obey the rules of the river and any other safety regulations in force. Again we tend to be so motivated that we are likely to persuade ourselves that conditions are safe even when they are not. In addition we must never forget that all water sports bring the dangers of hypothermia and drowning. All athletes and coxes must be able to swim well and must know what to do in an emergency. Coxes in particular must be well protected in cold weather. Whatever the type of training, safety considerations must be paramount.

Examples of training schedules

WEIGHT TRAINING

The training shown here was used by the St Edward's, Oxford, senior crews with some success during the 1980s. It is based on endurance work with moderate to light weights on Multigym machines. The reasons for choosing this in preference to, say, heavier free weights were: safety with inexperienced lifters, much less time needed, and better compatibility with other activities and training. Note that the circuit uses a variety of exercises and that the major muscle groups required change from one exercise to the next.

Senior Squad Circuit

- Always stretch and warm up thoroughly first. You should already be sweating before you start the circuit.
- All exercises must be done vigorously but smoothly with good technique, and through a full range of movement. Poor execution means you are wasting your time.

- Weights must always be controlled on descent – no crashing.
- This circuit should be carried out at a continuous fast pace for maximum training effect, move swiftly from one exercise to the next.
- Build up progressively, keeping a record of your progress. Follow this order of progression, taking yourself up to 4×15 as soon as you can.
 1 4 laps × 10 repetitions on all the weights
 2 4 laps × 12
 3 4 laps × 15
 4 4 laps × 15, increasing speed
 5 4 laps × 15, progressive increases in weights

The Circuit

 1 Module 15, exercise 1, shoulder laterals. Keep body still. 12.5 kg
 2 20 high squat jumps.
 3 Module 20, one hand seated row, pulling past side of body. Change hands. 12.5 kg
 4 Station 9, leg press, seat on hole 2. 80 kg
 5 Station 10, wide grip pull down behind head, kneeling. 30 kg
 6 Station 11, vertical row, knees bending, maximum weight movement. 25 kg
 7 Station 12, knee raise to chin.
 8 Station 14, bench press. 40 kg
 9 20 inclined bent-knee sit-ups with twist, hands behind head.
10 Station 21, overgrasp arm curls 25 kg
11 Station 2, squat, thighs horizontal. 50 kg

If you have particular weaknesses then there are many special exercises that can be used – ask the Sports Centre staff for advice and help.

THE ERGOMETER

Training on the ergo has the great advantage that it uses specific rowing muscles and at the same time enables you to improve your co-ordination and technique for rowing. Use it as often as you can, with the emphasis on endurance work. Test yourself regularly over 2,000 metres – colts should be aiming to beat 7 minutes while seniors should be looking for 6.30 or better.

BRITISH JUNIOR WOMEN

This schedule covers the period when the crews were first getting together after very intensive and tiring selection trials and also preparing for the National Championships where it was essential that they did well. After this they went on to the final training camp prior to the World Championships. Note that there is not much intensive work in the first week, but that the weekend before the Nationals is very tough. This, followed by an easier period,

causes 'supercompensation'; that is, an increase in performance on race day.

Training Programme for British Junior Women
Monday 4th July to Sunday 17th July

Great importance must be attached to the development of good crew cohesion and technique, especially in the higher-quality work. The use of video is strongly recommended. Wherever possible a third light technical paddle each day is highly beneficial. All training sessions to be preceded by stretching on land and by thorough warm-up on the water.

Mon 4	i)	Technical paddle 10k
	ii)	16k steady state
Tue 5	i)	Stepped rating. 2 min each at rate, 20, 22, 24, 26, 28, 26, 24, 22, 20
	ii)	Technical paddle, free fartlek, 10k
Wed 6	i)	Fartlek 300 str pyramid, fast $3 \times 10, 2 \times 20, 2 \times 30, 40, 2 \times 30, 2 \times 20, 3 \times 10$
	ii)	3×12 min, rate 4–6 below race rate, 6 min rest
Thu 7	i)	4×4 min race rate, 4, 3, 2 min rest
	ii)	12k low pressure steady state
Fri 8	i)	Technical paddle, practice starts
Sat 9	i)	6×500m rest 3 min
	ii)	$4 \times 1,000$m rest 6 min (first and last pieces standing starts)
Sun 10	i)	$3 \times 1,000$m rest 6 min (standing starts)
	ii)	4×750m rest 4 min
Mon 11	i)	10k steady state
	ii)	Technical paddle
Tue 12	i)	$2–3 \times 7$ min, full pressure, rate 4 below race rate
	ii)	Technical paddle
Wed 13	i)	Free fartlek but include 2×500m, standing start
	ii)	10k steady state, low pressure
Thu 14		Travel, rest and/or light outing
15, 16, 17		National Championships

More advanced ideas in training

In the previous chapter we saw that the body responds to the demands placed upon it so that it will be better able to overcome the same load next time. If we now probe rather more deeply into this mechanism we can learn valuable lessons in how best to structure our training so that we avoid overtraining but get the best results at the right time. There is no magic scientific formula which will turn us into supermen, if not overnight then at least by next Saturday, but an understanding of what the scientists have found about the way in which the body responds will at least point us in the right direction. Furthermore, an understanding of sport science, and particularly its jargon, will enable us to make the most of new findings as they come along and to pick out the parts that are most useful to us.

Response to stress

When our bodies are challenged by an increase in either physical or psychological demands, or both, we react to the challenge and this reaction constitutes *stress*. As a result of the experience of stress the body adapts in response, so that the stress may be met more easily on a future occasion. In our context, training and competition stresses are deliberately used to provoke adaptations that will improve performance in future.

This concept of stress comes from the work of Hans Selye who defined the stress response more precisely as the *general adaptation syndrome* (GAS). This consists of three phases. The first is the *alarm reaction* which results in the liberation of adrenalin and other stress hormones, which in turn increase heart rate, blood pressure, respiration and so on. These represent the normal physiological responses to impending stress, but by themselves will produce little adaptation. The second phase is characterized by *resistance* to the stress; the body is held in a state of readiness to meet the stress. When properly managed this phase is very productive of progress. The third stage is when the level of stress is so severe or maintained for so long that *exhaustion* ensues. This is potentially harmful if the exhaustion becomes chronic.

Stresses of all kinds will produce the GAS. What matters is the total level of stress as the sum of all the stressful influences to which the athlete is subject. It follows that the athlete's whole lifestyle will influence how much specific training stress can be tolerated, and that the well-managed training regime will seek to minimize other less productive stressors. There is no doubt that personal, social or work-induced stress may reduce training capability. Adverse weather, poor diet, disease, and lack of sleep or rest are five other potent stressors which are of great importance in determining ability to respond profitably to training.

In considering those aspects of the GAS specific to athletic training, in the last chapter we distinguished three vital principles which govern the effectiveness of the training; namely, *overload, progression*, and *specificity*.

The principle of overload is that the training load (whether in terms of strength, speed, endurance or any combination of the three) must challenge the athlete's present status. *Significant improvements will only result from significant efforts.* As a result of the overload the body will experience fatigue followed by recovery. Since the body tends to adapt to this stressful experience, the recovery will lead to an enhanced state of fitness. This is known as *over-* or *supercompensation*, after the work of Yakolev (fig. 76). If there is no loading, or underloading, then there will be no need to adapt further – indeed, fitness is lost. This concept is termed *reversibility*, and to a degree the rate of reversion will depend upon the previous frequency and extent of training (fig. 77).

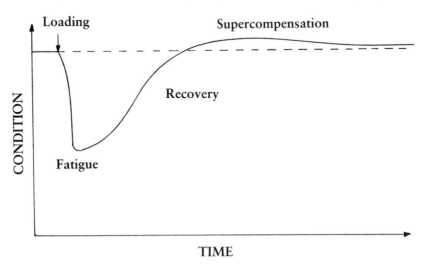

Fig. 76 **The supercompensation curve (after Yakolev), showing how the body recovers to a better level of condition after a training session.**

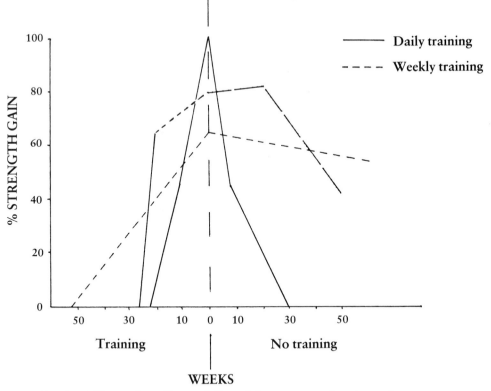

Fig. 77 Effects of weekly or daily training on strength gains or losses.
Daily training brings most rapid improvement but more prolonged training
enables the gains to be retained longer.

It follows that as a result of supercompensation the body will require a slightly greater overload in the next training session (after adaptation) if the same effects are to be maintained. This is what is meant by progression (fig. 78); *continual training at the same level will not bring about continued improvement.* Since loading and recovery are parts of one total process it is essential that the optimum ratio between loading and recovery is sought, and this necessarily raises the question of the appropriate frequency of training. Figure 78a suggests a frequency whereby the new load is applied just when maximum supercompensation occurs, but there are many other possible variations. For example, it can be more effective in some circumstances to adopt a scheme based on incomplete recovery, as shown in fig. 78b, where the extended periods of stress could lead to even greater adaptation. Most training regimes do not allow full recovery between sessions (Brendan Foster once defined an international athlete as 'someone who is always tired'!) – indeed it would be difficult to train even once daily at heavy loads on the basis of full recovery, and more usually full supercompen-

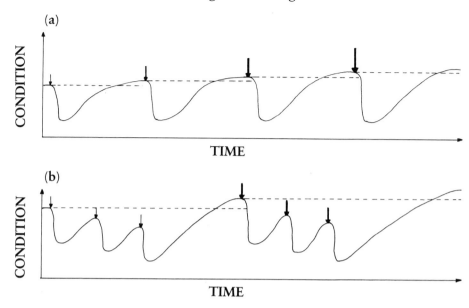

Fig. 78 Progressive overload training based on full recovery and supercompensation before the next session limits the number of training sessions (a). Alternatively, more frequent training can be used with incomplete recovery (b).

sation will be reserved for the day of the competition.

It must be remembered, however, that *rest and recovery are essential parts of the training process* and not just unfortunate human weaknesses. The physiological principle that must not be neglected is that *the body adapts to the stresses of a training session not so much during that session but more in the recovery period after it.* The wrong combination of frequency and loading will lead to a state of chronic fatigue when adaptation may fail and performance suffer. This is *overtraining*.

Overtraining is the result of overstressing either physically or mentally, or a combination of both, and it tends to occur in highly motivated competitors, especially those who are training themselves or whose coaches are enthusiastic but lacking in physiological knowledge. The symptoms are very varied but the commonest are feelings of fatigue and tiring easily which do not disperse with a few days' rest, loss of motivation, and a loss of desire to train and compete. Disturbed sleep patterns and irritability the next day as well as poor appetite and weight loss may all commonly occur. A reliable indicator, particularly in younger athletes, is an increase in resting heart rate of about five beats per minute for no apparent reason – more sophisticated tests will also show increases in

exercise heart rate and blood pressure with slower than usual recovery, and appreciable changes in proportions of hormones.

If you are suffering from overtraining then not only will you suffer from these signs of fatigue and depression but you may also be prey to greater muscle soreness, and more prone to injury and illness, so it is important to receive treatment. The first step is to make sure that there is no underlying medical condition, and then to see if any external factors, such as problems at work or school or poor nutrition, may be aggravating the condition. Complete rest is more effective than just reduction in training, but it may take weeks to return to normal and this can be very hard to accept. Good nutrition and adequate sleep will of course aid recovery, and perhaps a holiday in completely different surroundings would be a good idea if possible.

Lastly we come to the *law of specificity*, which states that the specific adaptations or training effects are a function of the specific nature of the load. Partly this will reflect the intensity of the training stimulus – that is, what percentage of maximum strength, or speed, or endurance is demanded – but it will reflect the nature of the stimulus as well. Thus training for rowing will carry over very well to provide fitness for sculling, but the fit rower may well be unfit for (say) squash where the requirements are rather different. In general terms, extended low-intensity work will develop endurance but not speed or strength, whilst brief bursts of activity with heavy weights will increase maximum strength but have little or no positive effect on endurance. Specificity even extends more precisely to the way in which the body is used, so that for example lifting weights using only the outer range of limb movement will have little effect on strength at more acute angles.

As an example of how a training schedule can be constructed for a specific purpose using the principles outlined above, let us look at the final training camp schedule for the 1988 Great Britain junior team. It must be stressed that this was an outline only which was intended to be modified by coaches of specific crews according to circumstances and individual needs. It was also designed to cater for the needs of a particularly high-quality group of athletes, used to training more than once a day, at a critical stage in their final preparation. I would like to draw attention to some particular points in the make-up of this programme:

1 'Technical paddle' features each day and had two objectives. Firstly the development of technique and rig both for individuals and for the very recently formed composite crews. Secondly, these sessions were intended to provide active recovery from the more vigorous sessions, which is often more effective than complete rest. In such a demanding schedule overall we must make allowance for

recovery, and we must have sessions where the emphasis is all on technique free of other stresses.

2 The effort demanded is not constant but follows the wave principle. There is a progression in quality of effort through the first days to a peak on Friday, followed by a much lighter day on Saturday. The next wave of effort begins to build on Sunday.

3 The last four days had the particular objective of time trials for the development of pace judgement, and crews of similar speed raced side by side while split 250-metre times were carefully noted. The wave principle is observed by starting and finishing with shorter distances and by increasing and then diminishing the total load.

4 Even with the most highly motivated athletes close to a clear final objective, it is desirable to provide plenty of variety – every day here is different.

GB Junior Rowing Team – Outline Training Programme

Tuesday	1	Assemble boats, technical paddle
Wednesday	1	Steady state 16–20 k
	2	Stepped increase in rating, firm paddle
	3	Technical paddle
Thursday	1	4 × 7 min, rate 4–6 below race rate, 6 min rests
	2	Fartlek, e.g. 300-stroke pyramid and practice starts
	3	Technical paddle, include some starts
Friday	1	4 × 4 min, race rate, 4, 3, 2 min rest intervals
	2	Steady state 12–16 k
	3	Technical paddle, include some starts
Saturday	1	Technical paddle, practise starts
	2	Free fartlek, including starts and transition to race pace
Sunday	1	3 (2 × 500 m)
	2	Technical paddle
Monday	1	2 (2 × 1000 m)
	2	Steady state 10–12 k
	3	Technical paddle

Tuesday 1 2 × 1,000 m
 2 2 × 750 m
 3 Technical paddle

Wednesday 1 Free fartlek
 2 4 × 500 m
 3 Technical paddle

Respiration – energy for action

Exercise brings about a fall in blood pH (it becomes more acid) as first carbon dioxide and later lactic acid diffuse into the blood from the muscles. These changes cause an increase in breathing rate and depth – that is, ventilation of the lungs (V_E), as illustrated in fig. 79 – and increased blood flow through the lungs as well as to the muscles. In steady-state exercise of a predominantly aerobic nature (a small lactate production), V_E will stabilize after a few minutes. Table 8 shows some typical changes in breathed air. Clearly, during the rowing effort, changes take place which enable a great deal more oxygen to be utilized and exchanged for waste carbon dioxide.

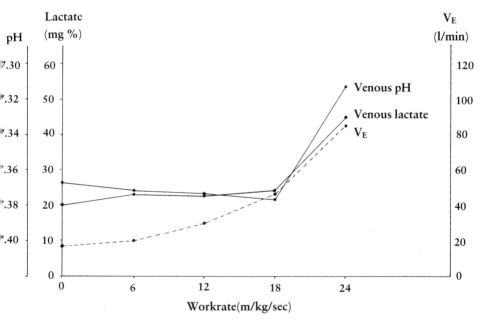

Fig. 79 With increased effort the rate and depth of breathing (V_E) increased. Beyond a critical level of effort there will be a sudden increase in lactic acid and this will increase breathing even more.

Table 8
Effects of exercise on composition of breathed air

	Unbreathed air %	Air breathed out at rest %	Air breathed out while rowing %
Oxygen	21	17	12
Carbon dioxide	0.04	4	9
Water vapour	variable	saturated	saturated

Once the anaerobic contribution to total power output exceeds about 10% then there will be substantial increase in both lactate and V_E. The highest level of exercise intensity that can be sustained without a further increase in lactate, and hence without a further rise in V_E, has been given various names, but the most generally accepted is the *anaerobic threshold (AT)*. The values for AT are usually very high in rowers and scullers but may be even higher in more endurance-oriented sports. Above the AT there is a marked rise in V_E as well as in subjective feelings of distress brought on by the pH changes – an experienced competitor can sense the threshold and adjust effort accordingly. It has been found that the AT occurs at a blood lactate concentration of about 4.0 m mol/l. A work intensity that causes no increase in lactate above the basal level has been called the *aerobic threshold*; this would be at a lactate concentration of about 2.0 m mol/l. and less than 60% of maximal oxygen uptake. Lactate concentrations are not difficult to measure and require only a drop of blood, often from the ear lobe. Many sportsmen now use this test regularly in training as a guide to training intensity.

Figure 80 shows the way in which oxygen uptake increases with workload – almost linearly at first, then curving to a plateau which represents maximal oxygen uptake for that individual (VO_2 max.). Values differ greatly between individuals and can be expressed either as absolute oxygen uptake (l/min), or in relation to body weight (ml/kg/min). Since aerobic power is so important to rowers and scullers and they are often very large people, it is not surprising that our sport has recorded some of the largest absolute values exceeding 8 l/min. VO_2 max. reflects the capacity of the whole oxygen transport and utilization system – including uptake from the lungs, transport by the blood and unloading and use in the active tissues. There is a fundamental relationship between VO_2 max. and the endurance requirements of different sports, and even more particularly between trained and untrained people. However, if we examine similar performers in any one sport there

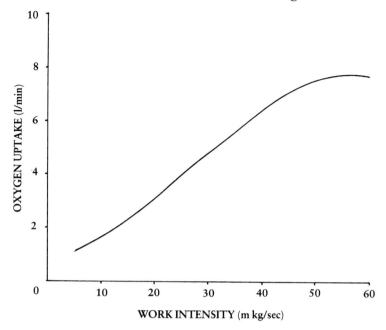

Fig. 80 Oxygen uptake increases up to a maximum with increased workload.

is no correlation to be found; in our sport a high value for VO_2 max. is a prerequisite for success, but small differences between individuals in that capacity tell us nothing about probable performance. Often maximum oxygen uptake will show dramatic rises as untrained people improve their endurance, but this is clearly not the whole story. Values of VO_2 max. recorded in champion endurance athletes have changed little in the past thirty years, yet performances have certainly improved. It is probable that modern intensive training gives better oxygen utilization by the muscles and that the force-time characteristics of the muscles are superior. This means that the athletes are faster and more powerful for much the same oxygen consumption. It has also been found that well-trained competitors continue to improve their performances with further training despite no further increase in their oxygen uptake.

About 80% of the ultimate capacity seems to be inherited, although some individuals seem also to have inherited an exceptional ability to raise their VO_2 max. by training. Training commonly increases the value by up to 20–30% but in a few cases improvements of 80–100% have been recorded. All the foregoing applies equally to men and women, yet it is clear that women have substantially smaller oxygen uptake capacities. This seems reasonable in view of their smaller lungs and lower blood volumes,

but there is another factor – the different amounts of body fat. If the values for VO_2 max. are related to lean muscle mass (not just bodyweight), then there is little difference between men and women.

In both training and competition a major factor to be considered must be the fraction of the (aerobic) oxygen uptake capacity which can be utilized before anaerobic metabolism plays a major role. In other words, at what percentage of VO_2 max. does the individual reach anaerobic threshold? This figure is very important in sustained high performance because a high value will enable the athlete to maintain a high work rate for long periods without lactate accumulation. For untrained people, continuous work at about 60% of their (low) VO_2 max. will be about their limit, whilst for trained athletes 80% of VO_2 max. would be common. Some individuals with exceptional speed-endurance abilities, such as the best marathon runners, will be able to use well over 90% of their (already high) VO_2 max. before they reach their AT. This is less likely to be found in rowing because a significant proportion of training and of power production in 2,000-metre competition must be anaerobic. Training at an intensity close to the AT (that is, lactate levels of 4.0 mmol/l), has been shown to produce larger increases in percentage utilization of VO_2 max. than in VO_2 max. itself – though both figures were improved substantially in previously untrained subjects.

The basis of anaerobic work has already been discussed in Chapter 6; its relevance here is its specific relation to aerobic metabolism in rowing performance. Maximum performance is gained by the addition of anaerobic power to that from aerobic respiration. If we refer again to fig. 73 (page 125), we see that the establishment of full aerobic power takes about two minutes in a 2,000-metre race. Up till then two anaerobic systems provide a larger proportion of the total energy needs of the muscles. The proportion of the total energy that cannot be provided aerobically is an oxygen deficit that must be repaid later as an oxygen debt. Anaerobic system II (glycolysis) is the one that produces lactate, and too much dependance on it will of course have a detrimental effect on the athlete.

The need, then, is for an aerobic system with great capacity which will reach a high level of energy production quickly and thus minimize lactate production early in the race. If the high aerobic energy generation can be maintained through the middle minutes of a race then the bulk of the energy needs will be met without excessive acidosis and fatigue – this will require a very high VO_2 max., high AT, and high percentage utilization. In the final minute or so of the race the contribution of both anaerobic systems can again increase, but although total energy supply

increases, the aerobic part will fall. This is because of biochemical interactions and also because nervous stimulation to the glycolytic fibres increases.

It is unusual to take special steps to strengthen the mechanism of breathing – that usually looks after itself as a result of training for other purposes. It is important, however, to appreciate the importance of good posture in ventilatory efficiency. A slumped position with folded abdomen, depressed ribcage and rounded back will reduce lung capacity appreciably as well as hindering the diaphragm and rib muscles in their movements. A few deep breaths before the start has a calming effect and can help to ensure that lungs are optimally charged with oxygen and low in carbon dioxide. Deliberate hyperventilation (overbreathing) is to be avoided because the lowered blood carbon dioxide levels can affect the brain and cause dizziness, tingling and cramp in the fingers, as well as a sense of panic. Warming up thoroughly before training or competition is important, for it brings about broncho-dilation and increased blood flow together with increased activation of the respiratory centre. This means that ventilation can adjust more rapidly and the 'second wind' phenomenon is reduced. During the effort of rowing or sculling there is a tendency to 'press'; that is, to hold the breath. This is common in weight training as well, and apart from the interruption to ventilation, high pressure builds up in the thorax. You should learn during training how to breathe freely and how best to fit the breathing rhythm with that of the stroke. There are also many good competitors who forget to breathe during the start!

The circulatory system

During a hard rowing effort the heart rate, and stroke volume (volume of blood pumped at each beat) will both increase so that total cardiac output rises from about 6 l/min at rest to over 30 l/min. Typical results from a group of oarsmen are shown in fig. 81. As the pH of the blood falls and exhaustion sets in, a maximal heart rate of about 200 beats/min is reached, with maximal stroke volume of 160–180 ml usually achieved at about 160 beats/min. Work at this exhausting level will be in excess of the AT and therefore large amounts of lactate will be accumulating. Responding to the pH change and the higher ratio of CO_2 to O_2 detected in the arteries, the brain will dilate blood vessels in the muscles and constrict some elsewhere (such as the gut) so that the flow of blood to the muscles will be enormously increased. Core body temperatures rise by several degrees during hard rowing or sculling and as a result much more blood flows to the skin, perhaps at the expense of total blood available to the

muscles.

All these adjustments take time, and particularly in the first minute of a race or demanding piece of training the ability of the circulation to supply the body's aerobic needs will lag behind the

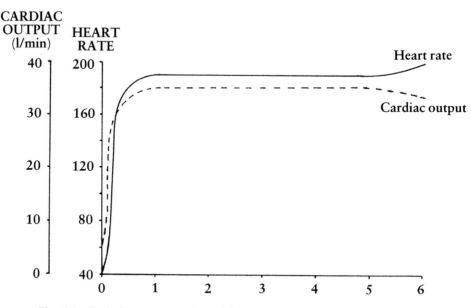

Fig. 81 Both heart rate and total heart output increase rapidly at the beginning of a race and then stabilize at a high level. When the rate goes up again in the final sprint there may not be time for the heart to fill completely, so output falls.

muscles' energy use. Consequently, carbon dioxide and lactate will tend to accumulate and lead to feelings of distress which then lessen as the improved circulation clears away these waste products and brings more oxygen. This is the 'second wind', and since many of the responses can be invoked in advance it is clear that a thorough warm-up is essential and will reduce the second wind effect.

During the recovery after the effort the heart rate will fall very rapidly at first, yet the various factors described earlier have hardly had time to change; pH is still low, lactate is high, CO_2 is high, and so on. The reduction in rate is so rapid that it must be largely due to changes in stimulation of the heart by the nerves, originating from centres in the brain higher than the fully automatic cardiovascular centres. The feeling of relief at the end of an effort may well be associated with this phenomenon. The converse is also true – apprehension before the start causes sympathetic stimulation of the heart and adrenal glands and other well-known symptoms including high heart rate.

After a minute or two the pulse recovery will slow and the heart rate will often level off before slowly declining again (fig. 82). Here we are seeing the true signs of metabolic recovery. After a brief and not too exhausting piece of work the heart may be back to its resting level within about five minutes, but more extensive effort will require much more recovery time and the raised metabolic rate may demand more from the heart for many hours. Several fitness tests (most notably the Harvard Step Test) rely on measures of heart rate recovery after exercise as indices of fitness, but such tests seem to work best with less highly trained or even untrained people and they are not designed for testing recovery from maximal effort.

Endurance training has beneficial effects on the circulatory

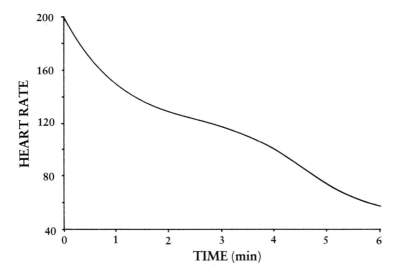

Fig. 82 A typical heart rate recovery curve after a hard but not exhausting effort.

system. Substantial intermittent or continuous efforts with large muscle groups lasting more than one hour, will give the greatest enlargement of the heart and will also improve muscle capillarization very substantially. Reference to the training information in the previous chapter will show that such training will also have very important effects on muscle endurance and VO_2 max. Other types of training, for example weight training for strength, will certainly raise the heart rate repeatedly but do not have the same training effects on the heart or vessels.

As we have already seen, where possible training loads should be related to the athlete's aerobic capacity and anaerobic threshold, but in practice these may not be easy or convenient to

measure. Fortunately there is usually a good relationship between heart rate in extensive exercise and the VO_2 max., and it is easy to monitor heart rates and use these as an objective guide in training. Taking the pulse at wrist or throat is simple but can be very inaccurate at high rates as well as impractical in motion. A number of devices are available which purport to measure the pulse during exercise, but many of them are very unreliable and need to be tested carefully. The best by far are those that rely on detecting electrical signals from the heart via chest electrodes, and in some designs the signals can be transmitted to a remote receiver and processed by computer. Figure 83 charts the heart responses obtained in this way of a junior international rower during a particularly demanding training session.

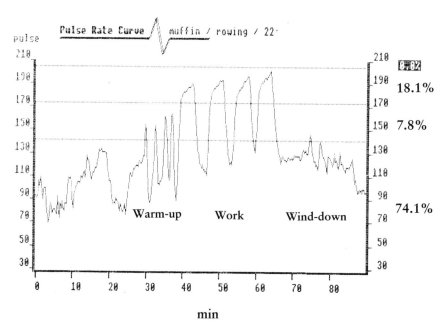

Fig. 83 The result of continuous monitoring of the heart rate during a training outing when the work was four four-minute rows with diminishing rest intervals. The dotted lines across the graph are estimates of (from top) maximum heart rate, anaerobic threshold, and training threshold.

As a useful rule of thumb, the pulse rate range that will give a good training effect in continuous work will be 150–180 beats/min; but the duration of the work will need to exceed 30 min at least three times a week if any progress is to be maintained with fit athletes. In the absence of more precise estimates of VO_2 max. and AT, the following calculation is commonly quoted for the minimum heart rate for any training effect:

Maximum heart rate (MHR) $=$ 220 – age in years
Heart rate reserve (HRR) $=$ MHR – resting HR
Effective training threshold $=$ 60% HRR + resting HR

Example: a 25-year-old with a resting pulse of 45 beats/min
MHR $= 220 - 25 = 195$

HRR $= 195 - 45 = 150$
Training threshold $= 150 \times \frac{60}{1000} + 45 = 90 + 45 = 135$ beats/min

In intermittent training, especially with weights, the heart rate may be higher than the oxygen uptake would seem to justify. In one study the HR was 155 beats/min but no endurance training occurred because oxygen uptake under these conditions was only 45% VO_2 max. It is thought that in such cases the HR is elevated by extra hormonal influences and disproportionate lactate production.

True interval training was developed in the 1930s by Gerschler and Reindell specifically as a heart and circulation training method. They found that repeated fast but sub-maximal runs of about 200 metres which raised the heart rate to 180 beats/min interspersed with recovery periods which allowed the rate to fall to 120 beats/min, had the greatest effect on the heart. It seems that the heart is expanded as a result of maximal stroke volume occurring during the recovery period. Karl Adam adapted these methods for rowing and showed that 500 metres, or 10% more for fast eights, was the optimal distance – repeated six times – and that a rest interval of 2–3 minutes would bring the pulse down to 120 bpm. Subsequently in both running and rowing the New Zealand coach Lydiard had much influence with his successful advocation of high continuous mileage as a long-term foundation for the shorter, faster repetitions nearer the time of competition.

Adaptations built up by more extensive work may be slower to show fruit, but do seem to be more durable and more effective in altering muscle capillarization and metabolism. There was a time when 'Long Slow Distance' (LSD) was the favoured method, but better results are likely from a judicious mix and periodization of extensive (but still high-quality) work, and faster, shorter, repeated pieces. Valuable though endurance training is for both rowing and sculling, it must be carefully balanced against the need for speed and some anaerobic power. The danger lies in turning the athlete into an 'endurance stereotype' – at an extreme we can imagine an athlete who trains solely by LSD on the water and slow, heavy, weight strength training in the gym, and who would be virtually untrained for a fast 2,000-metre race!

Causes of fatigue

It is commonly assumed that the major cause of all muscle fatigue is lactic acid. The truth is that there are several types of fatigue with several causes which are of importance, although the major specific cause of fatigue in a 2,000-metre race is indeed the effect of lactic acid. Other, lesser, causes of the sensation and reality of fatigue are significant during a race, but less specific fatigue factors will be encountered in relation to prolonged or repeated training, preparation and peaking for races, and in recovery between races. Some of the causes and effects of fatigue take a long time to disperse and tend to be cumulative, but a knowledge of them can help to minimize them. In longer-distance races, say up to about 20 minutes, lactic acid will still be the principal fatigue limit to performance – although the few very long races, such as the Boston Marathon, will create rather different problems. In the list of causes below it will be seen that some are specific to muscle, whilst others affect different tissues or are more widespread through the body. Minimization of the causes of fatigue is also dealt with here and is explored in more detail where relevant in the last two chapters.

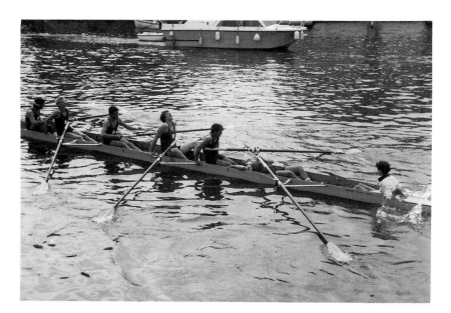

Fig. 84 Exhaustion at the end of a very hard race. St Edward's win the Princess Elizabeth at Henley in 1984. Photo by Chris Morgan.

LACTIC ACID

The problem with lactic acid is not that it is a specific poison, but that it is an acid. Any acid will have similar effects and this includes the carbonic acid formed when carbon dioxide dissolves in water. Acids release positively charged particles called protons (H^+) which will combine with negatively charged substances known as bases. A scale of values known as the pH number shows the concentration of H^+ in solution – 7 is neutral, higher numbers indicate bases (alkaline) and lower numbers indicate increasing acidity. Much of the harmful fatigue-inducing effect of acids such as lactic acid is that the protons they produce interfere with muscle chemistry. We have seen that lactic acid is the product of anaerobic respiration in the muscle fibre, so intense effort that recruits a high proportion of fast twitch (anaerobic) fibres will cause a rapid rise in acidity and rapid fatigue in those fibres. The acid diffuses into the tissue fluid and then has a deleterious effect on the muscle as a whole, before passing into the bloodstream and having more widespread effects. Improved blood circulation in the muscle as a result of training will help to remove lactate more rapidly.

Rowing and sculling uses large muscle groups very extensively, and champion rowers have been shown to have about 30% fast twitch fibres, so there is the potential for considerable lactate production. The 70 kg body contains about 47.5 litres of fluid, so the overall change in lactate and pH does not seem very much (Table 9), but it is critical. The effects of the acid are reduced by the presence in both muscle and blood of buffers; that is, bases such as hydrogen carbonates which can 'mop up' excess protons. The buffers in muscle can deal with maximum lactate production for only about 10–15 sec, but there is a larger reserve in the blood. Clearly it is advantageous to maximize aerobic energy production and to delay the highest lactate levels in a race until the end.

Table 9
Change in lactate and pH during rowing competition

	Resting	500m	2000m	40,000m
Blood lactate (mmol/l)	0.7–1.8	30–34	20	6–12
Blood pH	7.35–7.45	6.8–6.9	7.0	7.15–7.25

Racedistance

The tactics that will help in this are discussed in Chapter 8, whilst the methods and rationale for improving oxygen supply have already been given. As far as the muscles themselves are concerned, the training needs to emphasize the development of the oxygen-using fibres, but so crucial is the contribution of anaerobic power to a fast pace that its parallel development must not be neglected. Experience of work under high lactate levels is not only an essential stimulus to the development of biochemical processes to alleviate its effects, but is also important in improving co-ordination under this stress. Acidosis is painful and disturbing, so repeatedly overcoming its baleful effects during training is also most important from a psychological point of view.

We have seen that high lactate levels take a long time to disperse and therefore anaerobic training should be curtailed immediately prior to competition. The wise competitor will also attempt to use minimal lactate tactics in preliminary races by maintaining a steady pace and avoiding a sprint finish. Winding down after a training effort or race is also important, for it helps to maintain blood flow and tissue fluid exchange in the muscles and hence flushes out acid residues more quickly.

GLYCOGEN

For most race distances except the very long ones, the primary fuel for muscle contraction will be glucose, despite the ability of the fibres that form the majority in the rower's muscles to use fatty acids as well. Glucose comes from glycogen (a larger storage molecule made up from glucose sub-units) stored as granules in the muscle fibres. An untrained person would store about 300 g of glycogen in the muscles and a further 100 g in the liver; a well-trained and rested rower might have more than 600 g in the muscles. Blood glucose (blood sugar) contributes little to muscle contraction in the early stages of exercise or in a short race; indeed there are mechanisms to ensure that it does not, for it must be spared as the essential fuel for the brain and nervous system. Although blood sugar does fall during prolonged hard exercise, this is not an important cause of muscle fatigue in our races, but it may well affect the overall sensation of fatigue (fig. 85). It follows that attempts to boost blood sugar before training or competition by eating or drinking glucose will have little or no effect on the muscles, and as explained in Chapter 9 may even be deleterious to performance.

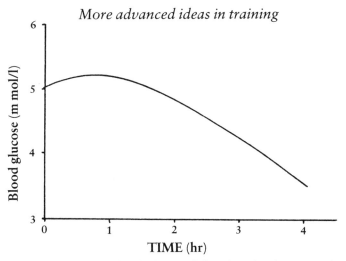

Fig. 85 Blood glucose levels do not fall unless the duration of a mild effort is greater than one hour.

The stores of muscle glycogen are likely to be adequate for all but the longest races, and exhaustion of glycogen is most unlikely to be the cause of fatigue in the few minutes of a 2000-metre race, but high initial levels of glycogen do help in biasing muscle chemistry towards maximum rate of energy production. Fatigue from this source can be very important, however, in long races or in prolonged training sessions, for in those cases the body will tend to utilize more fat, putting more emphasis on the slow twitch (aerobic) fibres and increasing oxygen requirements as well. Once the glycogen stores are used up, say after one to two hours, sustained performance can only be at a very much reduced level.

It should be remembered that anaerobic respiration uses glucose (and hence glycogen) very rapidly to produce a small yield of energy, and that the lactate formed will only slowly be reconverted. Thus intense efforts will deplete glycogen reserves much more rapidly. Even lower-intensity sustained effort will deplete stores significantly and it is important to appreciate that replenishment from the diet is slow. Although dietary adjustments are helpful (see Chapter 9), it is likely that repeated hard training will keep glycogen stores low and will lead at least to poor fatigue resistance. Rest, and recovery of glycogen levels, is therefore vital before important competition. Glycogen is stored with extra water, and very large stores will give a sensation of stiffness in the muscles as well as adding extra weight – the full business of 'carbohydrate loading' is therefore rarely desirable in rowing.

Most people find that strong coffee reduces general fatigue and this is partly due to effects on muscle metabolism. Caffeine not only combats the sensation of fatigue through its effects on the nervous system but it also affects fat metabolism – releasing fatty

acids into the bloodstream and encouraging their use by the muscle. Whilst this may be useful in long-term low-level endurance, and spares glycogen, it is not what is required for high-speed rowing. In any case, large amounts of caffeine have undesirable side effects and it is on the list of banned drugs.

ELECTROLYTES

During exercise, water and minerals are lost in sweat and water is lost through breathing. Sweat is much more dilute than blood plasma so the major loss is water (see Chapter 9). Surprisingly, the concentration of the body fluids changes little and this is particularly important in the cases of sodium, potassium, calcium and magnesium, which are excreted in sweat and are essential for the muscle contraction mechanism. They will have to be replaced from the diet after the exercise. During hard efforts these ions are lost from the muscle into the tissue fluid and blood. Significant losses or imbalances of these ions lead to fatigue and cramp and if not corrected in the diet will cause poor fatigue resistance at least (see Chapter 9).

Phosphates are essential in transferring energy to the contracting muscle proteins, and in some types of fatigue phosphate leaks out of the muscle and into the tissue fluid and blood. In the laboratory, bathing the fatigued muscle cells in phosphate does restore them. It has been found that drinking phosphate solution before training helps performance, but this is thought to be due to enhanced oxygen carriage by the blood. The long-term effects of such a procedure are not yet known so it might be unwise to experiment.

NERVOUS SYSTEM

At the nerve/muscle junction a transmitter chemical is released to cause changes in the fibre which then trigger the sequence of events leading to contraction. Numerous reports over the years suggest that at intense work loads this communication system may fail, and then the muscle will not contract optimally.

As muscles fibres become fatigued, from whatever cause, then the number recruited at any one time will rise from the usual 30% to 70% or more. This means that each muscle motor unit gains less rest and therefore fatigue increases rapidly. At this stage the electrical activity in the muscle becomes intense, causing marked tremor before final collapse.

The brain uses a large number of neurotransmitters, some of which are responsible for sensations of pain, fatigue and wakefulness. Many neurotransmitters are related to amino acids in the blood, and it may be significant that proportions of these change as exercise proceeds and fatigue sets in. It is reported that

when rats are exercised to exhaustion on a treadmill, and then their blood is injected into fresh rats, the fresh ones fall asleep! It may be that diet can help in reducing these effects; it is certain that drugs can modify the normal response.

TEMPERATURE

An active muscle produces a lot of heat and quite quickly warms up by 2–3°C or more at its centre with beneficial effects. The viscosity of the muscle is reduced, so making it easier to move, the transference of oxygen is more thorough, and enzymes are speeded up. There is no doubt that warm muscles are more efficient – as much as 40% more – but if temperatures rise further the enzymes and other proteins will be adversely affected. Thus high internal temperature can be a cause of muscle fatigue. Further effects of heat and their avoidance are discussed in Chapter 9.

VITAMINS

Some vitamins are essential in energy production. For example, B complex vitamins are involved in aerobic respiration chemistry within the muscle cell (as elsewhere). It is unlikely that race fatigue will be due to the depletion of these during the race, but if the athlete is deficient in them beforehand then early fatigue is probable. This subject is discussed more fully in relation to diet in Chapter 9.

Training for strength and power

Strength is the muscles' ability to exert force and overcome a resistance, whereas power incorporates the speed of the work done. The two attributes seem to be related, especially in the work of rowing where the ability of the muscles to overcome the resistance quickly is likely to be a function of the strength available. However, in practice it is found that power and absolute strength are not very closely correlated and require different training regimes having different effects on the muscles. This power should be distinguished from speed *per se*, which is a rather different quality with somewhat different origins.

The strength of a muscle is ultimately dependent on the size and number of fibres, and their nature – fast twitch being the stronger. Roughly, the strength of a muscle is dependent on its cross-sectional area, giving a force of 3–4 kg/cm². But the strength achieved must also depend on the number of these contractile units actually recruited, and that is the province of the nervous supply and activation. Both aspects are susceptible to training.

After a course of specific strength-training the muscle will be larger in cross-section – this is *hypertrophy*. Some of the hypertrophy is the result of increases in non-contractile elements such as blood vessels but primarily it comes from the increase in size of the muscle fibres – *not* from any increase in their number. In untrained subjects the increase in cross-sectional area occurs in the later weeks or months of a strength training programme when heavier weights are being tackled, and is very marked; it is less obvious in those with a considerable training background. In the early stages of both strength and power training, especially with previously untrained subjects, there is a very rapid increase in force without any appreciable increase in muscle size. This is due to improvement in the nervous control of strength; that is, there is a reserve of strength which can be mobilized by appropriate training.

The specificity of the training regimen is vital. Élite weight lifters, who are undoubtedly stronger, do not have as great a muscle mass as élite body builders. Power training, with the emphasis on explosive, fast movements, even with quite heavy resistance, may not lead to any great hypertrophy at all (fig. 86). The essential requirement for hypertrophy is that the training load

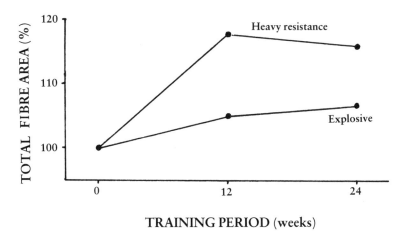

Fig. 86 Muscle hypertrophy depends on the type of training.

is maximal or near to it and that the stimulus is lengthy. This implies very heavy resistance training at slow speeds. Development of maximal strength follows the same rules of specificity i.e. a load of between 80 and 100% of the current maximum for a single lift (1RM) and lifted steadily rather than explosively. Such a load will probably limit repetitions to between one and five per set. Prolonged training of this nature will produce little additional gain

in strength and will tend to reduce ability to overcome the resistance quickly. For rowing it would be better to use loads that allow five to ten fast repetitions in each of three to five sets. It is usual in strength training to allow generous rest between sets, but some very successful clubs use a much more intense system with limited rest. This will give strength endurance benefits, but there are dangers in trying to work fast with heavy loads when fatigued.

Power training improves maximum strength as well as primarily developing the force–velocity abilities of the muscle. It is debatable how useful maximum-strength training is for rowing, for it would seem that more dynamic methods are more appropriate for the specific needs of our sport. It is worth noting that dynamic training will increase muscle power without a corresponding increase in muscle mass and body-weight. In addition, the further point of specificity must be remembered, in that the gains will be restricted to the range of movements used. The training regime must cover the full range of limb movement used in rowing or sculling. Most isometric training methods will clearly be of little value. Since, for biomechanical reasons as well as for reasons to do with the force–length relations of muscle, maximal force varies with limb position, various isokinetic machines have been developed. These may have specific advantages in improving weaknesses at particular joint angles, but we need to be wary of any training that does not resemble the rowing action.

Although there are as yet few hard facts to rely on, there is much debate as to the relative merits of free weights (on bars, for example) and resistance training machines. It is unlikely that resistance provided by springs or elastic will be generally useful for our purposes because of the way in which the resistance increases with extension, though it may have some particular value in strengthening that part of the range of movement. Most machines use weights lifted against gravity by levers, wires and pulleys, or by more unusually shaped devices to give a more complex effect. It is commonly said that a free weight movement, such as the power-clean, is particularly valuable because it involves a co-ordinated use of many muscle groups, including those for balance. It is questionable whether such 'Olympic' lifts really are close enough to the rowing action, but they are difficult to mimic with most forms of apparatus. One of the snags with such lifts is that they do reward skill, and for many non-specialist lifters this skill is the true limit to their performance (especially for 1RM) and they may not be training at optimum muscle tension. Machines do not require so much skill and have the advantage that training can be targeted more precisely to particular muscle groups. There is no doubt that weight training on machines is potentially much safer, and this alone must be a major consideration.

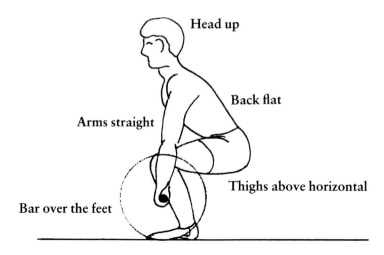

Head up

Back flat

Arms straight

Thighs above horizontal

Bar over the feet

Fig. 87 The power clean is a very valuable lift, but a good starting position and good co-ordination is essential for safety and effectiveness.

The free weight lifts that are most commonly used for rowing are the following:

The power-clean – lifting the bar from the floor to the clean position at the shoulders in one movement, a very useful exercise for the legs, trunk, shoulders and arms, and good for co-ordination (fig. 87).

The clean and jerk – the bar is thrust above the head after a pause in the clean position. This gives added work on the shoulders but can also cause trouble with hyperextension and loading of the spine.

The snatch – lifting the bar from the floor to above the head in one swift movement. It is exhilarating and requires speed and co-ordination.

Bench pull – a good exercise for the arms and shoulders which protects the back because the rest of the body is supported by lying on a horizontal bench.

The squat – either a half squat or a deep squat, in both cases with the bar across the shoulders or in the clean position. Although good for the thigh muscles, there are concerns about the load on the knees, especially with the deep squat, and it would be better to use a leg press machine if possible.

There are obvious dangers in using any form of heavy-resistance training with the growing child, and these are discussed more specifically in Chapter 6.

Training for endurance

In rowing and sculling there is a requirement for endurance of both aerobic and anaerobic systems simultaneously, and this presents a particular challenge in training. General endurance – the ability to withstand a low workload for a very long time – is of limited value in our sport, and specific training with that end solely in mind seems a waste of time. Higher-quality work will in fact be more productive of useful general endurance anyway. What is needed is improvement in power endurance, and the specificity rules show that the speed, force and duration of the training work need to be progressively matched to requirements.

There are some typical muscular changes as a result of endurance training, such as increases in capillaries, mitochondria and glycogen stores, which improve muscular endurance. There is a good correlation between these muscle factors and the standard measure of whole body aerobic capacity known as VO_2 max. Training that increases VO_2 max. will therefore increase the endurance capacity of the muscle, but it is also important to note that muscle endurance capacity can still be improved even with no further increase in VO_2 max., as shown earlier.

Training for co-ordination

Most of the problems of co-ordination in rowing and sculling are the business of the nervous system, but there are some muscle factors involved as well which are amenable to training and can be considered briefly here. The rowing and sculling actions require the precisely controlled contractions and relaxations of a very large number of muscles as well as the correct patterns of recruitment of motor units within those muscles. For optimum co-ordination the force, range and speed of all the contractions should be trained to the requirements of the racing stroke. This is difficult to achieve on land but it implies selecting those exercises that most closely resemble parts of the stroke, and also performing them in the most realistic way. Resistance training methods are often suspect on this score and such programmes commonly neglect the antagonistic muscles which must also be trained to extend in the optimal way.

Muscle fatigue can have important consequences for co-ordination because not all the rowing muscles will fatigue to the same extent simultaneously. The usual result is weird compensatory movements. Although it is necessary sometimes to train to the point of extreme fatigue, it is very important to strive always to maintain correct technique – thus the training will be most effective and bad habits will not become established. Muscle

soreness and stiffness, often resulting from heavy-resistance training, will inevitably affect co-ordination and in frequent training it will be important to warm up and stretch thoroughly to disperse the stiffness.

The rowing or sculling action has to be learnt, and although it is based upon pre-existing reflexes and motor pathways, they have to be modified, co-ordinated, and overlaid with more voluntary actions. Repetition of the actions over a long period tends to make them more automatic. This learning process is very much dependent upon the alteration or conditioning of reflexes, so that they become conditional reflexes. Many of the repetitive movements will be controlled more or less automatically this way, but there are still many ways in which the basic technique must be responsive to change. For example, rowing in rough water may require a changed hand height, or gusts of wind may present novel balance problems. At first the response will involve much conscious activity, but with experience the modified reflexes are brought into play much more rapidly and smoothly. After long-term training there are adaptations to the memory system even in the spinal cord. The cautionary part of this is that wrong movements can be learnt just as easily – and they can be very difficult indeed to eradicate once they have become well established.

Training for speed

The speed of muscle contraction required in rowing is not very high when compared with many other sports, and this is inevitable because the emphasis is on endurance and power. At the risk of repetition, the specificity of training will only allow the speed to be optimized for rowing if the training is carried out at a relevant speed. We have already seen that in heavy-resistance training there is a good case for emphasizing speed so that power rather than just maximal strength is developed. Increased speed of a boat through the water is largely achieved by increases in power, but if specific muscle speed enhancing exercises are required, the principle to be adhered to is low-load, high-speed, training.

Training for flexibility

Modern technique requires a large range of movement, which should be attainable without strain and without stiffness. It is commonly believed that heavy-resistance training in particular will limit such flexibility ('muscle-bound'), but this is not true in our sport even though it might be for some very hypertrophic body-builders. It has already been stated for other reasons that

muscle training should be over the whole range of movement and this will clearly aid mobility.

Specifically, each training session should be preceded by a general warm-up of at least 10 minutes, followed by stretching exercises of progressive amplitude, and if you are not training daily you should at least run through a stretching routine every day. 'Warming down' after a training session, perhaps even with further stretching exercises, is valuable in helping recovery and in minimizing subsequent stiffness.

Motivation

Training hard enough and long enough to be successful in this demanding sport is not easy, and inevitably there will be times when it does not seem to be working or no longer seems to be worth the effort and sacrifices. This is the time to remind yourself of your goals and ambitions and to think about the ultimate rewards. Keep a training diary and look back over the progress already made, and make sure that you have realistic targets always in view. Perhaps the greatest encouragement is a successful racing programme, and this aspect is dealt with more fully in the next chapter. It is particularly hard to cope with the tough times if you are on your own, and without a doubt the support and encouragement of a knowledgeable coach is of immense value. It matters too that your family and friends, school or colleagues are supportive, but if not, the best answer to your critics is to be determined to show them that they are wrong.

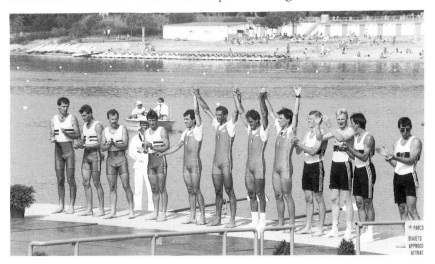

Fig. 88 The Italian lightweight four celebrate their victory in front of their home crowd at the World Championships in Milan. Motivation enough?

CHAPTER 8

Racing

One of the great joys of our sport is that we can pit our skills and strength against all-comers in competitions of several sorts, and that the sport is organized in such a way that we can compete fairly against others of a similar standard and yet still be part of a continuum stretching up to international level. Even if we are very fit and skilful in the boat, there is no doubt that getting the best out of ourselves when it matters in a race is an additional skill which needs to be practised and learnt. We should choose our races with care, prepare for them thoroughly, and make sure that everything is right on the day.

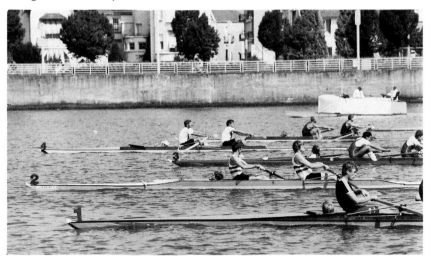

Fig. 89 600 metres into the final of the Junior World Championships at Vichy and the coxed pairs are jockeying for position.

Deciding on a competition programme

There are hosts of reasons for taking part in competition, but above all it should be fun, and I believe one should race often, for surely that is the whole point of the exercise. On the other hand it is certainly possible to race too often and as a result be unable to recover and to maintain form; nor is it possible to reach peak form more than once or twice in a year. Perhaps paradoxically we do

not have to expect to win every time out, since racing for experience or to measure ourselves against better opposition can still be rewarding, and many competitors treasure memories of hard fought but losing races above the easy victories. Nevertheless we need some successes to maintain morale, so the ideal racing programme should give us some not too difficult racing experience with a chance of success early in the season before we come to a peak for the more important races.

In Britain the racing calendar has evolved to present a wealth of opportunities just about every weekend throughout the year, and whether you are an ambitious competitor or racing just for fun, you can use these races as an attractive way to help your development and to give more obvious point to your training.

In the Autumn the majority of events are timed, long-distance, 'head of the river' races for small boats, and particularly for single sculls. I have already made the point that such small boats are the ideal vehicles in which to learn technique and to develop personal toughness, and I think that long-distance racing in these boats should be a regular part of the Autumn training schedule. In Chapter 6 I suggested that a two-week cycle between races was probably best, as it allows both full recovery from the previous race and a long enough uninterrupted period of training in between for some real progress to be made. Of course there may be some specific reason for sometimes racing more frequently, but this does not matter as long as the overall programme does allow you the chance to restock as well. Many of the small boat events have become so popular that the organizers offer separate divisions and different classes of boat throughout the day, and encourage you to double up – I think you should, as it's good experience and good fun!

The winter months of December, January and February have fewer events and in many years the weather and water conditions are less conducive to enjoyable racing. Training at this time is likely to be emphasizing strength and endurance development rather than speed, with a significant proportion being done on the land, and so it is probably best to do little if any racing at this time. The immediate aim will be the very well patronized head races, some of very high standard and status indeed, which take place in March and April. The original Tideway Head of the River race was instituted as a way of encouraging clubs to do more endurance training in the winter, and has certainly succeeded in that objective.

Whatever your current age, ability or status, you should aim to take part and do your best in one or more of these big events as the culmination of your winter preparation. Some of the earlier heads can also be fitted in to blow out the competition cobwebs and to

raise the quality of your training. Many clubs will not have finalized their crews at this stage and can use the events as part of the selection process or to try out new combinations. Again there are many small boat events where doubling up is encouraged and where you can experiment with different boats and partners.

For the Summer regatta season a different approach is needed, for here we should sit down with a copy of the regatta timetable and pick out the one or two competitive peaks, perhaps the National Schools Championships and Henley for example, and then work back from there. As before, a two-week cycle has advantages, but this may not fit with your other commitments or with the regattas you really want to go to. If you are ambitious and aiming for the top with a real chance of success, then ideally you should pick out the events that will give you the best preparation for the big ones that really matter. For those lower on the road to success it will be more important to map out a series of well-run regattas that offer the right events and are likely to attract worthy opponents. Either way you must take account of the need to spend some weeks in a transition period where you are learning to row at higher ratings and speeds after the head season, and also rehearsing the special techniques of regatta racing. You may not feel ready to race at all during this time, although perhaps the occasional short race could be useful practice, but prefer to make your début when you are fully prepared.

To do all this you will require information both as to the past standard of the regatta or head, and also up-to-date information about the events offered in the current year. For the former you can look up last year's records in the indispensable *British Rowing Almanack*, or refer to the sometimes more extensive reports in back copies of the rowing magazines, as well as ask people who were there. Details of forthcoming events are published in the *Almanack* and in the magazines, and all clubs will also be circulated with the necessary details.

Regatta and head organization

All domestic events are run by groups of highly dedicated and very hard-working amateurs whose aim is to make their event as attractive and worthwhile as possible, and at least they deserve our co-operation. Standards and facilities vary enormously, from the slick tradition and precise attention to detail of Henley Royal Regatta, to the sort of informal event where entries change on the day.

At least in theory, every event will require full details of your entry and the fee a week or so in advance, and it is vital to check

exactly when the closing date falls and to allow plenty of posting time. Some events welcome telephone entries, some do not – at any rate always check by phone that your postal entry has arrived on schedule. If necessary you can usually notify changes in a crew up to one hour before the first race – but make sure that you do it properly or you can be disqualified. If as a result of crew changes or a win at an earlier regatta your status changes, then the organizers may be able to fit you into an alternative event – but of course it is only prudent and courteous to warn the organizers as far as possible in advance.

When you arrive at the venue, check in and complete any paperwork, pick up numbers and so on, and make a point of confirming that the timing and details of the event you are in are exactly as you expect. Most organizers do try to stick to a precise timetable and it is very much in your interest and that of everyone else to help in this, so make sure that you boat and get to the start or marshalling area in good time. Some events have officials to chivvy you along, check who you are and that the cox is of the correct weight; others are a free-for-all and you will need to anticipate hold-ups as everyone tries to boat at the same time. For safety reasons there are usually regulations governing your route to the start, warm-up area and so on, and these can be very strictly enforced. As race time approaches, make sure that you are in the right place at the right time – don't paddle off for an extra bit of warm-up!

Coming to a peak

The final weeks before a major competition should see considerable changes in your training pattern so that you are at your best at the time of the race. This is known as 'tapering'. Just how much you have to modify your programme does of course depend on how much training you normally do, but for the purposes of this exercise let us assume that you have been training hard on a daily basis for some time. The supercompensation theory outlined in the previous chapter suggests that if you have been training hard you will not have fully recovered before the next training session, will be somewhat fatigued and therefore not at your best.

In most cases it would be appropriate to start the 'taper' two weeks before the event you are aiming for by reducing the quantity of work somewhat in the first week but emphasizing the quality or speed. One week before the race there should be a day or two of more intense work related specifically to race pace and distance, and then a marked drop in work for the final week (but perhaps with some useful pace work three days before followed by two

days of very light outings or rest). This system will give the best possible supercompensation on race day, maximize glycogen reserves, give good rehearsal of race pace and tactical bursts, and leave you fresh and raring to go. Sometimes it can be difficult to convince yourself that the reduction in training is wise, and inexperienced competitors often make the mistake of doing too much; training hard in the last week is too late to do more than make you tired, so if in doubt do less! Figure 90 illustrates the pattern that training will take during the taper, and the following schedule illustrates the sort of training that a good club crew might undertake in peaking for a major event.

FINAL TWO WEEKS OF TRAINING

Fig. 90 Typical pattern of the quantity and quality of training when coming to a peak (tapering).

Day	Training	Remarks
Saturday	Regatta	
Sunday	12 k steady state	Recovery and technique
Monday	Stepped rating, 2 min each at rate 20, 22, 24, 26, 28, 26, 24, 22, 20	Endurance and technique
Tuesday	Fast fartlek pyramid, 10–40–10 strokes, 300 strokes total, practise starts	Developing speed
Wednesday	1 × 500 m, 2 × 1000 m, 1 × 500 m, above race pace Time control	Speed endurance Pace judgement
Thursday	2(6×1min), 1½ min light paddling recovery	Speed endurance
Friday	Off	

Saturday	6 × 500 m, above race pace, 2½ min rest, 1st and last from standing start	Special endurance Pace judgement
Sunday	3 or 4 × 1,000 m, race pace, starts	Pace judgement
Monday	10 k steady state	Recovery and technique
Tuesday	2 or 3 × 5 min, below race pace	Recovery and technique
Wednesday	1 × 1,000 m, 1 × 500 m, starts	Pace judgement
Thursday	Light paddling, starts and sprints	Recovery and technique
Friday	Off	
Saturday	RACE	

More advanced competitors would prepare specifically over a much longer period, and before this final tapering period would be working very hard indeed in order to build the best possible condition. If you look back at the training schedule for the GB juniors in the last chapter, this covers weeks three and two before the World Championships, and was followed by travel to Italy and then a few days of light training on the course before the heats started. If on the other hand you are not preparing for such a big event, but have your eyes on later fixtures, then you will not wish to modify your training cycles to the same extent, and it is likely that a couple of days of lighter training or rest will be enough to enable you to race well.

Race day preparation

It seems to be a human characteristic that when we are preoccupied with some exciting happening, like going off to a race, we become forgetful − it is wise to have a checklist. Are all the bits of boat, blades and spares, and the necessary tools, on the trailer or other boat transport? Do you have all your rowing kit? Do you have all the paperwork you may need? Food and drink? Do you and the rest of the crew know exactly where you are going, and if necessary exactly where and when you are to meet? Competition is necessarily stressful and it is very foolish to add to your worries with bad organization; you want to be calm and confident and have plenty of time to think what you are doing.

When you arrive your first priority is to make sure that the boat

is ready and to ensure that the race is at the time you expect and has not been changed in any way. Don't waste energy by wandering around but sit somewhere warm if it is cold, or in the shade on a hot day. Make sure that you have enough to drink, and think about when and what you are going to eat – allow at least three hours for a meal to digest and make the last meal before your race a light one of mostly carbohydrate and very little fat, not forgetting that nervousness reduces your capacity to digest food. As the time approaches to boat, sit quietly somewhere and go over your race tactics and options. Think what you are going to do, and in effect mentally rehearse your race. Do allow time to go to the toilet, and expect adrenalin to increase the frequency and urgency!

Warming up

An adequate warm-up is essential before a race not just because it literally warms up your muscles and readies your heart, lungs and other systems for the contest, but also because it helps you rehearse your technique and gets you into the right frame of mind for the race. Often our pre-race nerves makes us feel very weak, possibly even sick, and wish we were somewhere else; a good warm-up helps to overcome these qualms and make you concentrate on the task in hand. In training you will have established a familiar pattern for your warm-up (see Chapter 6), and if you are able to follow much the same routine on race day it will be reassuring and of known efficacy. However, it is often the case that you will have to adopt a different plan, for example to fit in with marshalling at a head, or simply because of lack of space at a regatta, and in any case most regattas have quite strict rules about proceeding to the start and warming up in the start area. You should always find out about these limitations in advance and then plan your revised warm-up accordingly. For example, if you know that you will be able to do little on the water you should have a more extensive land warm-up before you boat.

The ideal warm-up for the first race will consist of your usual land procedure, say a ten-minute jog and your usual range of stretching exercises, then boating straight away and allowing about half an hour on the water before the race. The water work should be progressive; very easy technical exercises at first, gradually building into short bursts of firm pressure to increase heart and breathing rates and initiate sweating. You should wear enough clothing to ensure that you do get warm, compatible with freedom of movement, and you should also have enough clothing with you to keep you warm if you have to wait for the start.

At regattas you will also want to practise your racing start two or three times, and if you do about ten or fifteen strokes each time,

flat out, this will release extra adrenalin but not too much lactic acid. You should finish these bursts just a few minutes before you have to go on to the start, leaving time to wind down with a little light paddling and then move on to the start with no hurry. Regulations commonly state that you must be attached to the start at least two minutes before race time, and it is important to arrange things so that you are neither late and flustered nor left sitting around with nothing to do except worry. Don't watch your opponents but concentrate on your own boat and what you have to do.

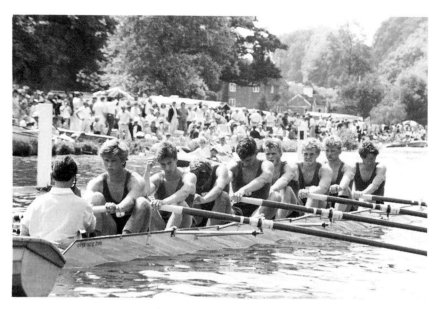

Fig. 91 Preparing for the start. The crew is nervous but ignoring their opponents and concentrating on what they have to do.

The racing start

For tactical and psychological reasons it is very important to be able to move off the start very cleanly and quickly and to settle into your chosen race rhythm well. If you develop a good starting procedure it will give you a much greater choice of tactics and boost your confidence, even if you choose to go off with something in hand. Technically the start presents some special problems because you will be applying greater than usual force to a boat which at first is not moving, and then accelerates rapidly to a much higher than usual speed.

Let us first take the simplest case of a stake boat or fixed pontoon start on still water. You will have backed carefully on to

the start and will be held by the person there. They have little to hold on to, and if it is your rudder you don't want it damaged, so when you are manoeuvring to keep the boat straight do not wrench it away but try to back down on one side as you gently paddle on the other side. To move the bows round it is much more effective to come up the slide and take just the beginning of the stroke. If there is a strong cross-wind it may be necessary to give your blade to the person in front so that they can pull the boat round with the oar almost parallel with the boat, a move that you should have rehearsed in training. In a cross-wind you should keep the boat pointing towards the wind a bit because it is much easier to hold there, and if you judge it well you can let the boat swing round just before the start so it is pointing the right way at the exact moment. Listen to the starter and make sure that he or she knows if you are not ready. This is usually done by cox or bow (or both) raising their hands, though in a single you may have your hands full and will have to shout. A good starter will see that crews or scullers are not ready, but do not rely on it, and do try to keep straight and ready, as soon as you are attached to the start.

Usually the starter will tell you how the start will be carried out and will warn you to get ready, and then it is really up to you to be ready. In multi-lane racing this will consist of a call over, naming each crew in turn and saying, 'Ready?' (or 'prêt' in international events), but this is not really a question and a reply is not expected, though you can try waving and shouting if you are desperate! In Britain the procedure is, 'Attention, set, go', but in internationals the start is reduced to 'set! go!', with a variable pause between 'set' and 'go' in order to make it difficult to anticipate the start. On still water I would advise that the blades are already squared and covered in the water and that you are sitting ready for the start before it is called, otherwise you will lose a fraction of a second, and a last-moment squaring and covering of the blade can upset the boat and can cause mistakes.

With stake boats on a slow-moving river – Henley for example – the same procedures can apply, but if there is a fast stream you will have to modify your approach. If the water is flowing in race direction, keep the blades out of the water until the 'go', and then square and cover them quickly and get pressure on instantly. You will find that the pressure on the beginning is much greater than usual, so it may pay to shorten your first stroke in order that you can still get it through quickly. In a moderate stream you could still square the blades before the 'go', but expect the pressure on the blade and beware that if the blades are not squared or covered together the boat will become unbalanced or will swing sideways. In very fast water the blades may keep digging in and it may be worth practising waiting with the blades over-squared, but beware

that it is then all too easy to get the squaring wrong for the start. When the water is flowing against you there may be more difficulty in keeping the boat straight and it is more difficult to catch the water at the beginning of the first stroke – it would help to reach further than usual. If there are no stake boats then the problems may be less, but the principles are the same; the main thing is to make sure that you are in the right position and not moving backwards before the start.

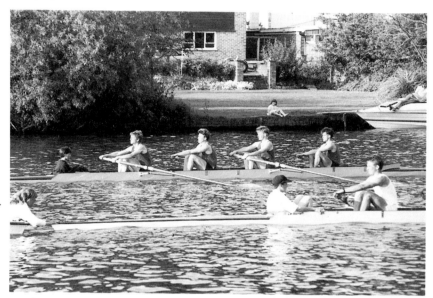

Fig. 92 Good body and blade positions ready for the start. Note that the blades are already square and covered.

The starting procedure that I favour begins with a long first stroke using most of the slide but little forward lean of the body. The object is to get the boat moving without upset (and in fact it does not move very far in that first stroke, nor does it begin to move the instant you start pulling but may even go backwards). To achieve this, every member of the crew must start from the same position, or rather with their blades in the same relative position, and the sculler must have the blades symmetrically placed. Drive very hard with the legs and hold the back exceptionally firm in order to transmit this great force to the stationary boat without 'bum shoving'. The blades will need to be better covered in the water than usual to stop them slipping, and this good coverage of the blades must be continued to the finish so that they do not wash out. In a sculling boat I find it helpful to reach out a little further and apply a little pressure as a gentle squeeze just before the 'go'. This takes up any slack in the stake boat system and ensures that the sculls are properly squared and

already locked in the water, and that the backs of the sculls are firmly up against their swivels. Good timing and balance is crucial, for the slow-moving boat must be level for the next stroke, so ensure that all blades leave the water exactly together. Never cut this first finish short but do get the hands away extra smartly.

The second stroke should be taken very quickly, so quickly in fact that it is shorter than the first; timing this is not easy and will require a lot of practice. This short, quick, driving stroke builds on the momentum of the first stroke, and by moving forwards quickly for it you actually help to accelerate the boat in the opposite direction. The third stroke should also be taken very quickly, but should be a longer one, and now that the boat is really beginning to shift, the catches and finishes will need to be very fast and clean. Because of the extra power and bigger puddles, it is necessary to exaggerate the actions at the finish to make sure that the blades clear the water yet do not wash out prematurely. The fourth and fifth strokes will be virtually full length, but must be very fast and powerful because the boat is now moving fast yet must still accelerate. Indeed, it may take ten strokes to get the boat up to full speed.

A full-blooded racing start is very exhilarating but also uses up a great deal of energy. Fortunately reserves of anaerobic power are available at the start, but these soon run out and to continue at maximum speed will demand more anaerobic work that will create lactic acid. Exactly where you 'stride' into a more economical rhythm depends on your choice of tactics and you can do it by a gradual lengthening and steadying of the strokes, or more abruptly at a pre-arranged signal. The danger is that as the excitement of the start passes, you will slump to too low a pace, and this often coincides with feelings of breathlessness and weakness as your body struggles to adjust to the race. It is very important to convince yourself that this is just a passing feeling and that you must push very hard into the race proper, and of course you must have rehearsed this difficult phase very thoroughly in training.

Race profiles

An experienced competitor's effort is distributed in a characteristic way over the race distance, and the pattern is much the same for all boat types and irrespective of whether men, women or juniors are involved. There are important differences, however; firstly, related to boat type – the largest and fastest boats often show the least variation in speed from one sector of the race to the next; and secondly, according to the abilities of, or tactics adopted by, the

crews or scullers in a particular race. As we shall see later, these very small adjustments of pace within the overall profile of the race can be of crucial importance, and can have an effect on the athlete's power production which might seem surprising at first.

	500 mm	1,000 mm	1,500 mm	2,000 mm
Cumulative times	1.34.9	3.15.4	4.57.3	6.36.8
Split times		1.40.5	1.41.9	1.39.5

Fig. 93 Video analysis of the race profile of the Great Britain 2–, Olympic Games, 1988.

The victory of Britain's Redgrave and Holmes in the coxless pair at the Seoul Olympics was a classic race where the pair dictated the pace from start to finish. If we analyse their race profile (fig. 93) in more detail we see that not only does the boat's speed vary in this characteristic manner but that the way in which the crew achieves and maintains that speed also changes substantially during the race. As a consequence the technical requirements of the different sectors also vary, and furthermore the physiological demands on them (and their responses) change during the race. A rowing race (even over the so-called sprint distance of 500 metres) is not a simple, flat-out effort; rather, it is a subtle and finely judged blend of physical and physiological capacity matched to the tactical requirements of the race. We have already seen in Chapter 6 how the various forms of energy supply contribute to the total in a way that also varies throughout the race. Let us now analyse the sectors of the race in more detail.

1 THE START

A fast and effective start is essential in side-by-side racing, partly for psychological reasons but also to prevent the opponents gaining any critical advantage, even if tactical concerns lead athletes to conserve their best efforts for later. As we have seen, the start procedure requires special and very well-rehearsed technique, the application of prodigious amounts of power, and a very high stroke frequency. At this point in the race reserves of power are available that will not be there later in the race, and indeed will be used very quickly before longer-term energy supply mechanisms adopt their principal role. Thus you are enabled to make the very powerful muscular contractions which accelerate the boat rapidly to maximum speed. Free from fatigue and charged with stimulating hormones, your nervous and muscular systems are also at peak efficiency and most capable of the fast and skilfully co-ordinated movements required.

2 SECOND SECTOR – TRANSITION TO RACE PACE AND ESTABLISHING A POSITION

In a 2,000-metre race it is usual for the pace to be particularly fast during the first 300–600 metres as each crew member or sculler changes from the explosive effort of the start itself to the technique, power and rhythm that can be maintained for the bulk of the race. At the same time tactical considerations will be much in evidence as the boats jockey for position. In their Olympic race, Redgrave and Holmes had established an early lead and were thus best placed to judge exactly what they must do to maintain it.

Rates of striking will be higher than in the middle part of the race and despite the higher boat speed, the distance covered per stroke will be less. This is not because the length of the stroke in the water is necessarily shorter (indeed it is often longer as you strive to maximize speed for tactical advantage), but rather because the rhythm of the stroke does not allow the boat to run so far before the next catch. It is during this sector of the race that a correct balance of anaerobic and aerobic power sources must be achieved. Excessive use of the anerobic power system in order to boost speed even fractionally can incur physiological penalties that at best will make the athlete uncomfortable for the succeeding parts of the race.

3 THIRD SECTOR – THE CRUISE

In this phase, often for the middle 1,000 metres of a 2,000-metre race, the competitor's target is to achieve or maintain the chosen tactical position with the minimum expenditure of energy. It is necessary therefore to maintain a pace of greatest physiological

efficiency; that is, where the energy output is matched almost entirely by aerobic energy production. Sufficient oxygen must be available to the working muscles for almost complete oxidation of available fuel, whilst at the same time nearly all the waste products such as carbon dioxide can be eliminated. Good technique is vitally important in husbanding resources, and as shown in fig. 93 the rate of striking will be minimized whilst the distance travelled per stroke will be maximized. The winners are likely to be those who arrive at the end of this sector in a good tactical position and with the greatest physical resources still in hand.

If we look again at fig. 93, we see that at about 1,100 metres into the race the British pair increase their speed, and this was in response to a challenge from their nearest rivals. It is clear from this that the Britons had something in hand and were determined to use it to maintain their lead throughout, and not to leave anything to chance in the last stage of the race.

4 FOURTH SECTOR – THE FINAL SPURT

It is common for the work rate to begin to rise at about 500 metres from home in a 2,000-metre race, with more dramatic increases in the last 45–60 seconds. As fig. 92 shows, the rate of striking will increase and the distance per stroke will fall, but because power and technical skills are fading owing to increasing fatigue, the boat speed may not increase very much. The power produced aerobically will be declining as the waste products of previous effort accumulate, but the final anaerobic reserves are now being called upon. The waste products and lack of oxygen will soon bring effective muscle contraction to a halt – but it is the end of the race!

Race tactics

The balance between available energy and speed over the course is a very delicate one and the wrong choice can be disastrous. Psychologically the chosen tactics and the way they unfold between competitors during the race can make a crucial difference to the individual performances; some will be lifted by the success of their tactical responses or pre-planned moves and their perception of fatigue will be altered, whilst others will be demoralized by their apparent failure or by their competitor's surprise moves. It is at such times that a well-informed and canny cox can be a major asset.

Table 10 illustrates a typical range of tactics, in this case employed in the coxless four final of the Junior World Championships in 1988. Examination of the race profiles of the three medallists (Italy, France and Britain) shows three very

Table 10

Coxless four final, Junior Men 1988, cumulative times and position (in brackets), split times, and deficit on leader at 500-metre intervals

Crew	Finish position	500 m	1,000 m	1,500 m
Italy	1	1.27.09 (4)	3.00.33 (5)	4.27.69 (1)
			1.33.24	1.27.36
		1.32−	4.29−	
France	2	1.25.77 (1)	2.56.29 (2)	4.28.34 (2)
			1.30.52	1.32.05
			0.25−	0.65−
Great Britain	3	1.28.45 (6)	2.59.50 (4)	4.28.71 (3)
			1.31.05	1.29.21
		2.68−	3.46−	1.02−
East Germany	4	1.26.41 (3)	2.57.91 (3)	4.30.51 (4)
			1.31.50	1.32.60
		0.64−	1.87−	2.82−
Czechoslovakia	5	1.25.97 (2)	2.56.04 (1)	4.30.93 (5)
			1.30.07	1.34.89
		0.20−		3.24−
Soviet Union	6	1.27.63 (5)	3.00.60 (6)	4.33.22 (6)
			1.32.97	1.32.62
		1.86−	4.56−	5.53−

different but common strategies. The Italian crew, perhaps confident of their fast finish, set off at moderate speed, content not to lead in the early stages but to remain well in touch; their pace remained steady in the first part of the course, as they husbanded their resources whilst they gathered for their most effective final run to the line. The French gambled on a very fast start and opening pace (together with the Czechoslovakian crew), which they maintained for as long as possible. Such tactics can have two benefits in that an unassailable lead might be built up before the more cautious respond, and sometimes the opposition may be rattled by this early demonstration of greater speed. The penalty, as the French crew demonstrates, is the metabolic cost of such a fast early pace and the inevitable slowing towards the end. In this case the gamble nearly paid off, as the Czechoslovakians, who attempted a similar race plan, could not hold on. The British crew were determined to race at as nearly even pace as possible,

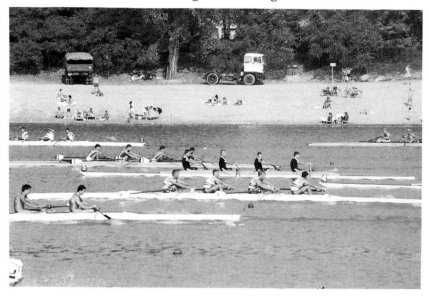

Fig. 94 The final moments of the epic 1988 Junior World Championships in coxless fours. The Italians (nearest the camera) are moving into the lead, as the GB four overhaul the Czech crew in lane 5 but just fail to catch the French (lane 6).

believing that to be the most efficient, and knowing that they had the ability to finish strongly. In the event they may have wished to have been higher placed after the start, and therefore better positioned in the middle of the race, but it is probable that they used their resources most effectively and completely but could not match the Italians' final surge.

In the discussion of tactics it is essential to bear in mind, firstly the way in which resistance is related to boat speed, and secondly the metabolic cost of increased power. It is a fundamental of hydrodynamics that resistance increases as the velocity squared, and that the power required will then increase by the cube of the speed. Thus any small increase in speed (say for tactical reasons) will require a large increase in power. In a hard race the athlete is functioning very close to the limit, and in particular close to, or more often already above, the maximum aerobic energy production (known as the anaerobic threshold). An increase in power over and above this will cause a sharp rise in anaerobic energy production, with a correspondingly large rise in harmful waste products. It is clear that increases in speed are very costly. On the other hand we have already seen that reserves of power are available in the short term both in the early stages of the race and in the final minute. Thus the best race profile may not be exactly even paced, even if we neglect the possible psychological advantages of a fast start or tactical surges (fig. 95).

The best competitors will understand the principles and will have developed, and tried out thoroughly, not only their ideal race plan but also the capacity to carry it out if appropriate – they will also have the flexibility to adopt another if the circumstances require, and the ability to respond to the tactics of their opponents.

In multi-lane racing or in an event with a *repêchage* system (second chance), you may not need to win your heat in order to progress to the next round. It is of course essential to check very carefully what the rules are, and to work out what all the implications of finishing in any position will be when it comes to later rounds. There are psychological attractions in finishing first and in many cases the event is organized in such a way that the

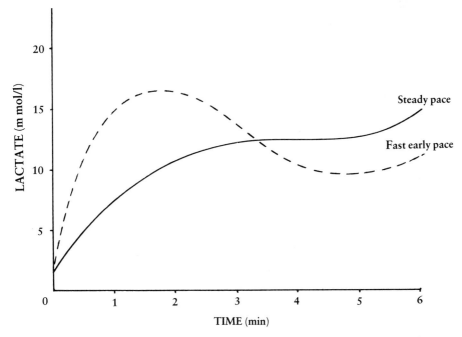

Fig. 95 Lactate production in a race depends on the pace – too much early on will hamper later efforts.

winners get the easiest passage to the final. On the other hand there is no point in racing flat out if you do not benefit from it. The best plan is usually to race hard for the first part of the course and then assess what needs to be done to arrive at a satisfactory finishing position. If possible at least avoid a sprint finish and its lactic acid and save yourself for the races that really matter.

Head races are usually longer than regatta courses and because you are not racing side by side the tactical considerations will be very different. What matters is covering the course at as even a

pace as possible, because as we have seen this is the most efficient use of energy, and at the highest sustainable speed. This means that you do not carry out a racing start and you avoid any marked changes in pace during the race until perhaps a minute or two before the finish. Even so, you will have some extra energy at the beginning of the race, and you may choose to go off at a somewhat higher speed for the first minute or so in order to maintain position with your main rivals. It may help you to settle into a good pace if you set off a bit faster and then stretch out to your race pace, and it is worthwhile experimenting with this in training. Sometimes too

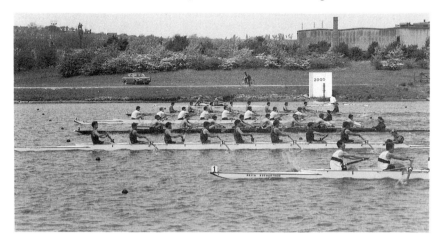

Fig. 96 **A clean and effective start gives the crew an immediate advantage and a choice of tactics.**

it can be worthwhile increasing your pace a little as you come up to pass a significant opponent, so as to make the move incisive and perhaps morale-boosting – you may also wish to get past quickly in order to resume a better course on the river. Do remember that even pace is not even effort – as you tire it will seem harder and harder to maintain the pace.

The umpire

Racing rules and regulations do change from time to time and you must make a point of checking up on those in force, and of course this includes any special ones for the race you are in. You must also understand the arrangements for umpiring and what to do in the event of their intervention or if you need their assistance.

At the start either an aligner on the side, or the starter (who may also be the umpire for that race), will be watching for false starts; that is, if your bows cross the line before the starter's flag falls. At the best international regattas a split-screen video showing both

the bows of the boats and the starter's flag enables the officials to look again at the start before you have gone very far. In the event of a false start, or if it is seen that there is something wrong, then a red flag will be waved and a bell will be rung to halt the race. All competitors then return to the start where the offender will be warned and awarded one false start penalty – if they offend again then they will be disqualified.

Not all regattas can have umpires following in launches – some have them in cars, some on mopeds, and many have them static on the bank. Their main task is to ensure that each competitor does not leave their proper course or interfere with their opponents; if you do you may be disqualified even though you may be way ahead. The umpire should warn you if it looks as though you are going to transgress, and should indicate which way you should move to get back on course, but will not help you steer the course otherwise! The umpire may tell you to move to 'port' or 'starboard', so do make sure you know what it means! If there is a bad infringement then the umpire can stop the race and disqualify there and then. If all goes well the umpire at the finish will raise a white flag to show the judges that there are no problems, but if there was a problem then a red flag will mean that umpire and officials must confer and make a decision. If you are unhappy about the race and wish to protest, then draw the umpire's attention before he raises his white flag and let them know (politely!) your grievance.

After the race

If you are racing again that day your priority after you have parked the boat and blades safely is to rest and recuperate. Do not stand around for long discussing the race just gone – that can be analysed in more comfortable surroundings – but do make sure that you know when your next race is, and what your timetable will be. You should have some drink, for even on a cool day you will have sweated, and if there is more than an hour before the next race you could have something like glucose unless you are dehydrated. If you have two hours or more before you boat again then you can eat (carbohydrate and not fat or protein), although how much and what you eat depends on how long you have and how your digestion copes. If it is cold then keep warm and remember that your hot sweaty body will cool very rapidly; if it is hot then you must try to keep cool. You will not need such an elaborate warm-up for the next race, but make sure that you do allow enough time for an adequate one.

If you have finished for the day, rest and recuperation is still vital because what matters now is doing even better next time.

The drug problem

My own attitude to anyone who deliberately takes any artificial substance to boost their performance either in training or in a race is simply stated: they are cheating. Any success gained that way is to my mind not worth having, and I am fully in favour of strong measures to detect abuse, punish offenders, and deter those who might consider it. Many of the substances that could be used in an attempt to improve performance are harmful, and as I write this I have in mind a recent inquest where it was determined that the abuse of anabolic steroids had contributed to the death of a young body-builder. Unlike some other sports, rowing has been relatively free of problems, although there have been a few cases. This is probably because the financial rewards in rowing are minimal, because there are few drugs of known efficacy, because international rowers and scullers have been subject to random tests for some years, and because of the generally healthy attitude to fair play that exists in our sport.

There are a few problems in practice because some medicines and medical treatments are potentially performance-enhancing and are banned, although competitors or their doctors might use them in ignorance. There are also treatments intended to keep an ill or injured competitor training or racing, and some of the potentially harmful treatments are also banned. The International Olympic Committee (IOC) and its Medical Commission, together with the governing bodies of the various sports and their medical advisers, are well aware of these problems and are responsible for issuing up-to-date guidelines. FISA, the governing body of our sport, has adopted the IOC recommendations almost in entirety. Essentially there is a very long list of substances which must not be present in the competitor's body at the time of competition, and of medical treatments that may not be used, and a much shorter list of substances which must not be found during the training period – thus leaving doctors free to use a wider range of treatments and medicine for genuine illness during training.

Information on the latest guidelines is available to all those who are likely to be affected by them (in Britain from the ARA or International Rowing Office), but it is as well to be aware that many proprietary medicines that are freely available at chemists may contain banned substances, and you must be careful to avoid using these near or during competition. The common sources of problems are likely to be:

(a) cough suppressants (codeine);
(b) decongestants for hay fever or colds (ephedrine, pseudoe-phedrine);
(c) antidiarrhoea mixtures (codeine, morphine); and
(d) pain killers (codeine, dextropropoxyphene).

You may be prescribed drugs for some other condition, perhaps a long-standing one such as asthma, which unknown to you might contain a forbidden substance. In this case you should consult your doctor, with the list of banned substances, and if necessary ask for some alternative. It is your responsibility to make sure that you do not break the rules, intentionally or unintentionally.

Medical science advances very rapidly and the cheats become more sophisticated. We hear of new abuses such as 'blood doping' (where blood is withdrawn during training and then reinjected later to boost the amount in circulation), using growth hormone, testosterone, or the hormone erythropoietin which increases red blood cell production. These natural substances being used in unnatural ways to gain an unfair advantage are just as much cheating as any drug abuse, and I feel that all of us in sport must be quick to condemn such actions and strong in our support for the authorities battling against them.

CHAPTER 9

Looking after yourself

A competitor in a demanding sport such as ours must not only train to get the utmost return for the effort put in, but must also try hard to ensure that there are no adverse and avoidable influences hampering performance. Good health is essential and to be really successful you must be determined to avoid the insults to health that so many of the population allow themselves – smoking, poor diet, drinking alcohol to excess, poor hygiene, and so on. Our environment is potentially hazardous too, yet many of the dangers are easily minimized. Overall one of the problems that we are faced with is that most of us pick up all sorts of ideas about health, diet and so on – some of these are harmless or even beneficial, but others can be very troublesome. For example, I would be prepared to bet that some readers believe that a big steak the night before is the ideal preparation for a race, or that after training in hot weather you need to take salt tablets. The purpose of this chapter is partly to dispel some myths, and in their place to give you a working guide to the maintenance of your body.

Environmental conditions

Because rowing is an outdoor sport it is essential for you to learn how to cope with a wide range of environmental conditions, and in some cases adapt to them. Poor preparation in this case can have results ranging from discomfort to death, and the problems must therefore be taken very seriously. For the competitor the result of poor preparation or adaptation can also be a disastrously poor performance. Fortunately our bodies do adapt somewhat to extremes of conditions, but full adaptation can take a long time and needs to be planned carefully.

There are four major categories of environmental stress which need to be considered, namely heat, cold, air pollution and altitude. Other factors such as wind or humidity can interact with these and will also be considered in this chapter.

HEAT

At maximal effort the rower or sculler will generate something in the order of 5.0 megajoules (MJ) of heat per hour – that would be enough to raise the temperature of the 40 l or so of water in the body by 2.8°C in a six-minute race. To this heat may be added radiant heat from the sun (say, 900 kilojoules per hour (kJ/h) in the afternoon), and convection from the hot atmosphere if its temperature exceeds that of the skin (about 32°C).

The normal mean body temperature is 36.7°C but fluctuations between 35.8°C and 37.5°C are quite usual during the day, and of no importance to us here. Stabilizing mechanisms, controlled by the hypothalamus of the brain, respond to small deviations in both core (blood) temperature and skin temperature in the first instance by changing metabolic rate (and hence heat production), skin blood-vessel dilation, and sweating.

Even in a cool climate the main way in which heat is lost during vigorous exercise is by evaporation of sweat, when the energy required for the evaporation is taken from the skin and indirectly from the blood supplying it – one litre of sweat dissipates 2.43 MJ of heat. Thus to lose the rower's extra heat production of 5 MJ/hr by sweating alone would require the evaporation of more than two litres per hour. The rate of evaporation is increased considerably by wind, and the movement of the boat will help even though only bow gets the full benefit! Humidity reduces the rate of evaporation and the worst combination will be a still sunny day, with both high humidity and high air temperature. Even in low relative humidity, more than 50% of the total sweat will run off the body, with little cooling effect, rather than evaporate.

Intensive exercise produces so much heat so quickly that although these cooling systems are activated, the core temperature still rises. A rise to about 38°C would have no adverse effects, even in an untrained subject, and in fact helps to increase rate of heat loss, and speeds up metabolic processes. Muscles become less viscous and can contract faster, and the heart's contractions are also helped. These are the beneficial thermal effects of the 'warm-up'. Trained athletes working very hard can experience even greater rises – to 40°C or even beyond – and can tolerate such rises without harm if they are brief; but longer periods above 40°C can be very dangerous.

Three major thermal problems can arise:

1 *Heat exhaustion* It has been said that an athlete who is not acclimatized to heat is reduced to the performance of an untrained person. This may be an exaggeration but it is certainly true that the effects of heat include a higher heart rate for any given level of effort, a reduction in VO_2 max., poorer endurance performance, a

lower anaerobic threshold, and if dehydration occurs, a reduced heart stroke volume and reduced circulation to the muscles.

Inevitably exhaustion will set in earlier than usual if you are hampered by heat in the ways outlined, but collapse and the possibility of more serious heat illness is threatened if you become dehydrated. Skin circulation and sweating may actually reduce and if exercise continues there is likely to be a rapid rise in core temperature. Treatment should consist of sipping cold water (or very dilute drinks), and cooling the skin by sponging and fanning – whilst being on guard against more serious distress.

2 *Heat collapse* This particular problem may afflict both spectators and athletes, and for the same reason (but with different causes). In both cases the collapse, or loss of consciousness, is due to poor blood flow to the brain. In the spectator this is commonly because with a large amount of blood diverted to the skin for cooling on a hot day, a further reduction in blood to the brain can occur either after standing for a long time, or sometimes by standing after a long while seated. The critical time for the athlete, on the other hand, is after a race – when again a lot of blood is required for cooling, and the pooling of blood in the muscles when the 'muscle pump' is interrupted as you come to a halt reduces blood return through the veins and so starves the brain of its essential supplies.

Lying supine with the legs elevated will help, and the victim should be cooled by sponging and fanning, and given cool water or very dilute drinks as soon as possible. As with heat exhaustion, the mouth temperature is not a good guide since rapid breathing or panting (hyperventilation) may cool the tongue – if possible the rectal temperature should be taken and if 41°C or above then heat stroke should be suspected.

3 *Heat stroke* Prolonged overheating can lead to a failure of the body's heat regulating mechanisms – and this is potentially fatal and requires urgent medical treatment and hospitalization. Symptoms may include excessive sweating, headache, dizziness, nausea, convulsions and disturbance of consciousness. Emergency treatment requires cooling by sponging and fanning.

Less dramatic, but still performance-limiting, are the longer-term effects of large losses of water and minerals in sweat during hot weather. Sweat losses when working hard can amount to more than 2 l/hr, which is 2.9% of the body weight of a 70 kg athlete. Further losses of water also occur in breathing. Fluid losses of 2% or more will certainly affect working capacity adversely – body temperature will rise further and heart rate will be higher. In addition this dehydration will tend to cause irritability and lowered motivation to work. For distance runners it has been estimated that each 1% loss of body fluid reduces performance by

2%. The problem may be more severe still for lightweights who commonly use dehydration as a means of making the weight.

More will be said about fluid replacement later in the chapter, but it is important to appreciate that water can only be absorbed at a rate of about 600–700 ml/hr. It follows that rapid re-hydration is not possible, even if a lot of water is drunk rapidly, and that you will be unable to maintain fluid levels during training in hot weather despite regular intake of drinks. You must become used to drinking small amounts at frequent intervals, both during training and in between training sessions so that the body starts each session as fully hydrated as possible and loses as little as possible. Obviously such considerations are even more vital prior to competition.

Sweat contains many salts (electrolytes) which are essential to the body, but despite losses – for example of sodium chloride, which may reach 8 g /hr – there is no need to replace the electrolytes *during* exercise. For various reasons the concentration of such salts in blood plasma actually rises during exercise, so it would be wrong to add to them, but it will be necessary to replace the substances afterwards. The kidneys can do much to compensate for electrolyte losses in sweat, but if cumulative losses exceed 0.5 g/kg then you are liable to feel tired and irritable, and may suffer giddiness and cramps – larger losses can cause a marked fall in blood pressure as well as other symptoms. The body reserves of electrolytes are large, and important deficiencies are only likely to occur after several days' hard training in the heat – and then only if the diet is poor in these respects.

Training in heat
The well-trained athlete will already have some heat tolerance but this will increase considerably after about a week in a hotter climate. This adjustment is termed *acclimatization*. There will be increases in blood pressure and blood volume which help to cover the larger flow through the skin, and there will be a major change in sweating. After acclimatization sweating will start earlier in the exercise and sweat will be produced in greater volume, whilst its salt content will be reduced. As a result of the various changes you will not only perform better and show fewer physiological disturbances, but will also feel much more comfortable.

Since the effects of heat are potentially very hazardous it is wise to avoid training or racing in hot humid conditions if at all possible. However, if some important competition is to be held in a hotter climate than the athlete is used to then protective preparation must be undertaken.

Experience of working in heat is important and outings could be moved to a hotter part of the day and/or you could wear more

clothing. This will help, but is not as effective as a naturally hot environment, and care must be taken to avoid over-heating and excessive fluid losses. As mentioned earlier, you must be in the habit of drinking frequently and should always have a drink bottle of cold water in the boat. Drinking only when thirsty is too late, for by then the body has lost a significant amount of fluid – the best guide is that the urine is copious and pale, for then you can be sure that you have been drinking enough. Cold water is the best drink – cold because it will not only help to cool you but will actually be absorbed faster, and water because anything more than a slight amount of dissolved salt, or of glucose, will delay stomach emptying and absorption of the essential fluid.

Ideally you should have a week or more at the race venue, and at least one of the outings each day should be at race time. Allowance must be made for the enervating effect of the heat so that excessive fatigue is not experienced. Great attention must be paid to recovery between training sessions – yet again, ensuring adequate fluid replacement. Drinks such as coffee and alcohol should be avoided because they cause the kidneys to excrete more water (they are diuretics). A good mixed diet will probably supply all the electrolytes needed but a *little* extra salt with meals, or dilute electrolyte drinks, may be useful insurance. Salt tablets are much too concentrated and may not be absorbed or may even lead to the kidneys excreting extra salt.

Lightweight, loose-fitting clothing will minimize the effects of the sun and it is very important for those with sensitive skins to avoid even mild sunburn, covering any exposed areas with a high protection factor sunscreen preparation. A white hat with a brim or peak, and even a neck cover, may be helpful, but some of us find headgear oppressive and uncomfortable and would prefer just short hair and perhaps keep it wet. Certainly in international regattas the regulations insist that all members of the crew must be dressed identically, so if one wants a hat then all must have one. Natural fibres such as cotton retain some sweat and allow more to pass but can be very uncomfortable when wet. While some synthetic fibres and weaves are very good in letting sweat pass from the skin, others are too impervious, and nylon uniforms for example have been implicated in some American football fatalities. Wetting the hair and clothing has a useful cooling effect and conserves sweat, but the athlete should beware of the likely contamination of the water in most rowing courses and avoid using it for this purpose.

On a hot race day it is very important that you should stay in the shade before racing, preferably where there is a breeze, and should use a minimal-length (but tried and tested and effective) warm-up when you go on the water. It is wise to time the end of the

warm-up to give just a few minutes' calm before the start, but to avoid sitting motionless and frying in the sun! At the end of the race there should be a thorough wind-down, to avoid the problems of a sudden fall in the blood pressure, and drink should be taken as soon as possible thereafter. Regatta and FISA protocol for finals often restricts proper wind-down, and some organizers need to rethink their priorities, especially in difficult climatic conditions.

There is a common fallacy that training in layers of thick clothing to induce copious sweating in some way speeds up gains in fitness, or helps in losing fat. Maybe this arises from pictures of boxers endeavouring to make the weight. Apart from any danger of overheating it should be obvious that this strategy will reduce performance, endurance and training capacity, and therefore will in fact reduce fitness gains. As for any weight loss, there will of course be a temporary loss of fluid but because of the restrictions in training less fat will be used up.

COLD

Rowers or scullers face several possible categories of problems if they train or race in cold weather, particularly if it is also wet and windy – for wet clothes have little insulation value and wind causes much more rapid evaporative cooling (the wind chill factor). Although fit athletes are capable of generating a great deal of heat they are also more at risk because of their lower percentage of insulating body fat. Particular thought must also be given to the special hazards for the relatively immobile coxswain. The problems that you are most likely to encounter in training and racing are these:

(a) *Lower than optimum core temperatures which reduce performance* The warm-up may be less effective than usual, or the loss of heat may cause a lower than normal core temperature (and even a 1°C fall will significantly impair performance). The speed of muscle contraction is slowed by cold and effort is increased by greater muscle viscosity. Relaxation of antagonistic muscles is also slowed and as a result co-ordination becomes more difficult. In the longer term, energy supplies (blood glucose, muscle and liver glycogen) will be depleted much more rapidly than usual by the extra demands of metabolic heat generation or shivering. Shivering of course makes muscular control very difficult and if you are that cold then the outing should probably be abandoned. Those who tend to grip the handle too tightly will restrict the circulation in their fingers, which will then lose sensation as they become too cold and then very painful as they warm up later.

(b). *Hypothermia* Exhaustion and collapse can occur because of rapid falls in blood sugar but low body temperatures themselves can bring about unconsciousness. 35°C is the critical low temperature below which mental confusion and poor muscle control precede a loss of control of body temperature which is potentially fatal. Food and warmth at an early stage will bring rapid recovery and hot sweet drinks are particularly useful, as well as covering with dry clothing or blankets to retain heat. Coaching launches should always carry survival blankets.

(c) *Frostbite* One of the ways in which the body conserves heat is by vasoconstriction, withdrawing blood from the extremities. As a result some exposed areas such as fingers, nose, ears may actually freeze in very severe cold conditions. A white, waxy appearance and numbness are symptoms to be taken seriously and demand immediate rewarming of the afflicted parts. A famous report in the *New England Journal of Medicine* drew attention to the danger of frostbite to the penis in runners wearing thin clothing in cold weather – but hopefully this is less of a problem in the seated rowing position!

(d) *Falling into cold water* Survival time may be only 15 minutes in cold water close to freezing, as heat loss and the onset of hypothermia will be rapid. Sudden immersion in cold water causes gasping and it can be very difficult to hold the breath for long enough to escape from an overturned boat; there is also the danger of inhaling water. In addition, particularly if the shock of immersion comes to a warm athlete whose circulatory system is in full flow, there may be harmful disturbances of the heart's rhythm. Rescue and rapid rewarming of the victim must always be first priority and all coaching launches must be suitably equipped.

Training or competition in cold weather

Acclimatization to cold is less obvious than to heat, but in time you will feel more comfortable and be better equipped to deal with cold; it has both subjective and metabolic aspects. In the latter case it is probable that the output of the hormones thyroxine and noradrenaline will be increased, and they will cause an increase in heat production but principally in tissues other than the working muscles. The main response will be reduced blood flow to the skin which will not only reduce heat loss from the blood but will in effect increase the insulating layers of the body.

Careful choice of clothing is the obvious key to maintaining safety and performance in the cold, but there is always the difficulty of matching freedom of movement with adequate insulation. As a general principle it is best to use multiple thin layers of clothing since this will trap more air for insulation and will enable layers to be shed as the active athlete warms up.

Synthetic fibre thermal underwear is ideal since it is light, stretchy, fits snugly at openings and does not retain excess moisture – and if the next layer is cotton that will absorb the moisture wicking through the thermal wear and so help to keep the skin dry. The outermost layer should be windproof and waterproof but ideally (though expensive) made from a 'breathable' fabric such as 'Goretex'. A hat, which should be capable of covering the ears, will complete the ensemble. Thin gloves will help to keep the hands warm and will be less clumsy than cold fingers – but for some reason they are often regarded as cissy!

For the cox too the multiple layer principle is best, and a good waterproof and windproof outer suit that seals well around the wrists, ankles and neck is especially valuable since there is little

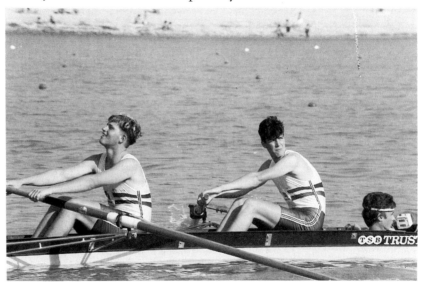

Fig. 97 Lycra rowing suits fit well and are comfortable in action, and they do not lose their shape when wet, though some nylon mixtures may seem hot and clammy. The right choice of clothing is important for bodily efficiency in all conditions.

problem with excessive sweating. Much heat is lost from the head, so a hat like a balaclava, covering as much as possible, will be most effective. Skiing gloves have the advantage that they are both very warm and partly waterproof, but much cheaper waterproof combinations can be made up with rubber or industrial gloves over thin woollen or cotton ones. Feet can get very cold but heavy boots are not advisable – make sure that your shoes allow enough room for several pairs of socks.

Particular thought should be given to the warm-up. A vigorous session in the shelter of the boathouse will raise internal temperature and establish good circulation before going on the

water. Less clothing can be worn for this so that it does not become soaked with sweat and lose its insulation value, but more layers will be needed outside to prevent rapid chilling and blood withdrawal in the now warm body surface. You should try to boat and get into action as quickly as possible, and interruptions should be minimized. In some competitions a wait before the start is inevitable and it is wise to carry extra clothing in a polythene bag – the extra weight is less harmful to performance than a cold athlete! Finally, additional clothing should be donned during the wind-down, as heat loss from a warm and perspiring body will be rapid.

AIR POLLUTION

Burning carbon fuels, especially coal and petrol, release many gases which are harmful to athletic performance. Inevitably this is principally a problem of urban areas but many of us have to train on waterways in such locations and will also probably run through the streets as part of our land training.

Oxides of sulphur from chimneys and vehicle exhausts form a reducing mixture which adversely affects the airways of the lung. In the longer term this type of smog not only reduces airflow but can establish conditions that increase the risk of respiratory infections such as bronchitis. Concentrations as low as 0.5–1.0 parts per million (ppm) will cause irritation and will reduce oxygen transport to the lungs; asthmatics will experience difficulties in even lower concentrations. On city streets these figures are often exceeded, particularly during the rush hour and in the winter when more fuel is being burnt. Ninety-nine per cent of this pollutant can be removed by breathing through the nose, but this is not very helpful whilst training. Reducing smog tends to accumulate in low-lying cold and humid areas in cities – where many of our rowing clubs are found – and training in such foggy conditions is unwise.

Vehicle exhaust fumes contain a number of gases which react under the influence of strong sunshine to form very irritating photochemical or oxidizing smog. One component is ozone which even at concentrations as low as 0.1 ppm reduces oxygen uptake and lessens the effect of aerobic training. The maximum concentrations are likely between 11 am and 4 pm, and the dangerous concentrations above 0.18 ppm are, for example, likely to be found in Los Angeles for at least one hour on 180 days in the year, and are becoming increasingly common in British cities. It is inadvisable to train if the concentrations are above 0.12 ppm.

Another component of air pollution is the toxic gas from vehicle exhausts – carbon monoxide, which has the highly undesirable effect of combining readily with haemoglobin to form the

cherry-red carboxyhaemoglobin. This will effectively prevent that haemoglobin from transporting oxygen until the carbon monoxide has been eliminated – and it takes 3–4 hours to dispose of just half of it! Carbon monoxide is likely to be more of a problem in city streets, where buildings trap the gas, than out on the river, but levels of 35 ppm or above are harmful – 100 ppm is often exceeded in the streets and levels above 500 ppm have been recorded in London underpasses and road tunnels.

Perhaps a less obvious problem may arise when travelling to a race through the city or in heavy traffic, when the inevitable exposure to the pollutants described will have an effect on later performance. Clearly it is best to travel at a less congested time of day – early morning will give the best conditions – and to allow time to recover from any ill-effects when you get there.

It is to be hoped that all readers of this book are sufficiently concerned with health that they do not smoke, and athletes should also be vociferous in condemning, and active in avoiding, other people's tobacco smoke. Not only does the smoke contain carbon monoxide, nicotine and carcinogens, but like smog it has an effect on the airways, by inducing extra mucus formation and paralysing cilia, that will predispose towards serious respiratory disease. It is a salutary thought that only about 2% of chronic bronchitics are non-smokers who live in rural areas. Apart from these longer-term effects, a smoker will have about 10% of the oxygen-carrying capacity of the blood nullified by carbon monoxide, and in addition will have blood vessels narrowed by the specific effects of nicotine.

ALTITUDE

The 1968 Olympics in Mexico City provoked a great deal of interest in both the problems of competition at altitude and the possible advantages of training there. The reduction in air density with altitude lowers wind resistance so that times for short distances (say, 500 metres) will be reduced, but since there will also be a corresponding reduction in oxygen partial pressure, aerobic endurance will be much less. In Mexico City (2,240 metres) the air pressure (and oxygen partial pressure) is about 24% lower than at sea level, and performances in the 1968 Olympic Regatta were about 5–8% down on what might have been expected at sea level. Additional problems are presented by increased ultra-violet radiation and attendant problems of sunburn, and the lower carbon dioxide partial pressures which can disturb the normal breathing control mechanisms. More severe medical problems can arise, such as pulmonary oedema (fluid in the lungs) and possible heart problems when exercise is undertaken at altitude, and these difficulties are likely to be more

severe even for the acclimatized athlete at altitudes above 2,500 metres.

Acclimatization

During a stay at high altitude, many physiological changes occur, particularly during the first 1–2 weeks, that will help to enable you to perform well at altitude. Some changes continue to accumulate over a much longer period but there is always an advantage to those who normally live at height. Some of the early adjustments will temporarily reduce performance at altitude and others will be a hindrance when you return to sea level, and it is by no means certain that altitude training will always be beneficial to subsequent race times at low altitude. Most authorities recommend 3–4 weeks of acclimatization at an altitude of about 2,000 metres, and the more severe stress encountered at 3,000 metres will do more harm than good.

As described in Chapter 7, the carbon dioxide concentration of the blood is a major factor in determining the rate and depth of breathing, but the sensors also respond to oxygen lack to some extent. On first arrival at high altitude there is a tendency to hyperventilate to meet the body's oxygen requirement, but most people quickly settle to a more normal rhythm. Since the air inspired will have a lower than usual carbon dioxide content, this means that the hyperventilation will cause appreciable falls in blood CO_2 – and this would normally *reduce* ventilation rates. The result can be disturbance of breathing rhythm as well as the more usual symptoms of hyperventilation discussed earlier; those who cannot adapt will need to return to low altitude as soon as possible. Within the first week progressive losses in buffers (neutralizers of acid, particularly bicarbonate) normally occur so that hyperventilation can take place without the same penalties; as a result about one-fifth of the oxygen deficit from arterial blood can be made up.

Also during the first week there is a loss in plasma volume which effectively increases haemoglobin concentration of the blood and improves oxygen transport. The reduction in volume continues during the next few weeks and consequently the blood thickens – and this may hamper free circulation. Maximum heart output may be reduced both by a lesser stroke volume and by lower maximum heart rates, so that VO_2 max. will be depressed. Both the rate of destruction and the rate of production of red blood cells (erythropoiesis) will increase, and it is normal to experience a rise in both red cell count and haemoglobin (fig. 98), though this will further increase the blood's viscosity.

Training under conditions of lower oxygen partial pressure can be used as a stimulus to increase enzymes for aerobic respiration in

Fig. 98 Red cell numbers and the haemoglobin they carry both increase rapidly during the first weeks at altitude.

muscle, to increase the number of capillaries, and oxygen transfer will be helped by increases in myoglobin, the red oxygen-carrying substance in muscle. Obviously, anaerobic respiration will set in at lower levels of effort and lactate production will rise earlier than usual. This could be a problem with the lower buffering capacity that develops at altitude, but fortunately the enzymes responsible for lactate removal will also be stimulated.

Altitude training
For the sea-level athlete the idea of training at altitude is attractive as it holds out the possibility of enhanced oxygen-carrying capacity in the blood. Unfortunately the possible gains can be nullified by a range of adverse reactions to altitude or to the specific deficiencies of the training venue, and there is also a problem of critical timing if the optimum performance back at sea level is sought. Many athletes in a range of disciplines have found altitude training disillusioning, and there were certainly competitors in the 1988 Olympic Regatta who mistimed their descent and failed to allow for the necessary adjustment to Seoul conditions.

Assuming that a training camp of 3–4 weeks at 2,000 metres or more is undertaken then there is the possibility of enhanced aerobic performance for about 4–20 days after descent; that is, after buffering capacity has been restored but before the extra haemoglobin is lost. As a general rule it would be wise to allow ten

days before major competition. Many athletes who are used to such regimes report a sense of well-being which enables them to resume their sea-level training with increased vigour after altitude, and they ascribe any better race times to this effect rather than the direct one.

Previous experience of altitude undoubtedly helps the athlete to adjust more quickly, and it would be very unwise for any athlete to experiment with this preparation for the first time before an important competition. If athletes are already in peak condition then the gains are likely to be small and must be weighed carefully against the disadvantages of training under unusual conditions. Apart from psychological problems, the disadvantages can include reduction in training volume and intensity until acclimatization is advanced, learning of incorrect pace, insomnia, dry and sore throats, lower glycogen stores, dehydration and sunburn.

Nutrition and diet

A good diet is essential for health and well-being and is also a prerequisite of optimum rowing performance, but such a diet is neither complex nor expensive. The diet supplies the body with all the basic ingredients from which it is built and repaired, with its sources of energy, and with essential biochemicals which it cannot manufacture for itself. Even an adult's tissues are constantly being replaced and modified, and this is particularly true for the athlete in training whose tissues are adapting to the stress. Such requirements for growth are of course even greater in the growing child and adolescent. Furthermore, large quantities of an enormous range of substances are used up, secreted and excreted by our bodies every day, and the losses must be made good.

There is a common fallacy that if this or that component of the diet is essential for health or rowing success then an extra-large helping will lead to even greater success. Despite all the claims by those with a financial interest, there is no proven case for any boost in performance by any foodstuff or dietary supplement for any athlete whose diet is already adequate from normal sources. We must guard against missing out on vital ingredients, but those who are looking for a magic ingredient before next Saturday will be disappointed.

COMPONENTS OF THE DIET

It is convenient to divide the essential components into seven main classes as follows:

1 Carbohydrates
2 Fats and oils
3 Proteins and amino acids
4 Vitamins
5 Minerals
6 Water
7 Roughage or fibre

Nutrition and dietetics are huge subjects by themselves and there is space here to present only an outline of the functions of these seven components with special reference to rowing; the reader should consult more specialist texts for further details.

1 Carbohydrates

Carbohydrate is the primary fuel for rowing, the major source of energy, although a number of other compounds (such as fat) may make a lesser contribution. At low levels of effort a mixture of fat derivatives and carbohydrate will be utilized, but above 95% VO_2 max. the source of energy for the muscles will be almost exclusively carbohydrate. Above the anaerobic threshold carbohydrate will be used very rapidly indeed since anaerobic respiration (glycolysis) generates so little energy from each gram of it. Far and away the the most important source of carbohydrate for the muscle will be the glycogen stored within it, though blood glucose can also make a contribution (fig. 99).

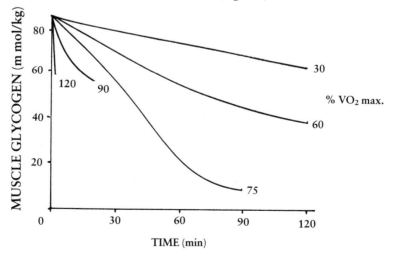

Fig. 99 The rate at which stored glycogen is used depends very much on the intensity of the exercise. (After Gollnick).

Carbohydrates are compounds of the elements carbon, hydrogen and oxygen only. They are conveniently classed as either sugars, such as glucose or sucrose, or polysaccharides, such as glycogen or starch, with very much larger molecules made up from many sugar molecules. Enzymes, particularly in our digestive juices, are able to convert polysaccharides readily to their sugar components and these simple sugars enter our bloodstream from the gut. Excess sugar in the blood will be removed by the liver and muscles under the influence of the hormone insulin, converted into glycogen and stored. The liver stores about 100 grams of glycogen and this is vital as a reserve for maintaining a constant blood glucose concentration since the glycogen can readily be reconverted to glucose as required. The total stored in muscle might be about 300 g in an untrained person but a fit, well fed and rested rower may well have twice as much.

At rest less than 10% of the muscle's energy is derived from blood glucose, much of it coming from fat, but during strenuous exercise, although the rate of glucose uptake by muscle increases perhaps twenty-fold, the larger proportion is provided by muscle glycogen. However, as exhaustion approaches and muscle glycogen stores become greatly depleted, the contribution of blood glucose increases. Thanks largely to decreased production of the controlling hormone insulin, the liver continues to release glucose into the bloodstream until its glycogen is nearly all used up, and then blood sugar will fall. By this stage profound exhaustion will have set in involving not only the muscles but also the central nervous system. Muscle glycogen stores therefore have a great influence on endurance above 70% VO_2 max., which is the range of interest to us in training and competition; the larger the stores, the longer the exercise can continue.

The muscle enzyme responsible for storage is glucose synthetase, and at the end of exercise when glycogen depletion has occurred the activity of this enzyme is very greatly increased. Further activation is brought about by both glucose and insulin in the bloodstream. It follows that the most rapid re-synthesis of muscle glycogen will occur immediately after exercise if quantities of carbohydrate are available. This effect can be exploited by eating carbohydrate-rich food or drink, particularly glucose drinks, as soon as possible after a race or training session. Such an emphasis on glycogen replenishment is important because if you are training every day, or racing frequently, your glycogen stores might not recover within twenty-four hours (fig. 100). As mentioned in Chapter 7, it is unwise to eat or drink carbohydrate in the hour before a race because this would activate the glucose storage mechanisms just as you were wanting glucose to be released.

Fig. 100 Exercise severe enough to deplete the glycogen reserves substantially is the greatest stimulus to storage. (After Bergstran and Hultman).

The energy value of food is measures in joules, but the value of one joule is so small that it is more usual to count them in thousands (kilojoules, kJ) or even millions (MJ). However, the older units of calories are still often in use (one calorie equals 4.2 joules), again more usually encountered in thousands (kcal). One gram of carbohydrate releases about 4 kcal = 16.8 kJ of energy, as does one gram of protein, whilst fat gives more than double the energy at 9 kcal = 37.8 kJ. Your personal energy requirements per day are not easy to estimate exactly as they depend on your age, size, sex, activity level and metabolic rate. However, we can be sure that your rowing and sculling training will demand a great deal of extra energy and therefore extra food compared with an inactive person. For top-class rowers or scullers training hard and regularly, it has been estimated that the daily energy requirements will be 300–315 kJ (72–75 kcal) per kilogram of body weight. For an 80 kg male this comes to 24,000–25,200 kJ (5,700–6,000 kcal) per day, and for a 70 kg female probably nearer the lower figure of 21,000 kJ (5,000 kcal).

These are very large values and will require a correspondingly large food intake to meet them. General nutritional advice now is to make carbohydrate at least 50% of the energy value of the diet, but in order to meet the special energy demands of rowing and to replenish daily the stocks of glycogen we should be aiming more towards 60–70%, largely through a reduction in the proportion of fat as we eat more carbohydrate. The problem is that this does make a rather bulky diet, and our top-class athletes can have

something of a struggle to eat the quantity of food that they undoubtedly need for their demanding training. Sixty per cent of 25,000 kJ would mean eating nearly 900 g of carbohydrate a day – about, say, fifty-five slices of bread! Even for less committed male rowers, but who are training hard every day, they will need to eat at least 500 g of carbohydrate if they are to maintain glycogen levels and performance.

Fortunately the recommended high-carbohydrate foods are easily available and very cheap, and can be made very tasty. It is suggested that the increase largely comes from the unrefined starchy foods such as wholemeal bread, potatoes, pasta, rice, pulses and so on. Refined and processed products such as sugar, jam, cakes, biscuits and puddings, although rich in carbohydrates may be rather low in other nutrients, may contain rather a lot of fat, and the sugar content may be harmful to teeth; nevertheless they will be hard to avoid if we are to maintain the high carbohydrate proportion in the total diet. It is also fortunate that these carbohydrate foods, particularly the unrefined ones with a good fibre content, are easy to digest and pass through the gut much faster than fatty foods; thus it is easier to cope with frequent large meals. Indeed it is suggested that it is better to eat more frequently rather than attempt just one or two enormous meals. From a practical point of view this means strategies like the large breakfast of cereal (without cream) followed by toast and honey, rather than the traditional fried breakfast; lots of mashed or boiled potatoes (without butter) rather than more meat; or spaghetti bolognese with the emphasis on the spaghetti. Eat sandwiches and sticky buns, and cereal bars rather than chocolate, for snacks in between or for that quick carbohydrate top-up straight after training, and for fruit try bananas which have a lot of carbohydrate and fibre in them.

The reduction in fat that comes with this dietary change will also be a help in ensuring that despite the larger quantity of carbohydrate, the total energy value of the diet does not exceed requirements and perhaps lead to obesity. It is wrong to regard the starchy foods as fattening; it is the fats that are the worst culprits. Reduce fat and increase carbohydrate, train hard, and it is quite possible to lose weight and body fat and yet maintain high glycogen levels for effective training and competition.

2 Fats and oils

Fats and oils should not be regarded as villainous substances that we should do without because they clog up our arteries and cause obesity. On the contrary, some oils seem to have a protective effect on our circulatory system, and we do need at least a minimum of a wide range of fats in our diet to maintain health and growth. Fats

and oils are compounds of glycerol and any three of a large range of fatty acids, several of which we must have in our diet somewhere because we cannot make them ourselves. Apart from their high energy value, fats are essential in many parts of our bodies for the construction of cells and they are also the normal carriers of the fat-soluble vitamins in our diet. Fat is the main energy store for the body – a 70 kg man with 10% body fat would have 63,000 kcal worth (enough for thirty days!) – and that fat also acts as a shock absorber round vital organs such as the kidneys and as insulation beneath the skin.

As we have seen, fat can act as a partial source of energy for rowing, particularly at lower speeds, but for higher performance and more rapid digestion we need to emphasize the intake of carbohydrate. In Great Britain the average adult will eat about 100 g of fat a day, making up about 40% of the total energy, but for health reasons this should be reduced to no more than 35%. Apart from the obvious visible fats such as butter, margarine and fat on meat we also eat a lot of fat in meat, cakes, pastry and confectionery, cheese and whole milk, and many other foods, especially if they are fried. If the total calorific value of the diet is being increased to cover training needs, and this is achieved by increasing intake of low-fat forms of carbohydrate foods, then there will be less problem with the now smaller proportion of fat that will be more rapidly metabolized. If there is a need to reduce dietary fat still further, for example to help a lightweight maintain target weight yet still take in adequate carbohydrate, or if your present diet is already too dependent on fatty foods, then it will be necessary to be more selective amongst the alternative foodstuffs and to avoid fried foods of any sort.

Female rowers and scullers should be careful about reducing body fat too far for whatever reason because of the problems of sports amenorrhoea that might result, and adolescent girls should never risk reaching that condition.

3 Protein and amino acids

Proteins are made up of a large number of simpler amino acids, of which there are twenty common forms, and as a result there is an almost infinite variety of types of protein. Every cell in our bodies contains thousands of different proteins, each with specific tasks to perform, and all of those proteins are assembled from the amino acids which we eat, or more usually from the amino acids released from proteins as we digest them. We eat a great variety of protein, unless perhaps we are following a very restricted vegan diet, so we are likely to take in a sufficiently varied mix of amino acids for most purposes.

Proteins are often described as the body-building foods, but this is misleading because although there is much protein in the structure of cells (especially muscle cells) and in connective tissues, proteins have many other roles to fulfill, and in addition it would be quite wrong to assume that the intake of protein acts as a stimulus to growth. Certainly proteins are essential for growth but there is no evidence that excess increases it, and most of us are already eating much more than we need. Although some 40% of our body protein is found in muscle, and its development and growth requires adequate supplies of the right amino acids, the rate and extent of that development depends on our hormones and the training we do and is not likely to depend on eating extra protein. Even if we were greatly increasing muscle bulk through a programme of heavy weight training, it has been calculated that we would only need an extra seven grams a day of protein. An average intake of about 1 g per kg body weight (or slightly less for the less muscular female, and more for the growing child) would be quite enough for our purposes, but in fact most of us when actively training will be eating much more than the average person and will be getting even more protein than this.

High-protein foods, let alone special supplements, are therefore unnecessary in the diet for most of us and are also expensive. High levels of protein or gross imbalances of amino acids do have unwelcome effects and should be avoided, so a total protein intake amounting to about 10–15% of the total energy in the diet should be about right. The only problems are likely to arise for those on restricted diets, for example vegans because some plant proteins are rather low in particular essential amino acids, and those on a small total diet who may have to think about using some high-protein foods in order to maintain a minimum of about 0.75 g of protein per kg body weight. The high-carbohydrate diet that has already been proposed will minimize the use of amino acids for energy generation (very little except in starvation or exhaustion anyway), and will thus have a protein-sparing effect.

4 Vitamins

These organic chemicals are not nutrients as such since they have no energy value, yet they are essential in small quantities in our diet for the maintenance of health, the release of energy from food and for growth. Tables in most nutrition books set out the functions and good sources of the principal vitamins, and the (frequently revised) recommended daily intakes of them. These latter figures vary greatly from one authority to another, but the truth of the matter is that very little is known about the precise levels for humans because we cannot very well do fully controlled

experiments on humans, and so many of the estimates come from animal experiments. Because these substances are clearly very important in exercise it is tempting to believe that we must take in more during training – either in hopes of boosting performance or just as insurance. There is some scientific justification for this, particularly with respect to the energy-releasing B vitamins, and C, where levels of up to 40% more than usual are currently suggested. For what it is worth, the East Germans recommended even higher levels for their rowers but it is not clear how well researched this was. These water-soluble vitamins can be safely tolerated in doses way above those known to be effective, but we must be much more careful with some of the other vitamins for indeed some are poisonous in excess. A good mixed diet with plenty of fresh ingredients, not overcooked, and not too much that is refined or processed, is almost bound to provide enough of all the vitamins, but if there is any ground for concern then a small daily supplement is unlikely to do any harm.

5 Minerals
These inorganic substances, in solution as charged particles called ions, are present in our body fluids and cells in a range of

Table 11
Daily intake of minerals suggested for male rowers

Calcium	2.5 g
Potassium	5.0 g
Sodium chloride	20.0 g
Zinc	15–20 mg
Magnesium	500–700 mg
Iron	35–45 mg
Phosphate	3.5 g

There are perhaps three situations where special attention may need to be given to mineral nutrition:

1 If you are on any sort of restricted diet.
2 If you have been sweating a lot, when losses of sodium and potassium in particular are likely to be large (see section on heat earlier in the chapter).
3 Females and especially girls or any suffering heavy menstrual bleeding, may need extra supplies of iron.

concentrations where they fulfill a wide variety of functions. For best results these concentrations should remain more or less constant, a task that is largely accomplished by our kidneys.

Because minerals are regularly used up, and excreted in sweat and urine, they must be replaced through the diet, and there is no doubt that the active rower will need to increase intake in order to match the more rapid losses. As with vitamins, however, there is no evidence that excessive intake will improve performance, and again a mixed diet of good-quality foods in adequate energy amounts should take care of our needs without supplementation. The East Germans studied the available literature thoroughly and recommended the following amounts for top-class male competitors (Table 11). These figures would relate to body weights of about 90 kg, and if you are lighter (which will include most females) then the amounts would be correspondingly less.

6 Water

The importance of adequate water supplies in hot weather has already been stressed, but even in more normal conditions we need something like two litres a day, and much more when we sweat during training. Many of us probably do not drink enough water and it would be better to err on the generous side and let our kidneys deal with any excess rather than risk the harmful effects of dehydration. As mentioned earlier, we should be cautious about relying too much on the fluid taken in with coffee or alcoholic drinks for they will encourage the excretion of the water. Thirst is not a good guide to how much we should drink, but it does tell us that we are already short of water and should have drunk more earlier! Intriguingly, some early books on rowing and on other athletic training clung strongly to the nineteenth-century belief that severe restriction of fluid intake was an essential part of fitness training. Such regimes must have been very uncomfortable at best and highly dangerous at times, as well as highly ineffective.

7 Roughage or dietary fibre

Plant fibres that we cannot digest give a firmer bulk to our food as it passes through the gut, and this helps the muscular action that transports it and finally eliminates it (peristalsis). Adequate fibre helps to prevent constipation and some diseases of the large intestine, but as with other things an excess can be harmful. If you regularly eat fruit and vegetables and not too much processed food, as I recommended earlier, then you should have plenty of fibre and there will be no need to look for any more.

LOSING WEIGHT

Untrained people who follow the training and dietary advice given earlier will very probably lose body fat and look leaner, but they may not lose much weight because some of the weight of the fat will have been replaced by extra muscle and connective tissue. If further fat losses are desired then it is best not simply to restrict calorie intake, which will reduce training and competition capability and be hard to maintain, but to emphasize low fat intake and endurance training even more, whilst maintaining adequate carbohydrate. It is not true, by the way, that when you stop training the muscle will turn to fat, but it may be difficult to reduce your food intake to take account of your smaller energy needs.

Fit adult male rowers will probably have about 10% body fat and females will possibly be in the range 15–20%; lightweights on the other hand will often be well below this (one British male world champion reached the extraordinarily low figure of 3.5%!) and will have to be careful with both the composition and quantity of their meals. Some lightweights and their coaches still believe that starvation and dehydration just before competition is the best way to make the weight, but the reverse is true. Lightweights should aim to be below target weight well before important races so that they can eat and drink sensibly in the last few days. It is common practice to lose the last pound or two in a pre-weigh-in outing, and there is no harm in this because the lost fluid can be made up before the race.

Hygiene and blisters

Skin damage and infections are uncomfortable and deleterious to performance and it is worthwhile taking some precautions. Keep the skin and your kit clean and always shower or bath after training or racing. If the skin does get damaged then clean it thoroughly and cover it with a sterile and frequently changed dressing. Small blisters are best left alone, but larger ones which will burst next outing anyway should be emptied by piercing with a sterile needle and then covered and protected; leave the skin intact to go dry and hard. Protecting the hands with sticking plasters is not always successful because the plaster rolls up, and a better answer is a light cotton glove or cycling mitt, over the top of plasters if necessary to protect earlier damage. With use the skin will thicken and harden, but this effect can be encouraged in advance of the rowing season by twisting a smooth piece of wood

daily between the hands so that the critical areas become just a little tender. It is said that rubbing the skin with surgical spirit has the same effect, but I have not found it effective and if the skin is broken the spirit is very painful! There is no doubt that a loose hold of the handle and good feathering technique will help to delay blisters.

Looking after yourself so that you are not harmed, or your performance reduced by avoidable factors, is only common sense, and now that you are armed with the information in this chapter you can at least take the practical steps necessary. This book is largely devoted to ways of improving your performance – by increasing your skill, by improving your training for strength, endurance and so on, by helping you to get the most out of your boat and getting the most out of yourself in racing. It would be tragic to waste what you have gained by neglecting your health or by taking in an inadequate diet. Making a success in rowing has been likened to making a cake – you need all the right ingredients in all the right proportions, and cooked in just the right way for the correct length of time. I hope that what you have read here will help you to select the right mix for you to achieve your ambitions in the sport – as a famous coach once said to me, 'If you do this you may not be world champion, but you won't be bad!'

Index